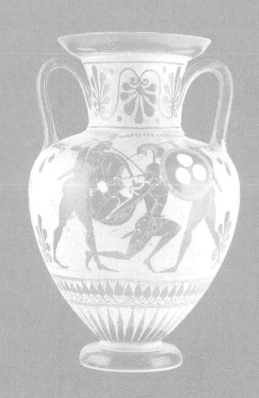

WITH CONTRIBUTIONS BY

Betty Adcock

James Applewhite

Daphne Athas

Gerald Barrax

Doris Betts

Linda Beatrice Brown

Kathryn Stripling Byer

Fred Chappell

Angela Davis-Gardner

Ann Deagon

Wilma Dykeman

Charles Edward Eaton

Clyde Edgerton

Anderson Ferrell

Marianne Gingher

Jim Grimsley

Allan Gurganus

R. S. Gwynn

William Harmon

David Brendan Hopes

John Kessel

Romulus Linney

Peter Makuck

Margaret Maron

Jill McCorkle

Michael McFee

Tim McLaurin

Heather Ross Miller

Robert Morgan

Lawrence Naumoff

Michael Parker

Deborah Pope

Joe Ashby Porter

Reynolds Price

Gibbons Ruark

James Seay

David Sedaris

Alan Shapiro

Lee Smith

Elizabeth Spencer

Max Steele

Julie Suk

Eleanor Ross Taylor

Robert Watson

Jonathan Williams

Huston Paschal
EDITOR

Advisory Committee
Reynolds Price
CHAIR

Betty Adcock

Gerald Barrax

Doris Betts

Fred Chappell

Allan Gurganus

THE STORE OF JOYS

Writers Celebrate the North Carolina Museum of Art's Fiftieth Anniversary

North Carolina Museum of Art

in association with
John F. Blair, Publisher
Winston-Salem

North Carolina Museum of Art.

The store of joys : writers celebrate the North Carolina Museum of
Art's fiftieth anniversary / Huston Paschal, editor : advisory committee:
Reynolds Price, chair.

p. cm.

ISBN 0-89587-207-2 (hardcover : alk. paper). —ISBN 0-89587-174-2
(pbk. : alk. paper)

1. Art—North Carolina—Raleigh—Literary collections.
2. American literature—North Carolina—Raleigh. 3. Art and
literature—North Carolina—Raleigh. 4. American literature—
20th century. I. Paschal, Huston. II. Price, Reynolds, 1933-
III. Title.

PS559.W58N67 1997

810.8'0357—DC21 97-7004

Library of Congress catalogue
number 96-079633
ISBN 0-89587-207-2
ISBN 0-89587-174-2 pbk.

This publication is supported in
part by a grant from the National
Endowment for the Arts.

The North Carolina Museum of Art,
Lawrence J. Wheeler, Director, is an
agency of the North Carolina
Department of Cultural Resources,
Betty Ray McCain, Secretary.
Operating support is provided
through state appropriations and gen-
erous contributions from individuals,
foundations, and businesses.

"June Issue with Swan Dive" from
A Guest on Mild Evenings by Charles
Edward Eaton. Copyright © 1991 by
Cornwall Books. Reprinted with per-
mission of the author.

"The Swan" and "The Possible
Dreams of Swans" from *New and
Selected Poems, 1942-1987* by Charles
Edward Eaton. Copyright © 1987
by Cornwall Books. Reprinted with
permission of the author.

"The Swan at Sunset" from
The Country of the Blue by Charles
Edward Eaton. Copyright © 1994
by Cornwall Books. Reprinted with
permission of the author.

Excerpts from *In Memory of
Junior* by Clyde Edgerton. Copyright
© 1992 by Clyde Edgerton.
Reprinted with permission of
Algonquin Books of Chapel Hill.

Excerpts from *Caruso* by Stanley
Jackson. Copyright © 1972 by Stanley
Jackson. Reprinted with permission
of the Estate of Stanley Jackson.

Photography:
Lynn Ruck and Bill Gage
North Carolina Museum of Art

Photographic Archivist:
William Holloman

The photograph on pages vii, 59,
and 71 of school children touring
with docent Tula Robbins was taken
by William A. Martin in 1960. Martin
also took the 1965 photograph on the
back cover of the original Museum
building in downtown Raleigh.
The back-cover photograph of the
building in use since 1983 was taken
by Glenn M. Tucker in 1991.

Design: Doug Clouse

The text and headlines of this book
are set in Perpetua and Perpetua
Expert. Designed by Eric Gill,
Perpetua was released by the
Monotype Corporation in 1928. In
1987 both fonts were digitized for the
Apple Macintosh computer.

Printed and bound through Mandarin
Offset in Hong Kong

Out of that mass of miracles my Muse

Gathered those flowers, to her pure senses pleasing;

Out of her eyes—the store of joys—did choose

Equal delights, my sorrows counterpoising.

from *The 21st (and last) Book of the Ocean to Cynthia*
by Walter Raleigh

CONTENTS

A CELEBRATION of the inspirational potential of great works of art lies before you. When a group of North Carolina's most distinguished writers agreed to create new works in response to objects in the Museum's collection, a remarkable tribute — not only to the Museum's founding fifty years ago, but to the profound, provocative energy of art — was born. We are grateful beyond words to the gifted writers who contributed to this project and to the inimitable Reynolds Price who was its shepherd.

As the Museum charts its course for the next fifty years, we hope that it will become an even more dynamic center of collaboration among the arts: a place where music, dance, theater, and film will be nurtured by the mute works in the collection, a place where new voices can be heard. By thus enlarging the museum experience, we hope that we will bring enhanced enrichment to people's lives.

When the state's legislators voted on April 5, 1947, to appropriate $1 million to begin this collection of art for the people of North Carolina, surely they intended to establish a museum that would not only present and develop the collection, but would also be innovative and purposeful in educating a growing public about the communicative power of humankind's creative genius.

As you savor the delectable fare which follows, a collective gift to you, it is our wish that you will discover, or rediscover, some of the many languages of art.

Lawrence J. Wheeler
Director

INTRODUCTION AND ACKNOWLEDGMENTS

Out of that mass of miracles my Muse
Gathered those flowers, to her pure senses pleasing;
Out of her eyes – the store of joys – did choose
Equal delights, my sorrows counterpoising.

> – from *The 21st (and last) Book of the Ocean*
> *to Cynthia* by Walter Raleigh

"AFTER ALL, a poet invented our state," a native son rather poetically reminded his listeners. Not only a poet, Walter Raleigh was also an explorer and a New World colonizer, a man who extended boundaries. Extending boundaries – or transforming them, if you will – is the goal of this response book. Uniting the visual and the verbal, the responses interpret the works in the North Carolina Museum of Art's collection through the renewing eyes of the state's poets, novelists, and short story writers. Their words transport the reader-viewer beyond the confines of received opinion, overriding comfortable habits of observation and perception.

One way to look at these responses is to consider the writers' words as synonyms for the works of art. The anthology comes to life as a metaphorical thesaurus, comely reminder of this word's classical origins in the Greek and Latin word for treasure, treasury. The shades of meaning allowed into play dance around the viewer's fixed ideas of art and life. For meaning can be transitive; truth can be evasive. These personalized projections make an asset of this often disquieting fact. By articulating their dreams, acting on their hunches, these poets and storytellers release transforming energies. Each intimate encounter between author and artist, a marriage of hearts, enables members of their audience to escape into a larger space.

Interplay between the literary and visual arts enjoys a lively history. Though their schemes of presentation – courting eye or ear, absorbing space or time – are disparate, the cross-pollination is unsurprising, since both writers and artists think in images. Thought is not linear. (And for that matter, the first alphabets were pictures, not letters.) Certainly artists have looked to the written word for source material. The Museum's collection is full of supporting evidence. Aside from those works related to Scripture or recorded myth, there is, for instance, Thomas Moran's *"Fiercely the red sun descending / Burned his way across the heavens."* One of a series Moran devoted to *The Song of Hiawatha* by Henry Wadsworth Longfellow, the painting bears an opulent title taken from the poem it opulently portrays. On the other hand, Paul Delvaux never meant *Antinoüs* as an illustration for *Memoirs of Hadrian*, the book by Marguerite Yourcenar that inspired his 1958 painting, but its literary origins are indelible. (Neither the Moran nor the Delvaux, by the way, figures in this compilation.)

And just as surely art has served as pretext for writers. Ecphrasis, literally putting a picture into words, has been practiced since the time of Homer and Hesiod. John Hollander illuminates this seductive mode of transliteration in *The Gazer's Spirit: Poems Speaking to Silent Works of Art*, and *On the Laws of the Poetic Art* by Anthony Hecht addresses similar ideas. It is a tradition to which participants in this project have contributed with verve – and on which they have improvised. Linda Brown finds in the Romare Bearden a jumping-off point for a short story that forsakes detailed description of the collage. The atmospheric correspondence between her story (excerpted here due to limitations of space) and *New Orleans: Ragging*

Home tells as much about the Bearden as true ecphrasis might. The homage of careful attention can take myriad forms. Anderson Ferrell brings a broad overview down to a point of the intensely personal. If one were to diagram his response, it might shape up as an inverted triangle — faithful to the smooth, simple geometry of the Cycladic figure about which he is writing.

Surveying this "mass of miracles" that the Museum contains, each writer picked up a live signal from at least one work of art. Voluble and volatile, the object beckoned in a private code deciphered and given voice by its author. The matches are instructive. Naturally enough a realist like Doris Betts has been drawn to a narrative painting by Andrew Wyeth. The Milton Avery must have been catnip to Lee Smith. James Applewhite and Winslow Homer meet on common, sacred ground. The pastoral won from this combination contemplates the poignant mysteries of *Weaning the Calf*; the poem strikes home. More unpredictable is Tim McLaurin's choice of the Monet. This tested survivor's paternal reflections turn out to be in tender communion with the French riverscape, making the Monet his and returning it to viewers touchingly amplified.

To go back to Walter Raleigh, the Museum has now gathered the writers' responses in an anthology, a Greek word whose literal meaning – a gathering of flowers – irrepressibly asserts itself. This book of equivalent delights has its own history. Three years ago Lawrence Wheeler asked his staff to come up with ideas, centering around the permanent collection, to celebrate the Museum's fiftieth anniversary in 1997. John Coffey, curator of American and modern art and chair of the curatorial department, gave serious thought to the director's request. Recognizing that the particular artistic genius of the South is literary, Coffey suggested inviting North Carolina's writers to respond to works of art on view at the Museum.

To realize the publication, the staff approached unquestionable authorities. Once Reynolds Price consented to chair an advisory committee, the Museum felt secure in proceeding. When Betty Adcock, Gerald Barrax, Doris Betts, Fred Chappell, and Allan Gurganus agreed to serve on the committee, the venture's success was further assured. This core group established guidelines and chose the other fiction writers and poets to be asked to participate, nearly all of whom accepted – and many of whom, it emerged, are long-time Museum loyalists. The definition of "North Carolina's writers" came to rest on lengthy residency or native birth. Beyond that, the chief criterion for selection was proven excellence. That a different list of names could have been devised is not contested. Acknowledging the subjective nature of the process, the Museum unabashedly endorses this committee's judgment.

Specifications were kept to a minimum, freeing the forty-five authors to construe the commission – to choose an object and respond to it – however they saw fit. Interestingly, the responses distributed themselves nearly evenly among poetry, fiction, and nonfiction. Only after embarking on this project did the Museum become aware of other recently published response books, notably the Art Institute of Chicago's *Transforming Vision: Writers on Art* and the Whitney Museum of American Art's *Edward Hopper and the American Imagination*. A distinguishing feature of *The Store of Joys* is that it consists exclusively of new, previously unpublished work.

Though duplication of choice was discouraged, it was not prohibited. In six cases, two writers selected the same work, expanding the dialogue into a symposium of a fascinating sort. Look, for instance, at the pair of responses to *The Eruption of Mt. Vesuvius*. Robert Watson builds a poem around an American's trip to Italy, while Michael Parker composes an episode based on an Italian's tour of this country. And what about those empty chairs

in Frieseke's *The Garden Parasol*? Have they recently been vacated, or are they about to be taken? Elizabeth Spencer and R. S. Gwynn see and write it differently.

All along, the Museum thought of the book as one in which the word comes first. (And we have respected the word as it came to us; a light hand has been exercised in preparing this manuscript for publication.) *The Store of Joys* is not a handbook to the collections. Its paradoxical revelations – life-clarifying, spirit-enlarging – apply to the authors as well as to the art.

This long-term enterprise has received bracing support from many whom I am eager to acknowledge. We all owe thanks to John Coffey for his magnetic idea, and to the director who championed it. Though at midpoint we lost the Museum's editor Lisa Eveleigh to a new position, she played a crucial role in the project's early stages and graciously made herself available for consultation in the months that followed.

The Museum staff has been enthusiastically cooperative – notably so my fellow curators, the registrars, and the photographers. There are as well other staff members who deserve singling out. Karel Shultz tamed and humanized the project's technological aspects, and Paula Mehlhop exhibited the genial willingness to help that I depend on. I could not have done without the organizational and editing skills of Michelle Mead Dekker, a curator who is also a sympathetic and astute reader. The North Carolina Museum of Art Foundation ardently endorsed the project and secured the essential funding, and Carolyn Sakowski of John F. Blair, Publisher patiently answered endless questions.

The Museum was heartened to find that the writers relished the challenge of responding. Working with them and being sometimes privy to the process of creation has been an invaluable experience for me. All of us have been well served by the advisory committee, six dedicated people whose manifest love for the Museum and this state translates into our great reward. Reynolds Price, a generous man of inspiriting good cheer, and the committee members gave of themselves unstintingly. To cite only one example of their inspired leadership, Fred Chappell – the native son quoted above – knew just where to find a perfectly apt title. The book's pages are graced with improvements suggested by the committee, and by no means can they be held accountable for shortcomings. In a very real way, then, this is the committee's book, as it is all the contributors' book.

That which we treasure we seek to preserve. The Museum cares for its collections – and by extension the entire cultural tradition of which the plastic arts are a part. With *The Store of Joys*, the Museum honors its holdings and helps perpetuate the idea of the book and the classical learning it symbolizes. At the same time, the Museum believes fervently in the art of our own time and wants to encourage the new. *The Store of Joys*, a felicitous means to that end, verifies that these poetical explorers' invention can be a sustaining place to live.

Huston Paschal
Associate Curator of Modern Art

RESPONSES

ANDERSON FERRELL

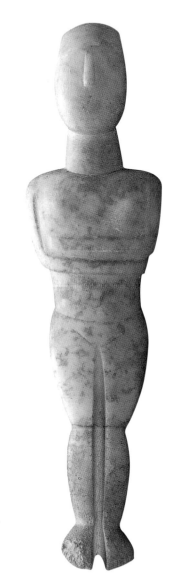

Female Figurine

THE MAKING of a novel, an essay or a poem requires the addition of words to a blank page or empty computer screen, whereas the sculptor's work is to take away from a lump of stone anything that is not what he intends the final image to be. So much about that process seems beyond the power of words.

We are much better equipped biologically speaking to view a painting or a statue than we are to read a book. The effect of the visual arts on a sensitive viewer is quicker than that brought about by a novel or even the briefest of poems. That same individual would have to invest more time to appreciate a written work of art. The connection from page to eyes to brain to heart is a less efficient one. Our ability to recognize and make sense of form is basic to survival. It is significant that this Cycladic figure was fashioned as far as we know by a person who lived in a culture in which there was no written language.

That there is here dedicated effort and masterful skill is apparent even to those of us who have no intellectual understanding of the process. The sculptor's solution, in awesome simplicity, reaches me directly across and perhaps in spite of thousands of years of history and changing cultures. It is its timelessness, its evocation of an essential and unchanging femininity, a womanliness beyond sexuality that is *named* by the is-ness of this figure.

Art historians and archaeologists have been unable so far to agree about the use or meaning this statue had for the society that produced it. I am glad this is so. To know the creator's intentions beyond what is available from beholding his creation would not, I believe, enhance my enjoyment of it. The genius of art — great art — I think,

is that it transcends specific canon, conviction, creed, doctrine even when the artist himself believes in the religion and mythology of his time. The work speaks heart to heart, spirit to spirit over the noise of cultural and religious particulars.

I think of an hourglass when I think about the experience of looking at art. Among the grains of sand falling through the tiny opening is one that is larger than the others and will only pass through by itself. I hope for that moment of communication between the hearts of the creator and the beholder when, after the specifics of his culture and personal history have past and while my own time is briefly suspended, there passes between us something—an assertion of an eternal truth, a deeper order that confounds the chaos of reality. This is a heightened state. It is an experience unique and overwhelming that confirms for me that in the play of opposites which holds the world together is found the whole truth. If I have a religion that is it. But I would not wish to abide forever in this condition anymore than I would want to be eternally sexually aroused or forever in the grip of laughter. So I come back to earth and look at art in an earthly way. I can't help viewing this marble lady in the light of my personal experience of life. My memories, my history pile around its essential truth like the sand collecting in the bottom of the hourglass, and perhaps I find, despite thousands of years and different cultures, evidence of common experience. Suddenly, the time and distance between me and the artist seem short. It is strangely reassuring, like waking up to the scents of home in a foreign country.

I go through a museum in much the same way I go through a grocery store, with no plan or purpose, wandering around until something irresistible catches my attention. I picked this object because of its abstract quality, its economy of line, because the absence of surface detail achieves a pure sophistication that is to me arresting. In the straight dissecting lines of the arms across the body and the subtle womanly curves, there is an odd mixture of tranquility and impatience that is a powerful evocation of essential, majestic femininity. It is not just a depiction of woman as a symbol of fertility. Although she is naked, the lack of emphasis on the anatomical is as diverting from the physically sexual as it would be if she were fully clothed. With the arms folded and held tightly across her abdomen, the head held upright, the legs resolutely together, she seems to be waiting for something other than her function as the bearer and giver of life.

She reminds me of women I have seen. They stand this way alone, sometimes in pairs at the edges of their yards talking together or in groups with their children at their feet. In my experience they have mostly been women of rural eastern North Carolina. She particularly reminds me of two women. The first is my grandmother, a hard-shell Free Will Baptist woman, for whom the Biblical admonition to judge not lest ye be judged had little importance. She had measured herself scrupulously against the tenets of the faith in which she was raised. She found herself not wanting and was willing to judge and be judged. I have watched her standing so on her front porch, searching the darkening summer sky for signs of a tornado. Before this pose I have lowered my head in shame as she waited for my confessions, hearing explanations that sometimes satisfied her, but usually did not. This is how she worried, how she hoped, how she attended life with calm expectancy and acceptance. My grandmother, like this sculpture, is to me the symbol of woman as judge. Those arms folded beneath the breasts seem to say, even to the sky: Stand to be assessed, explain yourself, answer.

The other is my mother, who along with her blue eyes and firm beliefs seems to have inherited this pose from Grandmother. Not long ago I saw Mother stand this way in a room set aside for the families of patients having surgery in a hospital in Richmond, Virginia. The surgeon who had just operated on my brother stood humbly

before Mother, almost childlike, the strings and flaps from his surgical clothes hanging about him. It was cancer. Mother waited silently, arms tight across her abdomen, head level, eyes slightly raised to hear him explain. I wonder if the surgeon felt as I did before my grandmother, and as I do before the enigmatic simplicity of this statue, that he was being confronted by a woman who had a question she did not ask—a question beyond the one presented by the immediate situation. A question deeper than he could answer.

ALAN SHAPIRO

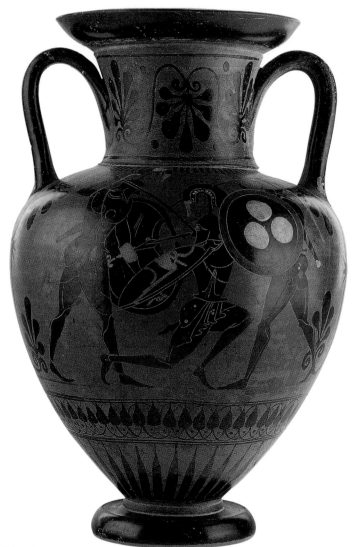

LEAGROS GROUP
Greek, Attic

Neck Amphora

circa 500 B.C.
Black-figure ceramic with added red and white paint
H. 13½ × Diam. (at rim) 6 7⁄16 × Diam. (at shoulder)
8 5⁄8 in. (34.3 × 16.4 × 21.9 cm)
Purchased with funds from the State of North Carolina
74.1.6

On Men Weeping

1. MVP

He was The Man, he said – "Understand what I'm saying" –
out there tonight, The Man. So while his teammates capered,
hollered and whooped in victory's unembarrassable light,
he having done at last what he set out to do, his whole life
flexed for so long in the expectation he would do it,
having met the rigors of the challenge, the challenge's exactions
and observances, met and surpassed them each one in turn,
The Man, the superstar, was weeping as he raised the trophy,
weeping as he caressed it, kissed it, the taut face so finely chiseled
to a single purpose now a dishevelment of tears, the body's muscled
concentration gone, the body all limp with the release of it.

Weeping the way he wept, it seemed, was what he won for,
as if the trophy in his arms, in his swoon of touching, were
the glistening proof he'd now gone far enough into his manhood
to be able to go freely back in time before it, as if the prize
for having proved he was The Man was that he got to be the boy,
the baby, weeping the way Achilles must have wept
because he could weep now, the bronze gear recovered,
the degraded foe behind him dragged in a wake of dust,
the war car circling the dead friend's opulent pyre, foremost
among the grieving warriors, like a boy, a slave girl, weeping,
bloody, behind the massive shield that only he could lift.

2. The Family Face

My father had no prerogative of tears, not in the stark arena
of the rest of us, not after he had filed out with his sisters
from the back parlor sealed off like a privy where
the body of his father lay. Only there behind the door
the stone-faced courteous usher closed, stood guard before,
in the dim light that would have kept his face apologetically
half hidden even from his sisters circling the casket,
only there was he allowed to give in at last and wail
the way he hadn't since he was a child. Yes, only there.

For when they filed out past us toward the waiting cars,
only he could not stop crying, having given himself too
freely over to his keening to realize where he was now,
that he was back among us, so that his brother-in-law,
his sister's husband, Joe, the millionaire, the lord and
magistrate of what the family exacted, was obliged to say
in front of all of us, so all of us could hear, "Hey Harold,
cut it out, you're gonna set the girls off all over again."
And he did, immediately he cut it out, abashed, his hands

a moment covering his face, he choked back what he had
no right to, what he hadn't earned. For who was he after all?
What was he worth, the second son, the clerk, the diligent
but ever-struggling provider, with a wife who worked?
No way to lift the shield, no way to prove he could except
to recompose his face as a man's face, Joe's face, brittle,
cleansed of feeling – while Joe two decades later, even months
beyond her funeral, in front of everyone would sob for his wife
with all the inconsolable abandon that he had put away.

GERALD BARRAX

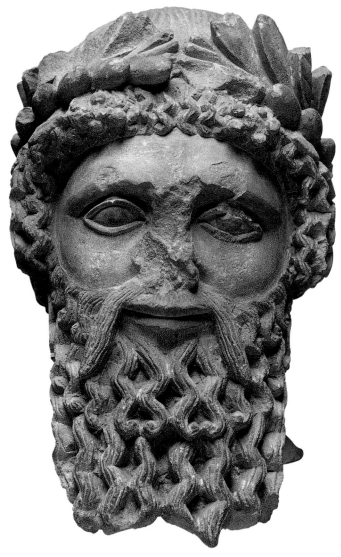

The God in Schrödinger's Box

1.

God or Priest? – he managed the smile after
The nose was broken, thinking now they'd see
How absurd an imperfect god. But there is
No face on Chaos: to escape its terror
They had to ask the wrong question. Surely,
He prays, loss of the nose is verdict enough.
He remembers Osiris and weeps. It makes no difference.
The crown he wears is laurel, not thorns;
The missing body, moved from the sanctuary
For a new god, had no wounds to finger.
All it takes, he pleads, is to look at him,
Human, for all his ruined face. Again
He remembers: cat, calf, ghost, dog, monster,
God, himself – man will worship anything.

2.

One-eyed Wotan, tormented Prometheus, lame
Hephaestus: we do not suffer the cripples' disgrace
Between us that you see in this "ruined face" –
Where you find no god worthy of a name.
Arrogant, mortal fool that you are, proclaim
Yourself free of us, not to choose, to displace
Us with a thought. Nothing you do can erase
The fear that we are as we will, to heal or maim.

But look, please, look at me again: no snout,
No carapace! You ask "*God or Priest?*"
Rather than god or not – not without seeing
That we are locked in paradox: without
A king there is no kingdom for the least
Of you; without you, I am uncreated being.

DAPHNE ATHAS

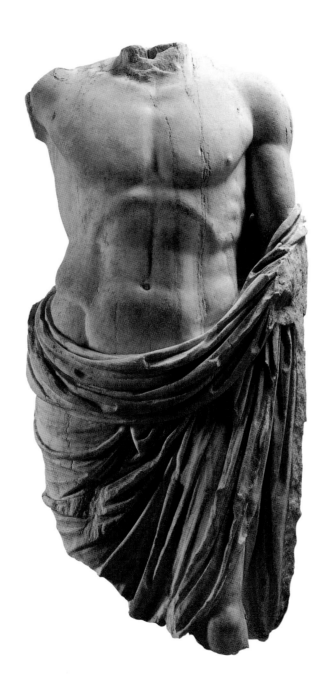

ROMAN

*Torso of an Emperor in the
Guise of Jupiter*

circa first century
Marble
H. 55¼ in. (140.3 cm)
Gift of Mr. and Mrs. Gordon Hanes 86.4

Roman Torso

AT THE DINNER TABLE when we were growing up our father would appoint us topics like knowledge, virtue, the good, and dictatorship. We were three girls, and our brother, the baby, sat in a high chair, too little for such talk. Our father would ask the questions, taking advantage of our answers to whip up arguments into which he stepped like Socrates to make a great illumination. So we learned ideals.

But he also told us Aesop stories – foxes outwitting themselves, greedy crows starving to death – and Greek myths – Zeus playing with many wives, Athena owning an owl, Apollo driving the sun, and Prometheus stealing fire for mortals. So familiar was he with these characters of barnyard and heaven that Plato's ideals seemed an extension derived from their actions, not separate. They were the complication, amplification, and mystery of the principle. We knew it was natural that our father should speak personally with donkeys, heroes, gods and turtles, for he was a Greek, born and brought up in the Peloponnesos on the site where Nestor's Palace was later found. At sixteen or seventeen he had emigrated to the States where he got his education and served in the army at Fort Devens during World War I.

He used to describe the vineyard and the sea below Hora when he was a boy. One day he found a pot with a warrior on it. He brought it home, cleaned it off, and used it to haul water from the well. A month later an old man with a beard teetered by on a bicycle muttering in English. He stopped and told him in perfectly good Greek that the pot had been made fifteen hundred years before Christ. The man turned out to be Professor Bury, the British archaeologist. Another time, spading around an olive tree, our father found a goddess in the ground. She was small, thumb-sized, made of terra cotta rather than marble, for she was a thousand years before the classical period. Our father used to pronounce the word "marble" with reverence, lifting his upper lip. He had a strong accent.

A few years later when we saw the photographs accompanying the Byron, Shelley, and Keats poems assigned in school, we believed we knew what marble meant. It meant whiteness, purity, and the ideal. How strange that these marble gods and heroes had once been painted, with agate blue eyes in their sockets, and had had their colors bleached by time and only then been pulled out of the ground to be cleaned! When we first came to North Carolina it was always our father who found arrowheads in cornfields on our Sunday walks. We were the ones who cleaned them off.

Our father spurned Romans. They were dictators and copycats and their statues looked like cement rather than marble. The statues were rough with brownish-red earth stains, and they pulled down the ideal of the Greeks to represent instead the particular, the personal, and the concrete. He railed against domes and dictators, against arches and their Christian progeny, archbishops and other authorities. I never realized until I had been thoroughly indoctrinated that this was the prevailing nineteenth-century attitude: Romans were imperialists who elevated Greek art because they had an inferiority complex about their own.

And now here is this Roman torso of an emperor in *the guise of a god*, headless and legless, with only one arm, his sex hidden beneath the toga, his surface rough and cementlike though made of marble. And yes, I can imagine earth stains and time, even though it was sculpted in the first century after Christ, two centuries nearer to my life than my father's terra-cotta goddess is to it.

Why does it evoke the mysteriousness of masculinity, an ideal if ever there was one?

There are only clues. The lines of his body rise like the essence of a rose when its petals open. Rose, symbol of the feminine. Rising out of the toga, a bloom. Beauty, ephemeral, but revealed through male power alone. The

pectorals defined but not pumped up. No "workout till it hurts" routine, no bodybuilder. Simple elegance held in balance between the relaxed and the regal, but with that rough surface. The tender spot where the hip begins and the groin disappears constitutes both his masculinity and his mystery. The ribs show. The navel is as anonymous and uncaring as God. The Roman arch is there, the great tendon bearing the weight of the shoulders and breast, the heart and the soul. We are under the spell of maleness in its prime. This is not a boy. He is some emperor – not Vespasian (a spitting image of LBJ) who invented the outdoor toilet called in Paris even now a *vespasienne* not a *pissoir* by those who know. Not Augustus nor Nero nor Caligula, who all evoked themselves as God, bringing Him down to man-size, reversing the Greek ideal. Not any particular emperor and not any particular god, and not even any particular man.

For without eyes and head or arm and legs he is past being Roman. Time and history obliterated his particularity and cast him into the line of continuity from the Greeks or before, which defies any set arrangement between man and god, barnyard animal and human being.

I understand now, looking back to the first male I knew, our imperial father, why I should be fascinated by pure masculinity. Every day teaching writing I am obliged by the *zeitgeist* to teach students to write of the particular, giving concrete details. But what do I really care whether the ideal rises out of attempts to create the particular or whether it determines the particular? Archaeology is always new, fulfilling each generation's needs, from each according to its discoveries, to each according to its scientific methods. History is a magic graveyard where gods lie whole or in pieces like people who can't die.

ALLAN GURGANUS

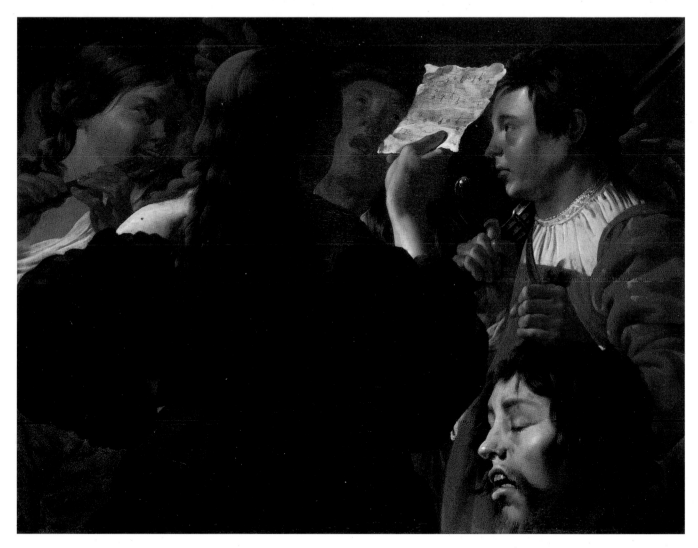

HENDRICK TER BRUGGHEN

Dutch, 1588-1629

David Praised by the Israelite Women

1623
Oil on canvas
32³/₁₆ x 41½ in. (81.8 x 105.4 cm)
Gift of the Samuel H. Kress Foundation 60.17.66

The Country Child, When Overpraised

Condensed from First Samuel, Chapter 17, King James Bible

And David rose up early in the morning, and left the sheep with a keeper, and he came to the trench, and shouted for the battle. And, behold, there came up the champion, the Philistine of Gath, Goliath by name, whose height was six cubits and a span. And all the men of Israel, when they saw the man, fled from him, and were sore afraid.

And David said unto King Saul, I, thy servant will go and fight with this Philistine. And Saul said to David, Thou are not able to go against this Philistine to fight: for thou art but a youth, and he a man of war from his youth.

And David said unto Saul, Thy servant kept his father's sheep and there came a lion, and a bear, and took a lamb out of the flock. And I went out after him, and smote him, and delivered it out of his mouth. And Saul said unto David, Go and the Lord be with thee. And Saul armed David with his armour, and he put an helmet of brass upon his head; also he armed him with a coat of mail. And David said unto Saul, I cannot go with these, for I have not proved with them. And David put them off.

And he took his staff in his hand, and chose him five smooth stones out of the brook, and put them in a shepherd's bag; and his sling was in his hand: and he drew near to the Philistine. And when the Philistine looked about, and saw David, he disdained him: for he was a youth, and ruddy, and of a fair countenance. And the Philistine said unto David, Come to me, and I will give thy flesh unto the fowls of the air, and to the beasts of the field.

Then said David to the Philistine, Thou comest to me with a sword, but I come to thee in the name of the Lord of hosts, the God of the armies of Israel, whom thou has defied. And I will smite thee, and take thy head from thee; and I will give the carcases of the host of the Philistines this day unto the fowls of the air; that all the earth may know that there is a God in Israel.

And David hasted, and ran toward the army to meet the Philistine. And David put his hand in his bag, and took then a stone, and slang it, and smote the Philistine in his forehead, that the stone sunk into his forehead; and he fell upon his face to the earth. But there was no sword in the hand of David. Therefore David ran, and stood upon the Philistine, and took his sword, and drew it out of the sheath thereof, and slew him, and cut off his head therewith. And when the Philistines saw their champion was dead, they fled. And the men of Israel and of Judah arose, and shouted, and pursued the Philistines. And David took the head of the Philistine, and brought it to Jerusalem.

AND, VERILY, the head did weigh twenty-seven pounds. And to hold it before him — as you would lift a lantern — costs the young David much strength. Was not his day's strength already well used by killing so great a warrior? Trumpets sounded on towers of the city that, seen from afar, looked sand-colored, a toy, and perfect. Twelve gates were being opened, slow, by vast crowds, even those gates long-bolted against the Philistines.

Bright robes of the thousands now appeared along Jerusalem's upper walls. And David lifted a grimacing head so huge it proved visible from the far settlement. A strange first roar did lift. And the power, which was the knowledge of his sudden power, was borne unto this rough subtle lad. But, yea, instead of rejoicing, he did begin to inwardly quake. And it weakened him, even as it vexed him to carry, in celebration, the trophy skull of this, the Philistine of Gath.

Toward jagged cheers, into the long shadow of Jerusalem's crenellated walls, a shepherd did walk. He was blinking. And, lo, his stride became as shy and considered as, in battle, it had looked swift and animal.

King Saul, who usually led such processions, followed this one. The king was seen to study the comely youth's advance toward Saul's own city. The king, sunk back into a sedan chair's blue shade, did touch the seams and lines of his own neck. He rubbed his deepening eyes. And Saul knew how little youth was left him. The lad moved well. His countenance was shining with a pure,

country certainty – as yet unaware of his own head's own complete perfection.

Supporting a giant's sword – sun-heated – in one hand, his other fist hoisted a rocking bushel skull. The ruddy boy neared the sweetening chants of women. His body absorbed the beat of expert instruments. Every gong and cymbal, all the strings of Jerusalem resounded, rhythms come forth onto the plain to greet the city's youngest hero, ever. This very morning did David not guard his father's flock against prowling beasts? And now, this same youth marched direct into a roar surpassing all lions', he moved unto legend itself. Legend had already described – before even seeing – him. Even now, the child belonged more wholly to Legend's habitation and lineage than to his father's house or the flock of his father's house. When one gray pebble did crack the broad skull – a snap so loud it caused the very horses to shift his way – this child became king. His immortality, like this head, already hung before him with a shop sign's creaking weight.

Now David's right hand supported the sodden object, twenty-seven pounds. Soon his left assumed it. Then again, the right. David made this shifting seem a courtesy offered those gathered on either side of the great spontaneous procession. But what David truly feared was: that in his sudden tiredness, cursed by a stage fright postponed, he might drop the head. The shame of that! To step upon it. To lose it, rolling, beneath the sandals of the multitude.

In such heat, this mission sickened him. The killing had been simple, it felt country-necessary, country-right. But David now watched its news spill before him, treacherous, enlarging, calamitous, back circling, already falsified. The danger of Giants was as nothing compared to the *news* of the danger of Giants. And he longed to cry into the chaos of the sudden music about him.

Weight of the celebrated head felt evermore solemn at his strong arm's slackening end. Do the newly slain grow heavier as their stripling killers find more light?

Cooled blood from the giant's neck splashed, half-conversational, against David's long brown shins. All but deafened by praise, he entered the steepest gate. David's own city appeared new to him. Before, he had been just another rustic tribesman leading his father's flock unto its market square. — Sometimes the boy's beauty did, yes, bring a second look, one slow and sleepy nod. But today, every mouth he saw was open with a song for him. A song about him.

All the women chanting — held verses written out. How could songs of his deed be composed so quickly? The ladies looked beautiful and refined and very rich, but uneasily identical. They studied his legs with glances so sexual — he himself ceased feeling sexual. This youth felt outranked by his very idolaters. Was he not roughly dressed? Should he have refused the armor of the king? David tried imagining what speeches he must soon say — screaming to be heard by the thousands now flocking onto Jerusalem's balconies and battlements.

How did citizens know that this young shepherd was the right young shepherd? By the maimed thing that he grappled foremost, usually at shoulder height. David tried sidestepping its swaying bulk, its messages of drips. His shearer's palm appraised the thick hair, improbably baby-fine. He wished only to set the object aside. On that low wall? Or just to heave it over the market's striped canopies where it might land, mouth open, in some vendor's basket of dates! The child felt convulsed with a need to giggle but, resisting, straightened his back. It only made him look the younger!

His country life counted as nothing here. Yet it soothed him to picture still waters, verdant pastures; they restored his sense of all he knew. The boy glanced back and — through the open gate — saw birds of prey already circling the plain, amazed at the good fortune of so huge a carcass. Live birds made David's deed seem real to him. Those, and this cranium's mass. Its scale almost argued Goliath's intelligence.

Finally, led into the official tent pitched at Jerusalem's very center, the boy nearly sobbed upon regaining the luxury of solitude. This was his accustomed pasture state. He could sing and recite anywhere. Who, but sheep, might hear? Saul would soon arrive to address the throng, to introduce this unknown son of the obscure Jesse to a nation that now owed the giant-slayer everything.

David found himself, almost alone, in a shelter of opulent maroon brocades. Yet standing, he stared, not at its rich furniture but a single curiosity. He had set his leaking prize upon one low stool in the tent's north corner.

As the women — seeming the same beautiful woman living at all ages — called David by name, as the boy paced, yearning for his father's house and familiar fields around it, he tried remembering manners in no way right for his exalted new station — and four satcheled stones made consoling rattles at each turn. David moved even closer to the giant's profile, fleshy yet repellent as some cactus bloom. "What?" he asked it, as if taunted.

The face had now gone green as bile. Both its eyes pressed shut. The teeth were horse teeth. Each feature squeezed in on itself as if from final shame at having lost a life so splendid and immense to someone twenty years and four feet younger.

But — with music rising, new cheers signaling the king's arrival — David understood a troubling contradiction new for one so young. It was an odd unlikeliness underlying warfare, politics, romantic love: The head of this, his tribe's vanquished enemy, had become the one thing in sight most abidingly familiar. Hatred was, it seemed, a form of loyalty. Toward the life he had ended, the boy now felt unexpectedly fond, even fatherly. Had he and Goliath not just come to town together? With all of Jerusalem overstating David's beauty, Goliath's head alone seemed true and terse, unflattering. It alone felt personal.

The tent, a valley of rich shadow now at noon, literally shook from the din of a fame unavoided. David sensed

he was – like the decapitated part – mute, overly mortal, torn from any steadying pedestal or restoring source. He squinted at this single face he recognized. – Its closed eyes now streamed some clear oil he read as surplus tears, shed by gravity alone. In the pitiable dented forehead, David's own stone was yet wedged.

The half-coarse child had ceased his pacing; he now stood stiller than anyone so young should ever stay for long.

A general called David's name, "It is time to show yourself." But the child yet lingered before the head. Tinted by maroon light, it now appeared black as a black fish. David bent from the waist, in courtly bow, his right hand reaching. This hand had killed two lions, had shorn twelve hundred ewes and only made six bleed. This hand now curved around the squared jaw of a former enemy.

Summoned louder from without to face his country-men – one unschooled shepherd straightened, bracing as for battle. He moved toward light, barehanded. He must have looked incomplete – for the general pointed back and down. There it waited, toppled, beard now uppermost.

David once more grasped his identifying enemy. Using both hands, he raised the familiar weight and, with one gentling roll, shifted a silver-green face so it mirrored his own. He smiled down into it. His own eyes full of tears, he seemed assured. Of what? Some truce? A professional understanding between warring male animals?

David waited within the tent, waited before its draped entrance.

Through split curtains, his fist now shoved Goliath face-first toward the world.

Such instant sound – thunder ground from human voices! Quick sun warmed David's knuckles and white wrist. The cheers, though musical, yet seemed bent on vengeance. In the loneliness of becoming so gigantically visible himself, David knew he was attached forever to this one shepherded head.

And when he himself pushed forth, now using the tent as both his cloak and curtain, he felt schooled by the act that had opened for him. To all sides, how this lad grinned his brilliant country smile. He threw back his head as an actor knows to do. His belief appeared believ-able. The boy now moved about his platform – sinuous, sexual, plain and splendid for all – his strength appeared increased. And the good shepherd's simplicity – now see-ing itself from all his subjects' eyes – became aware of its own worth, and forever ceased being simple.

David waved around at everyone. He accepted flowers from typifying children. His shyness had fleeced over now: to armoring charm. David made familiar with the tens of thousands determined to continue loving him. How did he know exactly what to *do* here? Had he sung to lambs? Had he practiced accepting ovations from wind-tossed trees?

– He alone, up there, half-guessed what a life of this was going to cost him.

– As the women – thousands, desiring David's body – shrilled beyond their own first songs of him.

DAVID BRENDAN HOPES

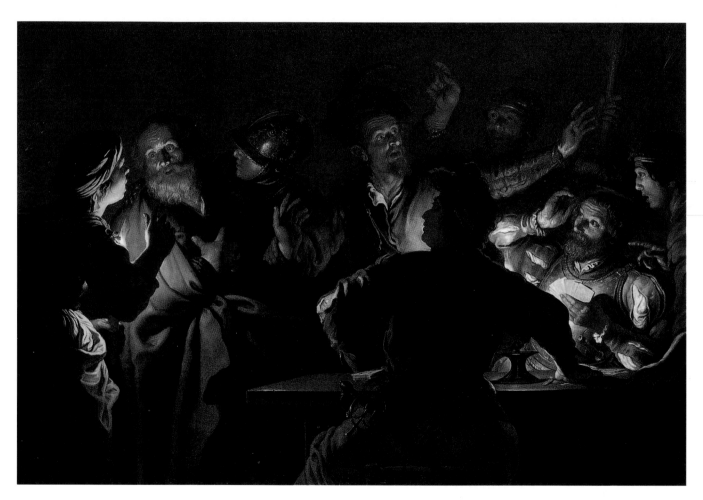

GERARD SEGHERS

Flemish, 1591-1651

The Denial of St. Peter

circa 1620-25

Oil on canvas

62 × 89⅝ in. (157.5 × 227.7 cm)

Purchased with funds from the State of North Carolina 52.9.112

Gerard Seghers: *The Denial of St. Peter*

Observe how every circumstance conspires
against the keeping of faith.
The eventful day sinks past its prime;
the dangers mount; the advantages dim;
the confused witness requires
the question to be put a second time;
in the mind's twilight a thin wraith
hovers, who was the once-beloved Him.

Observe how Peter turns away
from the golden, central light
to address his denial
to the dark periphery,
how hands uplift, how fingers splay
as if they were surprised this trial
would end so disappointingly, which might
have nailed a martyr to another tree.

The woman in the wrinkled turban
raises her finger to accuse.
I do not know him, cries Peter's right hand
gripping the astounded heart. The listeners lurch
to attitudes of disbelief, and yet again
I do not know him, says the left hand
raised in a mockery of blessing. This must amuse
those who heard Christ's, *Peter, build my church*.

Bald Peter in the mercy
of that triple lie excuses flagrant husband,
prodigals, false witnesses, amends cheating wife,
betraying friend, failed father, all the flood
of easy sins, the mortal heart's catastrophe.
Three times. After three cock crows comes life.
After three days the Pentecostal wind
transforms to rose the taint of blood.

Observe how none of this is shown.
In the next heartbeat the shabby fisherman
walks on till the soldiers' candles fail,
in darkness then,
a blackness outward from the bone,
a proverb of betrayal,
astonished, horrified.
Alone.

JULIE SUK

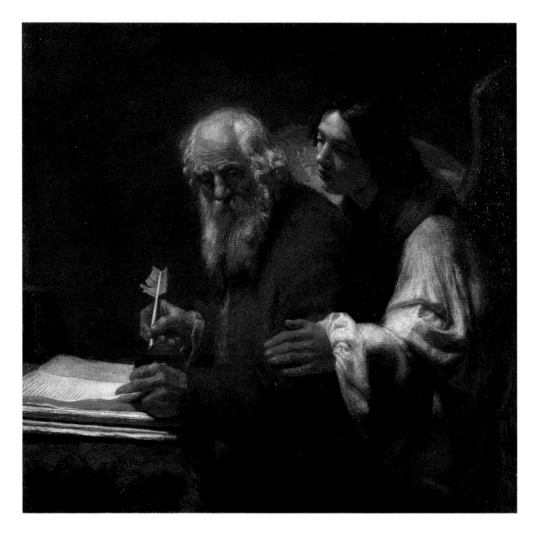

WILLEM DROST (attributed to)
Dutch, active by 1652-died after 1680

St. Matthew and the Angel

circa 1655-60
Oil on canvas
42 × 42½ in. (106.7 × 108.0 cm)
Purchased with funds from the State of North Carolina and Public Subscription,
in memory of W. R. Valentiner 59.35.1

St. Matthew and the Angel

Matthew worries the quill of his pen,
but only *begats* fall on the page.
The candle gutters.
From the shed a rooster crows.
The sound, and all it kindles, echoes.

Lord, I'm an old man
who grieves for the years
he blindly passed.
Suffer my weariness.
Driven this way, that,
I've lost myself in the world,
my name no more
than a scribble on wind,
your call unheeded,
the work undone.

Help me now
write you into our lives
so the blind might hear
and the deaf see
what can be lifted
from the waste of our days.

The faint glow of the room heightens
as if oil replenished the wick.
He feels a pressure
against his shoulder blades,
declensions of air swept by wings.

No, Lord, not yet.
Lead me instead
into the darkness of myself
that I might wait in the light
of your revelations,
my hand recording
what the heart recites.

Warmth on his arm
as if a palm had touched down
to rest there – Shalom!
Words gather beneath his pen.

Could it be as the prophet said,
that for those who sit
in the region and shadow of death
light will rise from its crypt?

He begins: "Now
the birth of Jesus Christ
took place in this way . . ."

REYNOLDS PRICE

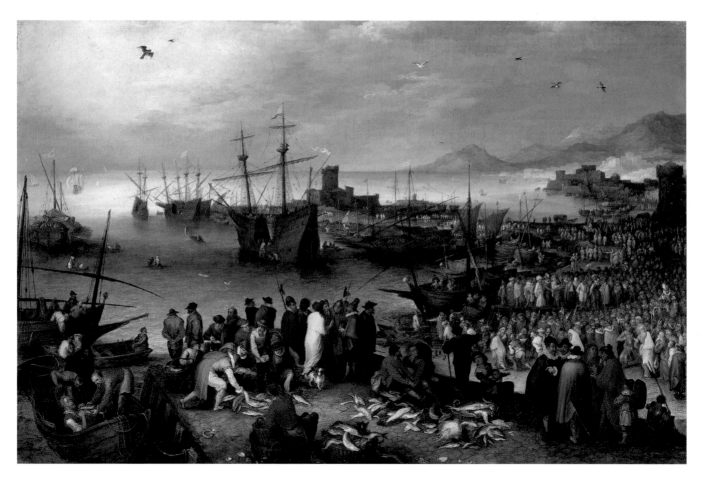

JAN BRUEGHEL THE ELDER
Flemish, 1568-1625

*Harbor Scene with St. Paul's Departure
from Caesarea*
1596
Oil on copper
14¼ x 21½ in. (35.8 x 54.6 cm)
Purchased with funds from the State of North Carolina 52.9.92

An Enormous Eye

IF PAUL IS LEAVING Caesarea again – this opulent port on the coast of Roman Palestine – it is surely for the last time. That would mean he is bound for his death in Rome. Charged with desecration of the Temple by authorities in Jerusalem, Paul has demanded his right as a Roman citizen to plead before the emperor himself (few Jews of his time were Roman citizens). Festus, the Roman governor of the captive province, has heard Paul describing his arduous past and asserting his innocence – how, after Jesus' death, Paul had remorselessly persecuted Jesus' followers; how Jesus had then appeared to Paul in a dazzling vision and won his allegiance.

The colonial powers in Caesarea feel that Paul is worthy of release, there and then; but in the face of his appeal to the emperor, their bureaucratic hands are tied. They must ship him to Rome under guard, a voyage of fifteen hundred miles, fraught with dangers. Once in Rome, that grandest of capitals, Paul will be kept in loose house arrest for some two years before – in the sadistic anti-Christian pogrom of Nero – he will succumb to the headman's ax.

In the elder Jan Brueghel's view of that momentous setting out from Caesarea, we are faced initially with the kind of visual and mental challenge that is characteristic of Brueghel's vision, wit and profundity. Where, for instance, in the picture is Paul; and who are the hundreds of other figures ranged around him in this teeming harbor scene? In the near foreground, to the left of the larger pile of fish, and standing between the man in the pink coat and the one in red, stands an older bearded man with an aquiline nose and a black hat above his brown robe. His right hand is raised as if in benediction to the official-looking man whom he faces. In my own first few sights of the painting, I assumed that this imposing man in brown was Paul. Brueghel's trap had caught me, but his crowded sly painting refused to open itself to a fool in too great a hurry to see the hidden point of the world – or a moment of the world's life as seen by a deeply piercing eye.

Paul's actual whereabouts on this swarming day, as he leaves the native land of his Lord and of his own ancestors, are harder to find than I initially thought. In fact, if the actual figure of Paul didn't appear in his patently supernatural halo – the only halo in sight in Caesarea – I might well never have found him in the mob. He's far to the lower right, all but out of the picture; and unlike most of those depicted, he is caught in serious onward motion (most other movement in the picture is limited to mild gesticulation, to the humdrum gestures of work or is frozen in the stillness of purposeful or idle waiting).

As always, since his Lord appeared on the road to Damascus, blinding Paul with his radiance for a number of days and demanding Paul's service, Paul is pressing ahead – to Rome, luck permitting; to the emperor's court where he'll argue his case and ("Who can deny it?" he thinks) where he may well win the emperor himself to trust the single truth Paul thinks he knows: the, for him, most important truth in human history. And that truth, he thinks, is as simple as a triangle scratched on the ground – that a man named Jesus of Nazareth was crucified some thirty years ago in Roman torment but was then miraculously raised from the dead to be the living Anointed Son of God, the beloved Son who (by his substitute sacrifice) has saved each member of the human race from the just reward for mankind's cruel wrongs.

Paul's forward stride is not impeded in any way by the escort of soldiers to his right and behind him, nor is he in chains or shackles. (Is the man on horseback, just behind the soldiers, Festus the governor? The superior quality of his dress, topped by a bright helmet plume, suggests at least an officer of considerable standing; and the book of Acts says that Paul departed Caesarea under the control of a centurion named Julius who treated Paul with consideration.)

Far from reluctant, in fact, Paul's whole body is eager

for the voyage, however dangerous it may prove. The fledgling Jesus sect at Rome has only recently received his most substantial letter, the Epistle to the Romans, a carefully argued tract which will prove of serious weight in subsequent Western thought; and surely Paul has, for many years, awaited the ripe time to carry his blazing certainty to the capital of his known world – that sprawling gilded wonder of human ingenuity and sublimity, that dark sink of human cruelty and filth: Rome extended on her seven hills in merciful light, beside the slow and muddy Tiber.

The chance of a pardon from Caesar must, even as we watch Paul, thrill him with hope for an extended life and for longer chances at his passionate mission. The perhaps graver likelihood of a death penalty may thrill him even more, though secretly, with the prospect of martyrdom and eternal glory. But, at this instant of Brueghel's attention to the scene, a penultimate practical question dawns. Which is the ship that will bear Paul onward to his violent but glorious fate? The only appropriate vessels are large and are anchored at some distance from the pier. Only now do I notice that a line of abjectly hunched and covered men precedes Paul, men likewise attended by soldiers. They will all apparently be loaded onto one of several available dinghies and ferried to the nearest of the seaworthy vessels. Any one of the prisoners can console himself with one reality at least – his captors intend to convey him safely; he has not yet been discarded. Yet whichever the ship, the book of Acts tells us that it will ultimately founder in a two-week-long storm, delaying Paul and his companions on the island of Malta for three months.

I noted, above, "this instant of Brueghel's attention to the scene." Plainly here, the painter is his own spectator, both the arranger and the watcher of the loaded moment. But is it Brueghel's intention that we, the bystanders who study his picture, should be aware of the strong yet impalpable presence of a certain immensely skilled Flemish

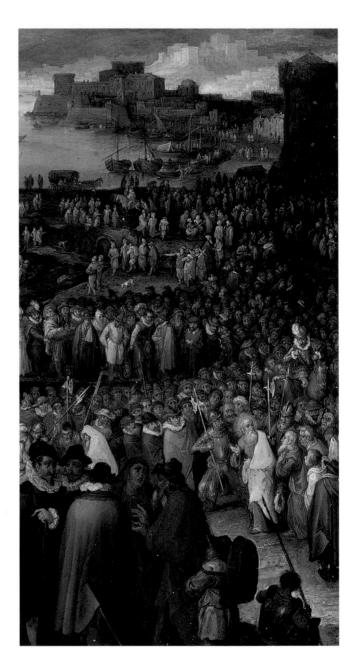

mind and hand in the same space which we now occupy, three centuries later, as his modern viewers? There is no reason to think that he was less appropriately respectful of his own gifts than he should have been; he must have known how high he stood among his contemporaries and his grand predecessors. Yet doesn't the hugger-mugger nature of his scene and its demands upon the viewer's keen attentiveness imply a certain desire for anonymity on the painter's part? Mightn't Jan Brueghel and his father Pieter be said to have imagined the candid news photograph some three centuries before it could actually flower in the years of the First World War of 1914 to 1918? (the technical limitations of nineteenth-century cameras rendered the great photographs of our Civil War virtually powerless to capture action).

Since the painter has, to an all but overwhelming extent, attempted to cancel any sense we might have of his presence in or near the picture, has he left us alone to view it from the angle of our choice? Obviously our choice of view is limited by the two-dimensional nature of the picture – we may view it from left, right or center; from high or low. With those limitations, we may roam its landscape, its bodies, ships and buildings, its birds, fish and the single brown-and-white dog.

When we have pored as long as we wish through the populated surface of the scene (a crowd scene with, nonetheless, a surprising amount of sky), we're ready to answer perhaps the final question posed by so complex a moment. Why are we asked, in the effort to find the unmistakable figure of Paul, to see and to value so many other lives and forms of the Earth and sky? One at least substantial answer would go like this – because the painter, consciously or perhaps instinctively, wished to share one final aspect of his mastery: his final power to choose and assume the eye of God as his own organ for seeing the world in its endless variety. In this result of the painter's choice – his now permanently still moment of significant spiritual history, seen from the ultimate height

and distance – we are lent, for as long as we care to stand watching, the incalculable privilege of possessing a whole big city of men for our unhurried attention and knowledge (if women are present in Caesarea this day, they are shown faceless on the distant jetty, at a kindly remove from Paul's deportation).

Only a few of those self-possessed men show any awareness of or concern for the crucial action. To the viewer's right of Paul, for instance, there seem to be a few concerned friends; elsewhere, there are (by the signs on their faces anyhow) only impassive observers in varying degrees of oblivion or, just conceivably, in clandestine sympathy with a harassed prisoner. Yet Brueghel's concern, though cool, is intense.

He knows, and has offered to us, what the eye of God knows, has known and will know eternally: that this one old man – white-bearded and licensed forever by his halo, bound for torture and unjust death in a foreign land – will prove a potent messenger through coming ages to all humankind who have the luck or the danger to hear him, the eloquent fearless bearer of the news of God's own love and baffling need for each of his creatures. Even the coldest or grimmest face in Caesarea, oblivious of Paul and his fellow prisoners or seething with hate, is powerless to resist that love from his maker. No painting – no statue, no work of art surely – can ask to see, or to tell its viewers, more.

WILMA DYKEMAN

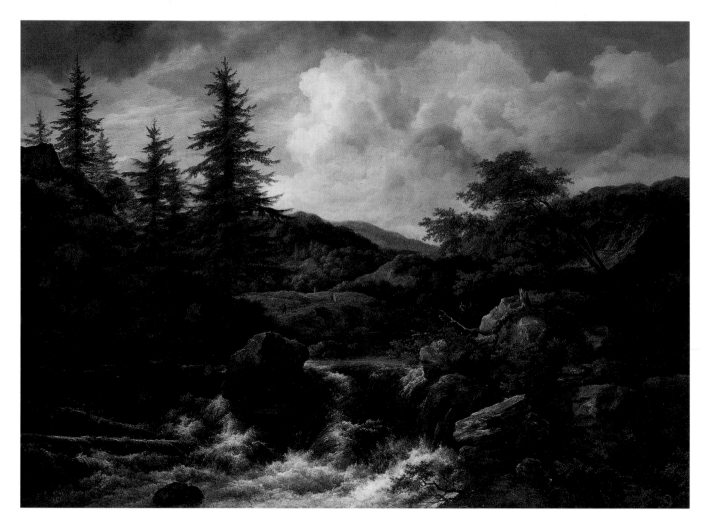

JACOB VAN RUISDAEL
Dutch, 1628/29-1682

Wooded Landscape with Waterfall

circa 1665-70
Oil on canvas
41 x 56½ in. (104.1 x 143.5 cm)
Purchased with funds from the State of North Carolina 52.9.56

On Entering Jacob van Ruisdael's
Wooded Landscape with Waterfall

"COME, enter my world for a little while," Jacob van Ruisdael invites, and from whatever impulse, I respond.

I sit before his painting and discover an autobiographical encounter.

Is the kinship of spirit I experience rooted in a common Dutch heritage – one settled in seventeenth-century Haarlem and Amsterdam, the other a transplant to New Amsterdam-New York and eventually in the twentieth century to the mountains of western North Carolina? Perhaps. But in this instance water may be more potent than blood.

In 1721 a Dutch critic said that Jacob van Ruisdael and falling water were inseparable. Born to the sound of wild mountain water, I relate to that kinship. The restful splash of summer's flow merges with the turbulent rumble of flood and storm. Carried to the stream's edge where I spoke my first words, "Water coming down," was I describing the sweeping grace of calm passage or the agitated foam akin to Ruisdael's waterfall? The painting refreshes my memory of the clean smell of water newly emerged from the earth's springhouse.

Little wonder then that as I enter *Wooded Landscape with Waterfall* Ruisdael's art and my literary voice merge in a kind of vision that remains, for me, evergreen, for my first book was an exploration, a history, a celebration of a river and the spruce-fringed mountains that were my home.

As I search deeper I relate to the change that is at the heart of his painting, as it is of my writing. At first glance this is a serene landscape of natural harmonious beauty. Apparent permanence is deceptive, however. Dying leaves creep along sturdy limbs of trees. The trunk of one monarch lies splintered across a rocky outcropping. Here is the stream of my childhood, challenged by boulders channeling it into a course not of its own choosing: Without this interference the water would follow the way of least resistance. And in its turn the water is incessantly widening, deepening its stream bed, gradually sculpting stone into new forms.

Time and the elements also take their toll on the human scene. The thatched roof of an ancient mill is frayed and sagging. Rotting timbers lean perilously askew. Nearby, the bridge used by a woman and man is ill kept with crumbling supports. The man and dog approaching a couple at the picture's center, an even smaller figure emerging from the woods, those on the rickety bridge are all so minute as to be almost invisible. The scene is rendered powerful by a hovering sky at once shining and threatening, towering spruce trees, water's force.

People are fragile, yes, but as the course of water is diverted by fallen trees and stone, a mountain slope in the distance seems to have yielded to a small human clearing surrounded by forest. Here is testimonial to various stages of life and change, nature and human nature in inescapable relationship.

And still I probe. Why have I chosen Ruisdael's painting?

The final piece of the puzzle emerges in three sentences by E. John Walford in his book, *Jacob van Ruisdael and the Perception of Landscape*. He writes: "Landscape paintings do not have their point of departure in a word-oriented culture, as pictorial embodiments of those words. It is more a question of how individuals in seventeenth-century Holland, because of their education and upbringing from their families, schools and churches, had been conditioned from earliest childhood to experience the various phenomena of nature in certain ways. They accepted nature as 'God's second book', an alternative and complementary mode of revelation to written and spoken words, loaded with significance in its very character and being."

This is the stronger bond! "Nature as 'God's second book.'"

This is the kinship that art makes possible across time and space. It leads me back to my own, oldest place even as it sends me deeper into myself.

To the mountains where my river is born, ancient before the Rockies emerged.

To the forests, richer in variety than all of Europe, where the greater part of life is invisible to humans, deep in the porous earth where roots penetrate and decay, leaving a network of underground water channels.

To the plants and shrubs of blazing beauty, the yellow woods azalea identified as "the plant life of another age left in our world today," and tender trillium and winter ferns and medicinal herbs for our healing.

To the powerful predators and bright-eyed prowlers, the multitudes of birds, of insects, of fishes, whole communities of life.

To people whose roots reach back to many lands, to experiences at once so private and so universal they challenge our understanding, our wonder.

I cannot resist the thought that Jacob van Ruisdael would find inspiration in the abundant water and forests and people of my place.

Of course, the reality each of us once knew no longer exists. Return to Holland and we will not find Ruisdael's scene. From distant explorations I return to my place and do not find the stream and woods I knew.

But something does not change: Ruisdael's picture and my memory.

In truth we share that credo stated by poet Walter Savage Landor: "Nature I loved, and, next to Nature, Art."

God's second and third books?

CHARLES EDWARD EATON

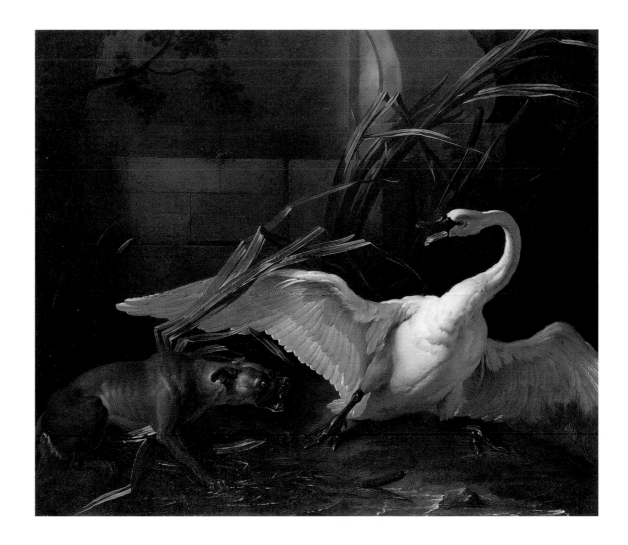

JEAN-BAPTISTE OUDRY

French, 1686-1755

Swan Attacked by a Dog

1745
Oil on canvas
70 × 82 in. (177.8 × 208.3 cm)
Purchased with funds from the North Carolina Art Society
(Robert F. Phifer Bequest) 52.9.131

A Story of Response

I HAVE ALWAYS had a strong affinity for animals and birds, particularly swans, which are a recurrent theme in my poetry and prose. When I first saw the Oudry painting, its dramatic power and beauty aroused a flood of memories and associations. I saw immediately that it was meant to take its place in a nest of my own images and allusions, and I am happy to recall that this largest and most handsome of the waterfowls, that breeds on every major continent except Antarctica, has had an equally memorable effect on artists down through the ages.

Shakespeare, whom Ben Jonson called "the Swan of Avon," makes this beautiful and moving declaration: "I will play the swan, and die in music." Like his great predecessor, Tennyson blends beauty and death in a characteristic line: "After many a summer dies the swan," which some readers will recall became the title of an Aldous Huxley novel. In the twentieth century, William Butler Yeats's "Leda and the Swan" brilliantly explores the Greek myth of the seduction of a mortal by a god, which resulted in the birth of Castor and Polydeuces, the Gemini, from one egg, and Helen of Troy from another. Though he adventured on earth in many other shapes and forms, Zeus, that great stud, seems to have outdone himself in this encounter.

Music is equally rich in reference. To name only a few of my favorites: Tchaikovsky's *Swan Lake* and Sibelius's *The Swan of Tuonela* that glides majestically on a black river while singing its deathly song. And who can forget Wagner's magical boat drawn by a swan in the opera *Lohengrin (Mein lieber Schwan)*, or, if you are old enough, or have at least seen the ballet on film, not remember Pavlova's Dying Swan, danced to the music of Saint-Saëns?

The image is present in sports as well. All one needs is a little imagination to see the Olympian Greg Louganis as the gilded bird himself when he does a swan dive:

> So this for us suggests the basic swan —
> Under the feathers this lean, gold-washed man
> Still lethal-eyed as if smothered too long,
> His sunburned nose a touch of orange beak . . .
>
> We borrow the world wherever we wish —
> The diver knows this, spreading his arms wide. . . .

> from "June Issue with Swan Dive"

A brief account of my own "swanology" might illustrate and explain why I respond so personally to Oudry's masterpiece, why it belongs among my deep images. I have indeed become the swan in many different ways and guises. I had my first prolonged intimacy while I was in Rio de Janeiro as vice consul at the American Embassy. I arrived early one day for a conference at the Itamaraty Palace, the Brazilian Foreign Office, and wandered into the garden of the elegant pink-and-white stuccoed building. There in the center of a long pool lined with royal palms, a swan came flooding down, lifting its reptilian neck. It was like a floating icon, both lyrical and menacing. That evening in my hotel room, I wrote:

The Swan

In the distance a swan beaks the air, twisting under the palm
 shade
Like an orange-fanged white serpent, striking from the pure
 nest of its own body.
Then the wind unmoors the current, and the webbed feet
 braid

The water with a lustrous jet ripple. Though the sinuous arc
Of the neck and the silver breast open and feather the air,
 the black eyes glint cruelly,
And no one knows whether evil or innocence drifts from the
 slowly opened arms of prophetic dark.

Whether evil or innocence, no one knows. But the soft
 fan-float
Of the wings draws a train of fascination across the
 afternoon,
And even the fingers of the water would reach up and
 stroke the irresistible white throat.

Though implicit with the qualities of my Brazilian bird, Oudry's swan has another story to tell, a moment of crisis. In the desperate situation in the painting, one could imagine that the swan might wish to change places with the dog or an even more formidable animal. Who has not wished at some time to be "someone other"? In "The Possible Dreams of Swans," I allow this to happen:

The Possible Dreams of Swans

Who knows but the swan may dream
Of being someone other,
To the hippopotamus a brother,
A water-thug enamored of a crime?

Nature scatters forms like pollen
And then the dreaming grows and turns:
The fecund, formal bird-nymph yearns
For singed jowls and belly grossly swollen.

And yet it never comes to harm,
Stays beautiful, a white flute
Rising from the passions of a brute
Because it does no more than test its form. . . .

One of the great joys for an artist is that the world is malleable and plastic, and he can do with it what he will. So it is with the reader and viewer. With any book or painting you have every right to experiment with running commentary or let it rest on its own.

What I have said so far is meant to suggest also my belief that every encounter with the arts has our personal history behind it. Events will later emerge in eventualities as we attach to our story a lifelong symbiosis with everything we see and do. A swan seen yesterday is still alive in a swan seen, or depicted, today. I was fortunate, then, that I came to the Oudry bursting with images of swans.

The title of the painting, *Swan Attacked by a Dog*, has also been known as *Swan Frightened by a Dog*, and "startled" comes to mind as well, suggesting a range of implications, for the swan does not look at all submissive or unequal to the situation. The right foot is in an almost balletic position as if it intends to move forward rapidly in defense, and the other leg and foot are crouched down like a powerful spring. The large, bent-back plants, which can be identified as cattails, a favorite food, could indicate that the dog surprised the swan while feeding. But the outstretched wings, the serpentine neck, the glaring eye, and the open beak suggest that the swan is by no means cowed.

We should not fail, however, to give the dog his due, to enter him with our imagination. It is certainly not his lot everyday to encounter a serpentine creature with powerful wings, plump breast, and talons that look as if they were coated with mail. We remember that Oudry was French, and that the dog, obviously a mastiff, is probably a *Dogue de Bordeaux*. He has status, therefore, and is used to terrorizing those around him. He has so far been able to push the swan into a defensive position, a glaring, strained, almost villainously human look in his eyes. It would make his day to sink his teeth into that mouthwatering breast, and strut around with a moustache of white

feathers. But the outcome of the encounter is latent in the painting. If aggression is repelled, as I believe it would be, the dog's experience will be richer; he may have learned something he had not known before about swans, and one form of life will again have been tested by another: Nature scatters forms like pollen.

It helps to know that Oudry was a famous still life and animal painter of his day and that he attracted the attention of King Louis XV, who appointed him the official court painter of the royal hunts, and that Tsar Peter the Great and the queen of Sweden were among his other clients. He was also the illustrator of a famous edition of La Fontaine's *Fables*, for which he did 267 drawings, and would have been well acquainted with the natures and capacities of animals. He would have known just how far a ferocious dog might have been able to go with valiant swans who jealously guard their breeding territories, themselves, their nests and their young. He would have been able to judge the relative physical and "moral" weights, and in this painting he is clearly on the side of the swan.

Make no mistake, though, the swan, for the moment, is up against a wall, a decidedly unhappy situation for this proud and majestic bird whose pinkish orange beak and black knob on the forehead identify it as a mute swan, the largest of all the species, which can weigh well over thirty pounds, and, as we can see, when threatened, present a formidable appearance. It is not *mute* in the sense of being soundless, but "mute" in that it does not vocalize like the trumpeter swan.

Like other swans, a pair of this breed normally mates for life, with occasional flings outside of marriage in an all too human manner. The movements in the Oudry painting may, in fact, have some similarity with the mating dance, as love is related to hate, but that implication is beyond the boundaries of the canvas. Only the image of arousal and present danger is powerfully registered. The whole drama of the painting is in tense

suspension, yet to unfold. Something could go badly wrong, of course, but swans can hiss like snakes, wings can flap with alarming force and noise, and, if worse comes to worst, they can rise and fly away. Swans have been known to kill geese and ducks and to attack children. Why not a dog? Oudry's bird is clearly not ready for its swan song.

A fabulous bird? Yes, indeed, and one that will linger in memory once you have seen the painting. Look at it, "play with it," according to your imagination and your nature. In passing, make up a story about it, if that is your inclination, if you have a lust for narrative as I do. Allow the swan the freedom of its possibilities, permit it to stretch out into as many directions as you wish. Give it the full benefit of your affection and interest. The "story of response" is yours, and yours alone, to develop and devise.

Consequently, the interpretations that could be drawn from the Oudry painting are limited only by the power of the mind itself. Here are a few: Is there a hidden allegory by the man who worked so closely to the court? Could the Prince of Birds be a veiled representation of the King at odds with some elements of the population? A hint of revolution, perhaps, beaten back now, but still to come not so far into the future? Is Romance in conflict with Realism? Poetry versus Prose? Beauty threatened by Death? No mental exercise is more delightful than the roving imagination as it expands, expatiates, glories in its creativeness, aware that, as Marianne Moore said, "The mind is an enchanted thing." Take *physical* pleasure in looking at the painting. Let your gaze play over it in what Karl Knaths called "a dance for the eyes," back and forth over the canvas, supple as the brush of the painter, and you will experience some sense of the actual production, the technique, so different in each painter. In this sense, every picture is an "action painting," and you can have a thrilling feeling of its original movement.

All of this is great fun, and certainly cannot harm any-one, or the painting itself, because "it does no more than test its form." Symbols, symbols, yes. License and liberty that must come back to a realistic base. As Freud wryly remarked, aware of this need for balance and return, "Sometimes a cigar is just a cigar."

May I indulge in one "long, last look at the swan," let-ting the poet move on, out from the picture, from what I hope is the "defeated dog" and the swan with its polymor-phic urges, its "possible dreams," its many rebirths in the womb of myth?

The Swan at Sunset

It is late. Shall I have one long, last look at the swan
As it moves on the river, sluicing its purity.
Or simply say, never in this world will it be done?

One wants something else, another more exciting part —
A second nature to rise in the orange beak, stab
And stab again until a sunflower opens in the heart.

I have had this counter-urge perhaps more often than I know,
Wanting a thing to be itself yet come at me like a sunburst
As I stand on the banks, waiting for the powerful orange glow.

Once more, then, the impeccable purity and the brilliant
 skewer
Just as the image darkens, goes down to dross, detritus,
As though the brain of man, at last, floats on a sewer.

It is so late. Can one now, in fact, rethink —
The palace, the palm trees, the bird sowing on the river —
Must I let go, throw the ultimate sunflower down into
 the sink?

Or simply say: An orange glow. A swan has passed me by —
How many times have I felt so full as this, a face of seed,
As if I would go on flowering and flowering against the
 splendid sky?

Jim Grimsley

Walk Through Birdland

HOW THE DEAD can love you. Stop. How the dead can love you when you. Stop talking. Why they take you into the yard when they do. Stop. Listen. The neighbor is always listening, walking past the house without any real reason. We are among the living and the, all the living and the. Other ones. And. When they want to, when they rise up, how they can love you, forever.

You have had bad news. You will stop talking, shut your mouth. You will lie down in the field and your heart will gather up in one knot. Flatten your palm against your mouth and bite the skin enough to feel your teeth. Your heart will gather. Shut your mouth up in one knot. Never open anything else. Die down in the field. Hard as a bone you will be one knot.

But today we will walk through the world, into the shadowed space between the house and the abandoned yard. Lately we have been smelling the dead in the yard next door, the ones they found and the ones they didn't. The smell lingers, incredible pulsation, as if the rotting is a kind of life. As if the smell of decay has become an emanation of waves over the grass where the dead were found. Abandoned, in the yard next door, along the yard next door, you and I, we are walking . . . Then

From above they are

Showering down they are

Showering down onto the yard they are falling out of the sky they are raining through the bare branches onto the leaves onto the ground where there they are, all the grackles in the world, all the glossy grackles with blue-black heads diving and showering down through the air in the late. Searching for pecans among the unraked

LUIS EGIDIO MELÉNDEZ

Spanish, 1716-1780

Still Life with Game

circa 1770-80
Oil on canvas
14 9/16 x 19 3/8 in. (37.0 x 49.2 cm)
Purchased with funds from the North Carolina Art Society (Robert F. Phifer Bequest) 52.9.177

leaves, the birds are chattering and chiding one another, talking about that last hop, whether they are headed in the right direction, shoving and digging their beaks into the leaf humus, searching. For food is everything this time of year. Their hearts are beating furiously and yet the flock seems relaxed. The grackles take everything in stride, lifting in waves as you pass, as I pass, the one of us. We are walking through the birds, through the midst of them, and they are accepting of us, and we are one, and everything is at peace within us. We are even inside the birds and they are inside us and everything is at peace. It is a walk through birdland and we stop.

In the yard. Where they are crawling over

My feet. The birds are crawling over my feet now. But farther ahead in the yard

Then down the street he is. He is always walking past the house without any real reason. When he walks to town he never brings anything back. And the birds are crawling over my feet and they are in the high grass ahead of me in the abandoned yard and of course you will not look, you refuse, you always leave the hard part of looking to me.

: Where the birds are crawling over the dead. Who can love you. Even so. With the grackles crawling over your face. The blueblackheaded birds, all of them, the world's whole population of them, crawling over your face, and you are dead, and they are not above eating you. Already, the eyes and face have suffered battery. It is no wonder you do not sit up, you dead one. It is no wonder you hide your face beneath the mask of feathers.

The neighbor passes and he sees you looking and you say, we say, we two as one, "Here's another dead one. Look."

"Yes, there's another one," the neighbor agrees.

"This one's good and dead."

"Yes, this one's good and dead."

"So," I say, and you are, naturally, hiding within; you are always quailing and hiding within at times like these;

"So," I say, "what am I supposed to do about it? I'm already late for work as it is." (A whole day late. As it is.) But anyway,

"I suppose you should call whoever you call. The ones who find dead bodies." The neighbor spoke mildly but in a clipped way.

"They already went through this yard this week," I said, slipping into the past tense myself, feeling the narrative gather force around me. "With a fine-tooth comb, they said. Those ones you were talking about, I forget the name." Sighing, firmly anchored in the past now, becoming "he." Becoming fully third person, like the neighbor. He and the neighbor stood in the yard looking at the dead one in the grass. The self-integrating sight of the dead and in fact stinking-dead corpse in the grass with the hundreds of millions of birds crawling over it and through it, very nearly through it, he and the neighbor watched this image.

The neighbor sighed and said, "It's always like this."

"What did he die of?"

The neighbor sighed again. "That thing everybody dies of. Probably."

The moment became perfect, the story culminating in the walk of the neighbor away from the yard, gloriously

serene, in the golden slanting bar of a sunbeam lancing through the gap of dormers across the street, the golden lance slashing onto the neighbor, illuminating him in one final resplendent burst, a halo of alabaster fire. "It's always like this," the neighbor had said.

Even then slipping, though. I am slipping back. I am not sure if the neighbor is really gone or whether he was ever really there. I know I was never "he." I am looking at the dead one who is approaching the upright position slowly. Tedious, when the limbs no longer bend, to get up off the ground like this. But this is the gift of the dead to the living, occasionally to stand upright. We are taking the hand of the dead one, which is cold, we are walking with the grackles perched on our shoulders, heads and arms, this is the real ending, there is no narrative, we are only here, where the dead can love you sometimes, forever sometimes, in birdland.

ROBERT WATSON

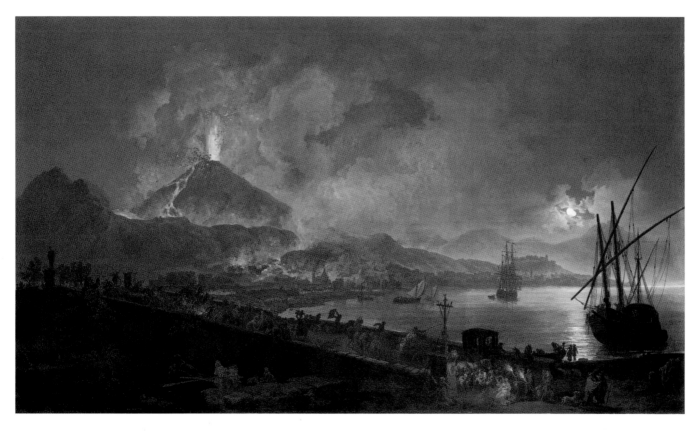

PIERRE-JACQUES VOLAIRE

French, 1727-before 1802

The Eruption of Mt. Vesuvius

1777
Oil on canvas
53⅛ x 89 in. (135.0 x 226.1 cm)
Purchased with funds from the Alcy C. Kendrick Bequest and from the
State of North Carolina, by exchange 82.1

Distances

I

Across the gallery I see what seems
A painting of a sunset: crimson, orange,
Gold lights wash the night sky, mountains, town
Below. On the right a full moon tints the clouds
And water silver. Two ships, sails now furled,
Sleep in the serene water of the bay.

I walk closer: the mountain top detonates,
Red rocks spew from its cone, geysers of flame
And rivers of lava gush down toward
The town, toward houses, a castle
And church. The populace flees through the night,
Around the bay, across the bridge to Naples
On foot, in carriages, on horseback with sacks
Of household goods. Some few raise painted images
Of Saint Januarius to ward off
The bombardment of rock, stop lava
Boiling down the mountain's blazing sides.

II

I plunge, I imagine, down burning slopes
Where cinders and ashes bury me
As nineteen centuries past they buried
Herculaneum and Pompeii, all houses,
Temples, baths, shops and bodies fossilized.

Yet the human heart's eruptions too will
Bury man as well as nature's can
When battering rams and bombs reduce whole
Cities to rubble and dust. Alexander,
Hannibal, Hitler had lava that boiled
In their veins, erupted in their dreams.

III

Now we wander through these excavated streets
Past fountains, priapic statues . . .
"It's time to go." The tour bus leaves Pompeii.
Our guide says, "In 1944 in wartime
Vesuvius had its last erection."
Her English falters. We laugh. "Alive still.
It can wake and blow its lid, destroy the people
Long resettled around its cone and sides."

From Sorrento across the smooth waters
Of the bay, beneath the silver moonlight,
I see in memory the peaceful distant slopes
Of Vesuvius, a giant sleeping on its back.
Its ancient heart beats on and on.

In his lifetime Volaire painted the volcano
Again and again: crimson, orange, gold,
The people of Portici in flight below.

MICHAEL PARKER

PIERRE-JACQUES VOLAIRE

The Eruption of Mt. Vesuvius

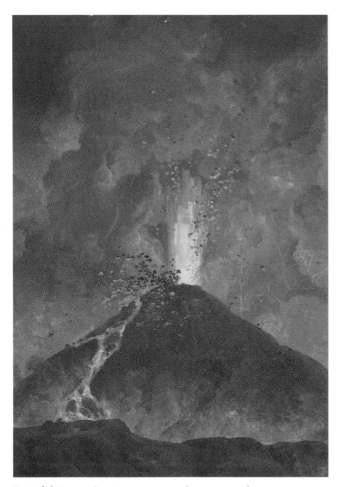

Detail (*For complete image, see preceding response.*)

Vesuvius: An Aria

In San Francisco on the night of 17 April 1906 . . .
Caruso had sung a graceful Don José and returned
jovially to the Palace Hotel. . . . At 5:13 a.m. the
hotel rocked. . . . His bed wobbled, then tilted
over. . . . Caruso was anxious to make a detour for
the Opera House and salvage his costumes, but
someone reminded him that it was already ringed by
smouldering fires. He looked blankly at the speaker
and muttered "Vesuvius.". . . "It's Vesuvius," he
kept repeating.

— from *Caruso* by Stanley Jackson

HE SANG THE WORDS first in sleep, when the pleasant
tinkling of the chandelier above his bed crescendoed into
dissonance, before the fixture was plucked from its
mount and the ceiling sleeted glass. Then the bed began
to shake and the tenor, accustomed to transatlantic ship-
sleep, swam up from a dream in which he was crossing
the water to his own beautiful country. Thrashing through
water tinted orange by a fiery sky, he opened his eyes and
watched a pair of boots heel-dance in through the
thrown-open door of his suite. He understood then: he
was still in California, and as the hotel began to sway, he
added San Francisco to the list of cities where he'd never
sing again. Pelted with chunks of ceiling, tossed to the
floor by the last and most powerful ten seconds of
tremor, Caruso closed his mouth tightly, tasted the chalky
plaster dust, the metallic bite of blood. Seconds of still-
ness followed, like the slight but radiant delay after a note

nailed high and clean turns an audience to stone. And then applause: window shades flapping, church bells tolling, one high horse neigh touching off a chorus of croupy dog barks and finally the crash of the first weakened buildings followed by the thunderous orchestra that roused him from the debris and sent him to the window where, facing the bay which reminded him of his home, Caruso opened his mouth wide to sing.

Notes not heard. An aria in only two words, backed by shriek and scream, earth rumble and ember spit. *It's Vesuvius*. He sang what he saw and what he saw brought sight: the familiar mountain exploding above the harbor, ash dappling the sidewalks in front of the *café-chantants* where he'd first sung in public. Naples beneath the blazing light: nocturnal sparkle of the gently curving bay, narrow twisting streets, harmony of hill and sea. He sang its beauty in a night lit by terror, sang ship riggings backlit by moonlight, sang moonlight strained through rain cloud. He set longboats asail with his song, sang them through rolling seas toward ships anchored in the harbor. He sang crazed streets, bridges teeming with all the people he wanted to save, people from life, from song. Beneath *Vesuvius* he sang his neighbors out from those dank tenements where he had grown up eating black bread and beans, sang from the grave childhood friends who'd died of malaria and typhoid. Sang herds toward the bridges past posts carved into busts of San Gennaro, patron saint of Naples, whose likeness the fearful flashed like shields at vengeful *Vesuvius*; he sang rats and cocks and foamy-mouthed dogs, men trampled by hooves of horses, sang it all in a voice which hours before on stage had emerged as sharp as California light but seeped from him now as thick and hot as lava.

He tried to sing what lay below: buildings folding into themselves like the slammed-shut covers of books, bricks and timber burying alive lovers. In a note held high above a trembling city, he scoured ruins for the woman who hours earlier had shared his bed, sang his way to where her breasts and bloodied kneecap peeked through plaster but found his words powerless to save her *Vesuvius* sweet tenor sifting dust from her left eye which stayed open, unblinking, defiant, a corpse's eternal gaze which became the moon above the city where ash rained, lava lashed the outskirts. *It's Vesuvius*. Beneath the bay his notes rose in bubbles, up through the water which had made his voice so clear and strong *It's* countless childhood hours spent diving from the Molo into the cool green water, floating up from the depths off of St. Lucia to glimpse, just before he broke the surface, cloud-tipped *Vesuvius its* sides raked with vineyards, pulling him into the delicious air, drawing from his lungs a voice erupting above a burning city.

It's Vesuvius. From deep within came the rain of cinders that buried Pompeii, and from someplace deeper, ancient, untapped, rose the thickly vibratoed mudflow that covered Herculaneum. He sang an elegy for those claimed by the volcano only days before, while he was en route to San Francisco; sang elegies for the dead of 79, 1631, 1767. Song of lovers, of love triangles: Carmen, Escamillo, Don José; Sir William Hamilton, Admiral Nelson, Lady Emma; San Francisco, Naples, Caruso. *It's* the song of painters who set up their easels on the outskirts of the city and made *Vesuvius* their lifelong subject *It's* the song of the mountain boiling from its center, spewing words toward heaven *Vesuvius* rivulets of fire etched down its slopes, edge of the city buried in hot notes, *It's Vesuvius* exploding in music never heard *it's* a song unsurpassed until that morning years later when Caruso's last notes covered the sidewalks in ash, along the volcano-shadowed avenue, beneath the hotel *Vesuvio*.

Eleanor Ross Taylor

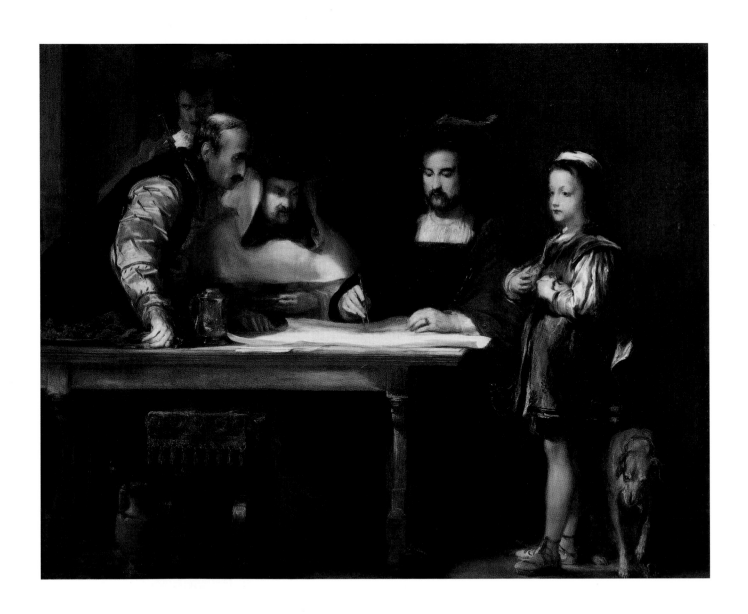

DAVID WILKIE

British, 1785-1841

*Christopher Columbus in the Convent of
La Rábida Explaining His Intended Voyage*

1834

Oil on canvas

58½ x 74¼ in. (148.6 x 188.6 cm)

Gift of Hirschl & Adler Galleries, New York 57.17.1

Imago Mundi

The prophecy in their faces and
that present they are grouped in,
both history now as much
as Spain's world power,
the lure of ocean sails,
dreams of Cathay.

The Discoverer's stance
and gaze not unlike one
writing the first sentence
of an inspired text
or setting down
the first line of a poem,
but not with pen, with compass
lantern-light picks up
and seems to move,
an automatic writing,
fate drafting history.

He halted in despair,
becalmed in his firm course,
this man of destiny,
"in person tall and shapely,"
at anchor with the monks;
wrote his own prayer
to "Him who created
heaven, earth, and sea."

Confessor to the Queen,
in shadow, plots
the decked ship and two caravels,
the royal letter to the Great Khan
of Cathay. Does he foreknow
the meteor that will fall into the sea
the eighth day into voyage? A sign
from God? Approving? Or indifferent?

Does he already wonder if it means
a second voyage with missionaries
and more boats (that carried back
five shiploads of bound Indians,
sold in Seville as slaves)?

Young Ferdinand stares, lost;
his hands, forgetful of
what he is holding – his bread?
his top? – already
relics of young appetite,
his child's eyes feverish
with old seamen's tales . . .
"Men fancied that there hove in sight . . ."
the secret of the Western seas,
the mystery of Aztec sacrifice.
The rough pirogues that Lewis took,
with whiskey, no missionaries, no
fur-trimmed robes for greeting a Great Khan.

They are conjecturing
figures we've seen transmute
and disappear, they dream
of distances that exhaust
explorers, exhaust geographers.

They dream of us.
One frightened face, half
darkness, sees all to be
given up along the way:
the ships storm-crippled;
the wives in wagon trains,
racing winter: "Today threw out
the old clothes press;"
the Trail of Tears, moving slowly,
all things moving Westward.
They're listening to the vast largo
of sea and space; see,
not this world, one new.

Written on their faces,
all theirs not to know:
De Soto's trek through
Western Carolina; the Rockies;
the landing on the moon;
mechanical Explorers
charting space.

All we are dreaming still,
all still to come of it
gathers in this monastery light
of 1492.

Meanwhile, the 1490s Spanish hound,
head hanging, slinks off
nearer the fire. He knows no
ideal world; he sees Italians,
Spaniards, Indians, and Chinese
a single, puzzling species, Man.

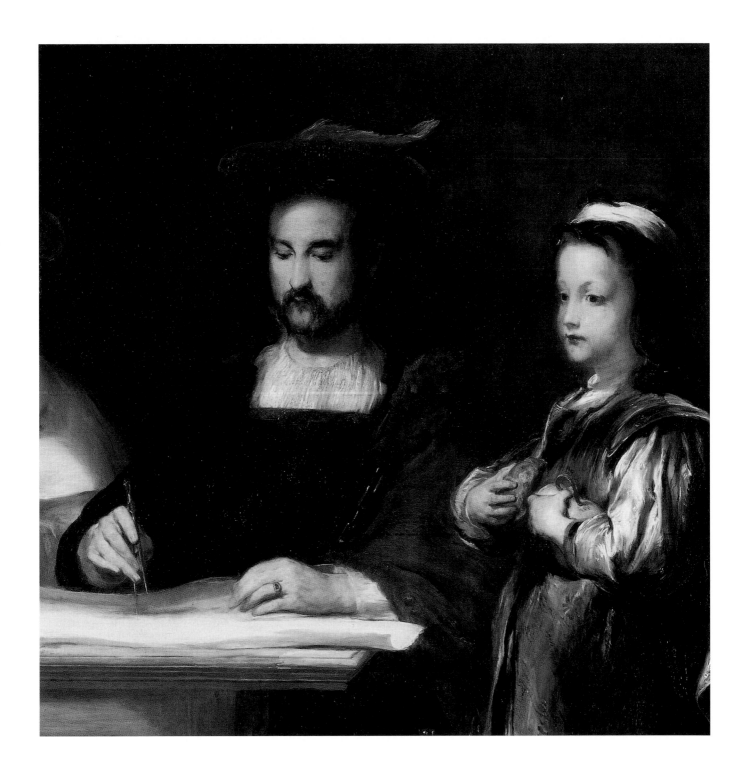

JAMES SEAY

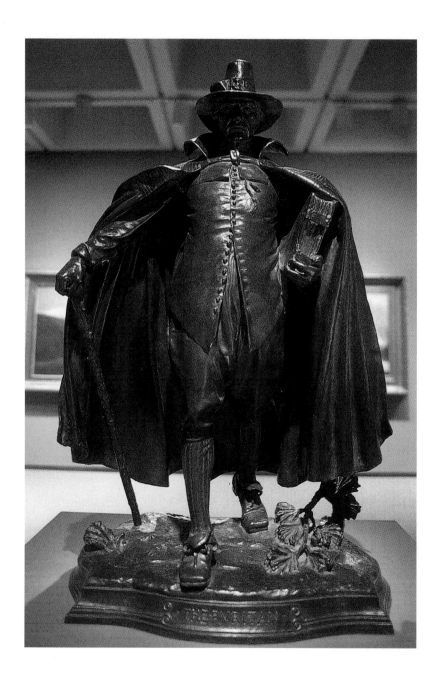

AUGUSTUS SAINT-GAUDENS
American, born Ireland, 1848-1907

The Puritan

Modeled 1886; reworked, reduced, and cast
after 1899

Bronze

31 x 19½ x 12¾ in. (78.7 x 48.3 x 32.4 cm)

Gift of Mr. and Mrs. Fabius B. Pendleton 71.40.9

The Puritan

Wee must be knitt together
John Winthrop preached in purest metaphor

to those aboard the Puritan ship
Arbella, word and vision sure as apocalypse.

And that is what is easy to ignore,
looking at Saint-Gaudens' foursquare,

embronzed, and square-toed monument to dourness:
how their sense

of social covenant
informed so much of what we meant,

how intensely it was community,
and how by only sternest Liberty

in their narrow town
could we parlay the toe-hold of taken ground

into what we now call home.
Hawthorne spoke of a lamp

of zeal within their hearts, enriching all
with its radiance, and all was well

until the lamp began to dim
and then we saw their system,

how hard, cold, and confined it was,
he said, who surely knew them best.

In his tale "The May-Pole
of Merry Mount," you will recall

that iron Endicott
orders cropped the locks

of the bridegroom's hair who had gaily danced and wed
the Lady of the May. Even the trees turn sad.

But what invariably saddens me more
is when they shoot the dancing bear,

Puritans bent
on killing any merriment,

grim in their iron armor;
hard toil, he wrote, . . . *sermon and psalm, forever.*

Tell me, though, why do I pause
in the steadfast contractual gaze

of this bronze Puritan that Saint-Gaudens
casts before us, pilgrims? —

this early one who looks across the years
and makes discretion clear.

Too rigid still,
his sense of evil,

but of common cause his sense is firm,
what's now being knit into our fabric as a blur.

JILL McCORKLE

GEORGE COCHRAN LAMBDIN

American, 1830-1896

The Last Sleep

circa 1858
Oil on canvas
40 × 53¾ in. (101.6 × 139.1 cm)
Gift of Peter A. Vogt 79.4.1

48

The Last Sleep

MARGARET KNEW when she opened her eyes and looked about that she was looking on the world for the last time. It was the heaviness she felt, heavy of eyelid and arms. The very air was heavy with dampness and the smell of roses, velvet petals and thorny wood. Someone had placed one in her hand but she let it fall to the side. Her hands were numb with sleep, *dark with sleep* she heard someone whisper in passing. *The shadow is passing*, one said, *the time has come.* There were whispers throughout the days and nights, how much time had passed she did not know; it seemed an eternity and all the while, everyone she had ever known came and passed through the room like ghosts, like shadows. They talked of her illness as if it were human, a form to lie waiting, watching and waiting to strike the right soul. They said, *God needs another angel in heaven*, and she willed her body to rise to its fullest to raise one arm high if only for a second. She wanted to say, *Get from my room, I am not up and dressed.* She wanted to say, *who do you think you are anyway? Preacher or teacher or old Mrs. Combs from the market? You have no right to see me this way.* She could feel the anger in her neck and face, mouth twisting as she pulled herself higher and higher, high enough to see Charles at the door letting in more women with trays and jugs and boxes. She could smell chicken and biscuits, cheese and johnnycakes. *Get up* was all she could manage. *Nonsense*, she thought as she fell back against the pillow, someone there with a cool cloth on her forehead. This was a daughter's job. But she had no daughter. A son should have guarded the door, protected her, but she had no son.

She turned her head to the side, and beyond the people and the heaviness of the dark warm room she could see light. The dining room beckoned her, there, the chair by the window, the light making the room golden and hazy as in a dream. That was a healthy room. Every morning for ten years, every morning since she married Charles, a man old enough to be her father, and he brought her here to this house, she had risen early and sat there in the early morning light. She liked a moment to look out on the world before the work began. She liked to look out on their yard, a line of pecan trees flanking each side of the road up to the house. The land was flat and wide, pine trees filling in the spaces, their soft needles cushioning the sound of a walk into the woods. She liked to pretend that she was the daughter of the house, a princess trapped and waiting for something to happen, for somebody to come and carry her off to the seaside, a day's wagon ride away.

"Come quick," someone said. "She was trying to get up."

"She moved?"

"She spoke?"

"She said, 'Get up.'"

"Now, now, you got to stay put." Of all the voices, she knew this was Charles; too loud and too flat. He was forever telling her what to do.

A calm low voice came from the corner behind her head. She had heard this voice from the pulpit. She had heard this voice speak of God's anger at those who had fallen by the wayside. Those who walked through the world coveting and desiring earthly belongings and pleasures. She spent her whole childhood wanting her Aunt Emily's coat with the fox collar. Her Uncle William had shot the fox himself. Shot it and skinned it for his wife to drape proudly around her neck while her stomach got big and round and hard with what they would all soon come to call Helena. Margaret remembered being seven when she hid in the wardrobe in her parents' room while Emily and William were there visiting; she pulled that fox fur up to her face and felt the silkiness. Margaret wanted that coat. She wanted to grow up and look just like Emily with painted-up lips and red in her cheeks. Emily said that she liked this coat but what she really wanted some day was mink, and not just a collar but a full-length coat.

"You'd die in this heat, woman," William said, and they all laughed while Margaret squatted there and peeped out of the wardrobe. Later her momma asked who did Miss Emily think she was, royalty? Her momma said Emily had herself a bed with curtains draped around it like she might be Sheba. Margaret wanted that bed; she coveted that bed and when all was said and done she got it because nobody else wanted it. She was lying in it now like a queen. Margaret's parents talked of how Emily's daddy made a killing after the war. Textiles. Margaret's daddy said that only in these parts could a stupid man have done so well. Margaret wanted all that Emily had and when Helena was born she hated her at first, hated that Helena got to snuggle up to sweet-smelling Emily in that big royal bed. She often came and stood closely as Emily held Helena. She would reach her arms out to touch Emily, to stroke her long hair. Sometimes Emily let her brush it and she had to reach up high and then pull the brush through the long thick hair. Stroke after stroke.

"I have seen many reach out in such a way."

"Do you think that . . . ?" another asked, pausing for the divine intervention.

"The Lord works in mysterious ways."

"The Lord is my shepherd. . . ."

She closed her eyes against this recitation. This was her house, her church. If there was a recitation she would do it, thank you. The light would stay in the dining room all morning while she cooked the breakfast: sausage, eggs that she had just collected, fresh biscuits, milk, butter she had churned herself just days ago. She liked to sit on the porch with the churn at her feet and work the handle up and down while watching the road or the edge of the woods for a sign. If a redwing blackbird came and landed, for example, she might up and leave. It would be so easy to steal off across the yard, Charles busy out in the field, his body hidden by the mule and plow. Even if he glanced her way, she would head eastward and the sun would be so bright in his eyes that he would have to look away. He

might think he saw her is all and he wouldn't know for sure until he came in for lunch and found his ham biscuits out on the table. She wouldn't even leave a note. She would simply disappear. It wouldn't be the first time that had happened, a woman up and disappearing.

If she chose to stay for one more day then she would find herself coming back to the dining room all morning just to catch the light. It would pass by early afternoon and then she would have the feather beds outside to beat and warm in the sun. She used a broom to beat and beat, each thwack striking a rhythm in her head. She would race through the yard to catch a chicken and when she got one she would snap its neck easily as a dried-up twig. She would bleed it and scald it; pluck it bald before rinsing and flouring and frying it up in fat. Used to she felt something for those chickens; she looked into their hard pebble eyes and begged their forgiveness for what she was about to do. She tried to swing them around in a gentle fashion but that was a cruel thing; slow death, neck only part broke. Would they race across the yard with no head as Charles said? She had no desire to know what a half-dead chicken might do. She would simply catch a chicken and ring its neck while looking elsewhere, thinking elsewhere; she would weed the garden, up and down, bending and stooping, reaching and pulling, her fingers running up and down pea hulls like a blind person reading the news. *Are they filled out? Are they ready?* She walked and walked, the sun high in the sky, her hair pulled off to one side, her face and neck drenched in sweat. Her basket was so full of peas she had to put it down, her hand and arm numb from holding it there close to her chest. She looked way out in the field where Charles was no more than a dot in her vision and she looked over at the woods, at the pine needle carpet. She could begin by walking and then set off running if she needed; she could make it into town and climb on the train. She could say she was going to visit some relatives; she could say she had somebody who was dying and who needed some

help. Didn't dying people need all the help? Didn't they need all that food in there on the dining room table, piled so high it blocked her view? It was ruining her day and already the light was moving, shifting. Another hour and this side of the house would begin to cool while the sun baked the front, that afternoon light so strong and harsh. It made her close her eyes; it swaddled her with a numbness she could hear, buzzing like a head full of bees, a swarm of bees.

"Why her?" someone asked. "Too young," said another. She thought she heard her cousin Helena who had died in childhood. She wanted to ask who in the room sounded like Helena. She wanted to ask now after all these years what exactly had happened to Helena because it was something she only knew as whispers among the grown-ups. "Helena?" she called, meaning what happened to Helena? One day she was out on the porch swinging her plump naked foot out into the summer air and the next she was stretched out on a tabletop for the neighbors to come and see, a still dead child with lilies on her chest. She meant to ask what had happened to Helena's mother, where was Emily on that very same day while William sat in the corner tying and untying his shoes – tying and untying – over and over like that was his vocation in life. "Helena?" she said again. She wanted the facts, but they misunderstood her request. They called her *delirious*; they said she was reaching for heaven, reaching for the light, reaching for the Lord Jesus to come and take her home. They said she was hearing voices, voices from a life that no longer existed. She was reaching for childhood friends and parents and relatives. But these people didn't even know Helena. They don't even know about all the days Margaret rose with the notion that this would be her last day spent alone in this house; her last day working like a slave to clean and cook. They don't know how she looked off into the woods and pictured herself there, running back to her childhood home, past the churchyard, past her school. It was tiring to run so hard, to work so hard,

and her eyes felt heavy like she might close them just for a second. Charles was there now, his hand as rough as sandpaper against her face. The preacher was there, his breath tinged with the odor of the food he had been partaking in this very house. They all looked little to her. When they asked if she had any last things to say she was suddenly filled with the thought of all that she would *never* know. All that she would *never* do. There was no word for it all, no way to say it. So she closed her eyes to their tired old faces and let sleep come. When she woke she would be in a thick pine forest winding her way to the morning light. She would wear fox fur like a queen and she would never look back.

MAX STEELE

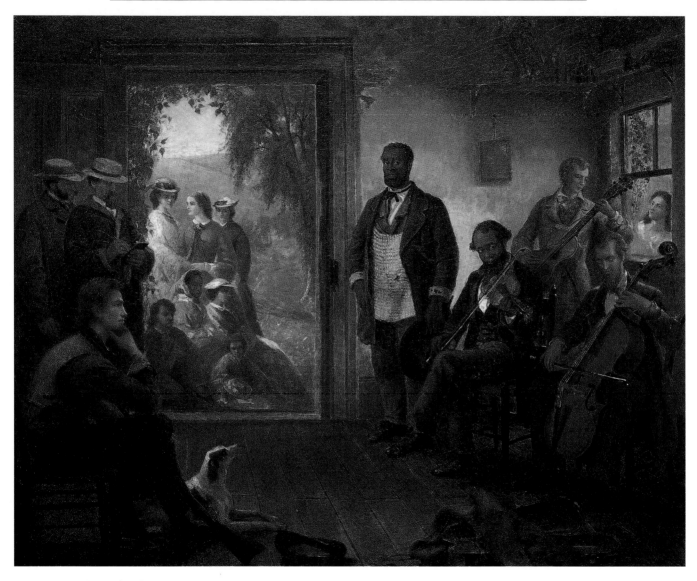

THOMAS HICKS

American, 1823-1890

The Musicale, Barber Shop, Trenton Falls, New York

1866
Oil on canvas
25 x 30⅛ in. (63.5 x 76.3 cm)
Purchased with funds from the State of North Carolina 52.9.15

Speak, Painting, Speak

WE'VE LEARNED FROM PHYSICS that the observer changes the thing observed, and since I could change, maybe forever, the way you see a work in the North Carolina Museum of Art, you should know who the observer is.

Perhaps I should tell you that the house of my childhood was truly bohemian, though we did not acknowledge the word. My father had an uncanny eye for period antiques and the great designers. Two brothers, as a hobby, could, upon commission, copy from century-old walnut or mahogany, any Hepplewhite table, Sheraton desk or Adams mantelpiece my father brought home. Another brother was first a portrait painter with a studio in our backyard where five or six local artists gathered each evening to paint, and later he became a nationally known photographer of women.

Always I've heard that you can tell when you're among artists and writers because the talk is about money; and that you can tell you're among rich people because the talk is about art. Each group must sound ridiculous to the other.

Some years after leaving the studio of my brother (where my fingers split open like hot dogs after developing photographs all night, week after week), I lived for five years in Paris where I attended the Académie Julian on the rue du Dragon. Here among the glorious blonde and nude Swedish models the war-wounded French students complained about the price of paper, conté crayons, and charcoal sticks. More important I spent hundreds of rainy afternoons listening to music in the cathedrals of Saint-Sulpice, next door to where I lived, and Notre-Dame near where lived a wise old woman analyst who was trying to help me make sense out of a deep sorrow and disorder. (A good enough definition of art itself.)

Other rainy days I wandered through the Louvre, which was warmer than my hotel room. Or on sunny days I sat reading manuscripts for *The Paris Review* in the garden of the Rodin Museum. (How fortunate I am to have had, at the University of North Carolina, art history courses with that great doctor, Clemens Sommer!) All in all, the triumphant organ music, the soaring architecture, and the masterpieces in marble, on canvas, and on paper were part of a healing process, and I loved them all as one might love the kind hands of a nurse.

"Well, then," I think now, the handsome North Carolina Museum of Art catalogue in hand. "I know something about art but I don't know what I like."

It seems a wise idea to let a piece of art choose me, rather than my choosing it. I hope it will be one of the fabulous Egyptian pieces (given by members of the Hanes family) so that I can remember my week of revelation and transformation in the Valley of the Kings.

The picture that chooses me in the catalogue and again in the museum (a building not as brutalizing and diminishing to a man as many architects of that era aspired to be in their blueprints) both surprises and disappoints. It is the Thomas Hicks: *The Musicale, Barber Shop, Trenton Falls, New York*.

Why? Maybe because it seems to be a narrative picture and everyone likes a story. I learn that the museum once refused to lend the Hicks because it is so popular with its visitors.

But from reading thousands of student stories for thirty years, I am sick-tired of stories and all literary talk and events. So why has a seemingly narrative work chosen me? At first I think it is because I believe it is by the Hicks who did the *Peaceable Kingdom*, where the wonderful soul-eyed lion looks less ferocious than the lamb he lies down beside.

"Aha," I think, remembering that Joyce Carey once said to me that a writer has only one story to tell and he may as well learn to tell it well. "This is the *Peaceable Kingdom* again: All the conflicting social issues of 1966 are here, one hundred years early, for an eternal moment in equilibrium – liberated women, blacks, whites, maybe a gay or so, who knows." A good artist captures his own

time; a great artist creates the future. Then I realize it is Edward Hicks, not Thomas, who did the animal pastorals. The two men are cousins and both painted carriages, and Edward taught Thomas, so maybe they were both dreaming the same dream of a peaceful coexistence. After all, in 1866 corpses from the Civil War were probably still being turned up in woodlands throughout the South.

But then I find from the title that this is a Northern Picture. Surely it must be propaganda. Can one be so naive in 1866 as to put blacks and whites together and portray the former as musicians with no self-consciousness? I read and find that Thomas Hicks was primarily famous in his day as a portrait painter and that he painted portraits of Harriet Beecher Stowe, Abraham Lincoln, Oliver Wendell Holmes, Margaret Fuller, Edwin Booth and other prominent Yankees. Surely he talked to them while they sat: about abolition and even about the Emancipation Proclamation. But does an attitude from such talk show here? There are few nineteenth-century paintings of African American men and women and his seem to me to have a bit of caricature and cliché about them. (Are the whites of the eyes too large and startled?) If the canvas is not about integration / segregation of gender and race, what is it about?

Or is it about anything? Is it merely a pleasant Sunday painting by a proficient artist? Perhaps it is even an illustration. We read and find that this is the barbershop, poolroom of the fashionable Moore's Hotel where the wealthy stopped to see Trenton Falls, often on their way to or from Niagara Falls. Hicks liked vacationing here among the fashionable tourists. I am not afraid of the dirty word "illustrator" because I admire the elder Wyeth, the illustrator of *Treasure Island* and other of my childhood books, more than I do his proclaimed artist-son, who illustrated so many times that one sentimental note of isolation.

At any rate, Hicks seems to have approached the scene with the attitude of a portrait painter, an incidental historian, capturing, as his first aim, the outward appearance without too much question of psychological or sociological problems. He has included a stuffed owl, which a fellow of the Academy of Natural Sciences notes is one of the earliest stuffed birds in American paintings, and musical instruments, which delight a surprisingly large number of people interested in references to music in paintings.

But why has the picture captured my imagination? Is it because Hicks was born almost exactly one hundred years before me, and like me, after a boyhood in a small town, had gone to Europe to learn? After the Pennsylvania Academy he studied in London, Florence, Rome and Paris. Thus the happy blend of naïveté in subject matter with sophistication in technique. (I think of Reynolds Price with his superb stories of North Carolina innocents told in a voice polished during his Oxford days.)

But I did not know all these things when the picture captured me. So what is the connection? Now standing across from it in the museum itself, I see. There is a picture within a picture. The women and children outside are framed by the doorway of the barbershop.

I have learned by working with thousands of students that the story within a story is an actual memory. And in intoxicating conversations with an analyst friend I have learned that the dream within a dream is often an actual memory. What is the relationship of the picture within the picture or the story within the story or the dream within the dream to the main picture, story, or dream? What does it mean, the picture of the women and children in their fashionable clothes and brilliant sunlight framed by the dark barbershop where the manager of the hotel and the artist himself stand in one corner? And why is the seated man separated, by the picture of the ladies, from the musicians? That is something for me to think about, for you to contemplate. Is this picture within a picture merely a memory of the artist's European days, which were like the Europe that formed Sargent and Whistler? Certainly the outdoor picture is romanticized in a way the seemingly naturalistic interior is not. And wait, there is another picture within a picture, the young girl flirting through

the side window. I do not know what the juxtapositions mean. But then I do not ever want to know completely what any work of art means. I want to play around with it, to see something new each time. For if art does indeed grow out of a sense of play, shouldn't talk about it have the same joy and freedom?

Maybe, just maybe, it is not a surface painting. Untalented students often defend their manuscripts by saying: "It really happened." Fiction must be more than that. Pictures must be more than that. To have worth they must also tell in what way the creating of the scene informs or transforms the soul of the artist or writer. Hicks was a successful portrait painter, which implies a certain degree of falsifying in the direction of flattery. Did he never look beneath the surface? Is the owl a symbol of Athena, goddess of wisdom and artisanship? After such a devastating Civil War does she seem dead, stuffed and left on a top shelf? Or is it merely a hoot owl that hooted once too often? (Hoots are that way: They tend to end in violence.) Is it all surface? Is that why his portraits of all his famous sitters are not known?

There is something troubling in this painting. (One tends to read it in sections rather than as a balanced whole, as one sees a Vermeer.) Does this suggest that Hicks did see beneath the surface, that he had not found the equilibrium his cousin had found in his *Peaceable Kingdoms*? Yet here, in the center, the brightest spot in the shop, is a happy dog, reminiscent of Edward Hicks's lion and lamb in his satisfying kingdoms.

I stand here in the windowless room (for in museums each picture is a window) and become suddenly nostalgic, almost sad. Most reminders of the Civil War choke at my throat. But it is more personal than that. To stave off melancholy I turn to my notes and see that the museum bought the painting in November of 1951 from the John Nicholson Gallery in New York for one thousand dollars. It was thus bought from monies in the first State appropriation for the museum. (I remember at the time, talk among the New York dealers was that men from the North

Carolina Museum of Art and from the Ackland Museum had shopped around in New York and gotten the best bargains going.) I am safely back in talk about money. This painting cost about as much as a used car.

Now I know why this sadness, this interest in a painting that is far from being the most distinguished in the building. It is of a type that my family might have bartered. Not too grand, a good painting but not a great one. I am again in our dining room during the Depression on a sweltering summer afternoon. The dishes have been cleared from the table and a stack of oils is leaning against the fireplace. One by one I, as a child, hold them up for my father and brothers to inspect. It is the back of the frames they study first. They know something about various exhibitions and about labels, but more important they know about the framers near the great art centers. I hold one canvas up to the Chippendale mirror above the Hepplewhite sideboard so that they can see why a composition is not pleasing.

They talk endless talk. And then they discuss the lines of the sideboard, the inlay, the secondary woods, the overall design. This is not dilettante talk. It is bread-and-butter-on-the-table talk. It is talk about paying the taxes on this piece of vacant property or that. It is talk about the Depression. About why knowing something about art and design is essential to our staying alive. We do not need to know much, just more than anyone buying ancestor portraits and instant family heirlooms from us. Enough to speak with integrity, with money-back guarantees for what we are selling, without realizing that what we are selling is taste.

My mother appears in the doorway with a Queen Anne pitcher of water, gamely rattling the silver pitcher with slivers of real ice, not cold napkin rings, as she once did, to assure us that the Depression will soon be over, that soon there will be iced tea again.

Only now do I realize how much I have inherited, how important paintings are to me.

James Applewhite

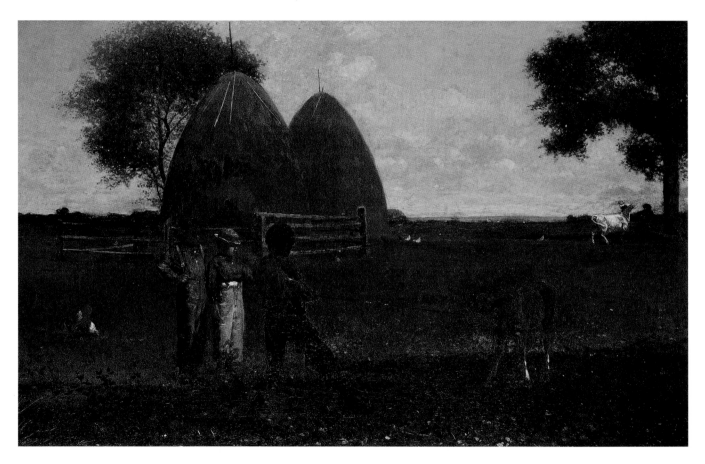

WINSLOW HOMER

American, 1836-1910

Weaning the Calf

1875
Oil on canvas
23⅞ x 38 in. (60.8 x 96.5 cm)
Purchased with funds from the State of North Carolina 52.9.16

On Winslow Homer's *Weaning the Calf*

What shadows my happiness? The boy and calf so linked by
 a rope seem to forget all else. Grass recedes to the horizon
and chickens roam free. Hay stacked richly as memory bulges
 mountainously on the sky.

My wish is matched by this scene, where green reflected in
 aqua and clouds lets the perspective between take sight into
a vapor refusing to be mist, a balmy air which will not weep
 but reveal: two town boys in hats

and suspenders, bystanders, who also look past the other boy concealed
 in a ragged shade. His brother the calf resists being hauled
from its source. Here the grass with its highlights, sunflakes like
 the whites of chickens and cow and

of splashes on a boy and the calf's legs, seems mother of everything –
 this vista between the framing trees, where farms and towns
hover as invisibly as sorrow is in this air, as if seasons were
 only apparent. Yet the cow being

led away switches her tail, tossing her head back lyrically so
 that the arc of her horns pinpoints the clouds. What forgetfulness
of vines twists this open fence not enclosing one earth-breast,
 where red on a rooster's combs and on

the farther chickens leads my eye into a landscape without limit?
 I trust in it, give myself to the summer as if breathing it,
this American horizon. Yet the farmhand leaning hard to pull the cow
 away remains as faceless as seasons.

His figure cannot go home, for Homer has not painted those houses
 hidden by borders. The gesture of this white mother's neck
sharpens her horns so that they pierce me with loss. The dark boy cannot
 follow, as spring does winter,

beyond concern, assumed, too close to see. Part of the farm.
 Now I grasp his braced legs, work-strengthened shoulders,
the curve of his back and neck, though his face is averted.
 The rest is pastoral, a tale of expanse

and ease not purchased by any expense of breath. I turn away,
 the points of hurt in my chest an ache after beauty: almost grasped,
like ice, composed to last. I feel it melt into a world where
 sun conceals its shade, and seasons pass.

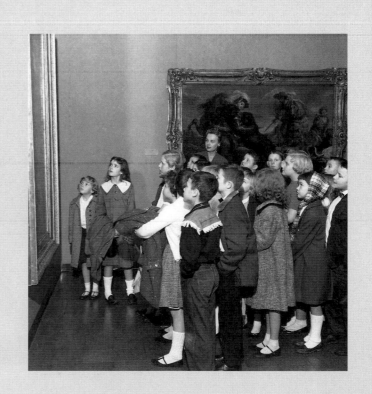

MARGARET MARON

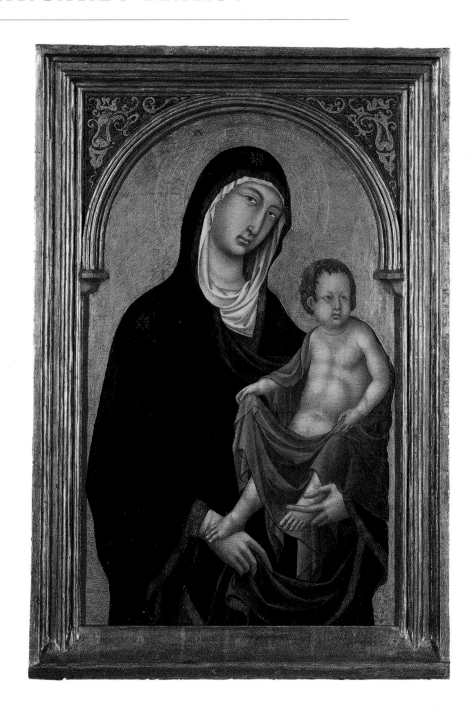

SEGNA DI BONAVENTURA
Italian, active by 1298-died circa 1330

Madonna and Child

circa 1320-30
Tempera on panel, with gold leaf
35⅜ x 22¼ in. (89.9 x 56.5 cm)
Gift of the Samuel H. Kress Foundation 60.17.1

60

Craquelure

"BEAUTIFUL, isn't it?"

Startled, she looks around and sees a guard, a pleasant, smiling, gray-haired man, slightly smaller than his dark gray uniform.

She smiles back politely. "Yes, it is."

"You really like these pictures, huh? I saw you here yesterday, didn't I? And maybe last week, too?"

"Yes."

Heretofore she's been unbothered in this quiet room of the museum. Italian primitives don't seem to be high on the pop charts of most visitors.

"You taking an art course?" the guard persists. "Maybe writing a term paper?"

She glances down at her notepad. A reasonable guess. The pages are covered with scribbled notes and crossed-out possibilities.

"Not exactly."

"Reason I ask, not a lot of people stop for a second look unless it's for a course or something."

That figures, she thinks. Despite the brilliant colors and all the gold, everything in this small gallery has an austere religious cast. This might be the Bible Belt, but the Bible of authority is the King James Version, the imageless Bible of Calvin and Wesley, not the illuminated gospels of medieval Catholicism.

"Actually," she says, "I'm researching a book. Is there someone here who could talk to me about a picture?"

"That Madonna?"

"Yes."

Once the Renaissance hit its stride, Mary would soften into a real mother with rosy cheeks and rich blue robes and she would gaze fondly at a chubby pink infant straight out of a Gerber baby food ad. In the early 1300s though, Mary was an unsmiling, abstract idealization and in this case, the baby that balances stiffly on her boneless hands has the solemn brow of a miniature adult.

She decides abruptly that she has wasted enough time wandering through the museum's collection of religious art. This picture will fit the needs of her current book as well as anything else. The period is offbeat enough to interest the character who is slowly taking shape in her mind and surely one primitive Madonna is much like another.

Isn't it?

"You might could ask somebody at the front desk," says the guard.

"Oh, I'm so sorry," says the receptionist. "Our curator of painting will be in Italy all summer, but maybe one of our interns could help you."

The receptionist summons a young man who appears knowledgeable about the period.

"Researching a novel you said?" he asks when they are standing in front of the picture she's settled on.

"Yes. A mystery novel. I need a picture that someone would kill for and I thought a Madonna might make an ironic contrast to the modern art setting I'll be using. This one looks interesting, but I need more information so I can sound as if I know what I'm writing about."

"Well," he said dubiously, "it's certainly a fine example of the period. Are you going to have it stolen from us?"

"No, no. I'll fictionalize a legitimate-sounding provenance. Maybe change a few details. After six hundred years, you can't prove that this artist didn't paint one more picture, can you?"

"Probably not," he says. "Especially since uniqueness wasn't a great virtue back then and artists rarely signed their work."

The young man is steeped in knowledge recently acquired in pursuit of a Ph.D. and he is happily voluble about the techniques the artist must have used. He explains how the wooden panel was prepared to receive paint, why the gold leaf around the Madonna's head was

applied over a base coat of red, why the flesh tones are now the greenish gray of *terre verte* instead of a rosy pink, and he discusses the problems of restoration and maintenance. He even explains some of the symbolism inherent in the picture. "Her face, her head, her halo – those three concentric circles echo the Trinity, and the red swaddling clothes foretell the Crucifixion."

He is patient and he answers her questions without condescension, but she goes away vaguely dissatisfied, feeling as if she's just been released from an Art 101 lecture.

She borrows from the library books about fourteenth-century Italian art. Several are literate and lively, and all are full of technical terms and aesthetic speculations that bring her no closer to the nameless *something* that she senses she is lacking.

She returns the books and spends the rest of the summer writing, hoping that the killer's passion for the picture will become clearer as his personality emerges.

She decides to make him an international art dealer. European.

French?

Too bloodless.

Italian then?

Yes. Mature and cultured and a lover of beautiful things. A citizen of the world who moves easily between his gallery in Milan and a smaller satellite gallery in New York. A decent, well-respected man who makes a comfortable living dealing in twentieth-century European art; a warm man, well loved by his friends; a man she herself would enjoy knowing.

"Why would someone like you kill for a Sienese Madonna?" she asks him.

He gazes back at her with intelligent brown eyes and does not answer.

Summer passes, autumn arrives, and she continues to doubt the validity of the motivation she has, by default, given to her character. She goes back to the museum and stands again in front of the picture and is pleased to realize how much she has learned since she first chose it.

Thanks to that young intern and the books she has read, she now has more knowledge – more vocabulary, anyhow – with which to assess the picture. She knows this is the central third of a wooden triptych, she knows that *craquelure* is the technical term for the fine red lines of the *bole* ground that show through the cracked gold leaf around the Virgin, and she can see clearly how the proportions of the figures have been altered to fit the religious requirements of the age. "Hieratic medieval theology wrapped up in a single painting," she can tell herself glibly.

But she's no closer to the essence. Something is still missing and she wonders if she's too far removed in time and temperament. Perhaps she should choose a more accessible work? One of the French Impressionists or maybe an American realist like Copley or Eakins?

And yet . . .

"You ever talk to the curator about that picture?" asks the guard, who has approached unnoticed.

"No."

"I hear he's back from Italy now."

She takes a second look at the man and is dismayed by the changes three short months have made.

He's shrunk even more inside his uniform and his skin is now almost as gray as the Madonna's.

"Fugitive colors," she thinks and doesn't realize she has spoken out loud until he nods.

"Yeah, that's what he called it," he says. "I asked him once how come so many of the faces have that ashy green skin and that's what he said. I forget exactly how it worked – something about how the artists used white for light and put in the shadows with green and then painted over both of them with some pink to make it look like real skin? But the pinks, they didn't hold up good – fugitive colors, that's what he said."

He gazes at the picture with proprietary pride.

"You like it, don't you?" she asks, surprised (and is immediately ashamed of the snobbishness implicit in her surprise).

"Yeah," he says simply. "The real colors may be gone, but you can still imagine how she looked when she was first painted – all pink and red and gold. That's twenty-four-carat gold, you know, and it must've really shined when it was new. And I like it that she's serious. See the way her fingers curl around that little foot, all sweet and tender. She *knows* she's the Mother of God."

His gaunt face echoes the same certainty.

"Sometimes, when nobody's in here, I think about what it must've been like back then, back when it was new and had all its parts. It used to have two little side panels, you know? See where they hinged? They folded down over this one and when it was shut, it must have looked like a plain wood box. I think about a gloomy little stone chapel where the good priest comes to say Mass. He stands the closed box up there on the altar, then he lights all the candles and opens it up and the Queen of Heaven glows like the golden promise of salvation in a world all dark with sin and disease and – "

His bony fingers sketch the glory of his imagination and she wonders if he knows he is dying.

He sees her staring at him and breaks off. "Sorry. I guess I shouldn't be bothering you and you trying to look at the pictures."

She assures him that he isn't bothering her and to encourage him, she says, "It's too bad that the gold leaf has cracked so badly."

"Oh, I don't mind that. It's like one of those pictures you see in medical books, isn't it? Where they show somebody without his skin and you can see like a net of healthy red blood vessels?"

He gazes intently at the delicate red lines that spider-web the gold.

"Blood of Christ," he whispers, almost as if he's forgotten she's there. "Blood of life."

Yes, she thinks. He knows.

And suddenly her book's elusive character stirs within her. For the first time, she who has no faith can feel the depth of his.

And the core of his despair.

"Now you know, too," he tells her.

David Sedaris

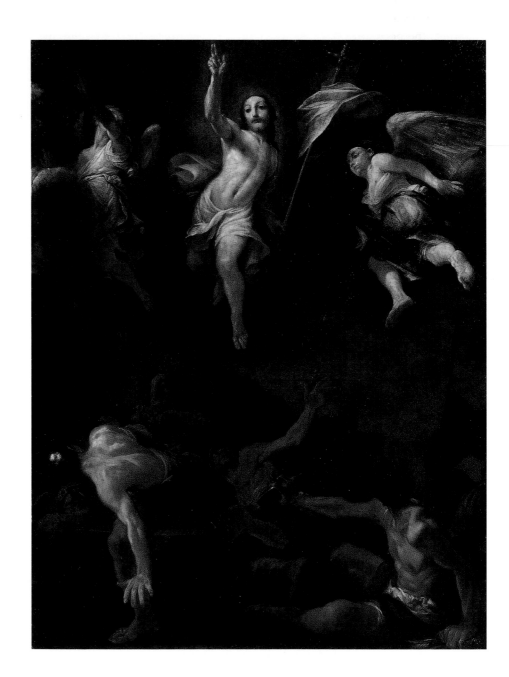

GIUSEPPE MARIA CRESPI
Italian, 1665-1747

The Resurrection of Christ

circa 1690
Oil on canvas
56½ x 40 in. (143.5 x 101.6 cm)
Purchased with funds from the State of
North Carolina 52.9.153

The Resurrection of Christ

EACH YEAR our elementary school class took a field trip to the North Carolina Museum of Art. To prepare us for our visit, the board of education sent us a roving arts ambassador, a trained cultural cheerleader. To our fifth-grade class this person arrived in the form of one Mrs. Kingman. This was a woman who favored floor-length capes and appeared to wear all of her jewelry at the same time. She had about her the air of a middle-aged man masquerading as a woman and having a very good time doing so. Mrs. Kingman claimed to adore the capitals of Europe, "the very idea of the Far East," and the livers of geese mashed into a paste and served upon crackers. We were enchanted.

While the teacher and a handful of parent volunteers would transport us physically, it was Mrs. Kingman's job to prepare us intellectually for the many splendors that awaited us. She shared her enthusiasm and prepared us for the follow-up test with a series of little tricks designed to help us recall pertinent information. She was a joker, a splashy wise guy, setting up her slide projector to deliver a well-oiled comic routine.

"One look at this Italian altarpiece and you'll know the museum practically went *baroque* trying to pay for it," she said. Further along in the carousel she paused to note, "They coulda boughta Rembrandt, but instead they Botticelli!"

No one understood her jokes but we laughed anyway because it seemed the polite thing to do. Through Mrs. Kingman we learned to identify Rubens's *The Holy Family* by telling ourselves the plump, satisfied Christ child was sleeping off the effects of a sandwich.

"A Reuben!" she said. "He's just eaten a Reuben." Noting our blank expressions, she threw up her hands in frustration. "A *Reuben*," she repeated. "Corned beef and sauerkraut on rye? What's wrong with you people? Don't we have any Jews in this classroom? Any New Yorkers?

Oy, this is a tough crowd. All right, just remember that the virgin figure is *sandwiched* between the old lady and the baby."

On the follow-up test I was to identify the artist as Peter Paul Hoagie but the teacher gave me partial credit as I'd at least gotten the first two names right.

The art museum was, at that time, located in downtown Raleigh and had the feel of a vault. It literally smelled of old money: worn bills and barrels full of nickels. The floors groaned beneath our feet and, because it was in such short supply, even the air seemed valuable.

"This is your cultural clubhouse and you're welcome to visit anytime you like," Mrs. Kingman said. "Each of you deserves to surround yourself with beautiful objects. Just don't touch anything or they'll have one of their goons break off your fingers. While we're at it, I advise you not to scream, shove one another down the staircase, or lean against the walls. You can't eat, drink, spit, or sit on the furniture. Other than that, I want you to make yourselves at home."

In a misguided effort to both relax and engage her audience, Mrs. Kingman proceeded to reduce each painting to its most basic elements. *The Adoration of the Shepherds* became, in her words, "five peasants staring at a little boy's *schmeckl*."

Her omission of any religious aspects made the paintings seem fresh and exciting. It was her hope that we might direct our reverence towards the art rather than the subject, but for the students of our fifth-grade class the idea was unthinkable.

"That baby is Jesus," the Castle twins shouted in unison. "And the lady is his mother, Mary."

"I'm well aware who Jesus is," Mrs. Kingman said. "I use his name every time I catch my skirt on the car door. This though, this isn't Jesus. It's a lump of paint. Several lumps really, beautifully arranged upon a canvas." She said it sweetly but the twins reacted as if she were the devil

himself, sent from the fiery furnace of hell to command their souls.

"Look here," she said. Gathering her cape she crossed the room and stood before a painting of several barnyard animals relaxing in a grotto. "Is this a goat?" she asked. We agreed that it was.

"When do they feed it?" she asked. "Do the guards come by late at night with straw or cans or whatever it is that goats eat? Of course not! This is not a goat, it's a *painting* of a goat. There's a big difference between the two, is there not?"

It was a simple enough concept but we found it astonishing. Of course we couldn't bathe in Monet's seascape or shear the sheep huddled in their shallow cave; we understood that those were just pictures. Christ, on the other hand, that was a different story. Surely that was he behind the red-rimmed eyes of his many portraits. The man was invisible, a spirit. He might be hiding anywhere and this seemed to be the perfect place.

"This figure might *look* like Jesus," Mrs. Kingman said, "but nowadays so do a lot of people. You don't see it much down here but visit my son in Greenwich Village and you'll think you've wandered onto the set of *The Ten Commandments*." She stared at a painting of Christ in the Garden of Gethsemane. "Fashion, fashion," she said, "it all comes down to fashion. I don't mind the long hair and the beard and that robe is to die for. What gets me is the bare feet. I prefer something with a heel but, then again, that's just me."

Continuing her tour, she led us to Giuseppe Maria Crespi's *The Resurrection of Christ*, suggesting, in a bad Italian accent, that we recall the artist's name by reminding ourselves that the title character looked a bit crispy around the edges. Indeed he did. I had been spooked by this painting on earlier visits. There was something in this Christ's eyes that suggested that the period between death and rebirth was far from pleasant. Unlike the charismatic saviors pictured in the other versions, this one looked as

though he had truly risen from the dead. He seemed to have passed the point of being tired and arrived at that refried stage one achieves after staying awake all night watching horror movies on TV, his eyes reflecting that instant when the fatigue burns away and one is left feeling he's the only person on earth capable of understanding the terrible truth that the zombies are coming.

Seen as Christ, the picture was grim and frightening. Seen as a painting, I was able, for the first time, to enjoy its freakish beauty. Without the fear of God's judgment I was free to acknowledge the fact that this was one ugly Jesus. The angels fared no better. Neither buoyant nor graceful, they sailed through the air as if tossed by an unseen explosion. The moonlit, waxy skin offset by pale robes, the desperate scramble of the disciples – against all evidence, the painting was stunning.

"I want you to take a good, long look at this Resurrection," Mrs. Kingman said. "Study the central figure carefully because that's the exact way you'll need to hold your hand should you ever need to hail a cab."

The parent volunteers were horrified, as was our teacher. They'd whispered and frowned for the last half-hour but this was the last straw.

"That is not the 'central figure,'" one mother said. "That is Christ resurrected and he is *not* hailing a cab, he is seeking salvation for all mankind."

"Dressed like that I wish him all the luck in the world," Mrs. Kingman said.

By the time I reached the sixth grade Mrs. Kingman had been replaced by a dull, soberly dressed docent who led us through the collections with all the charm of a dental hygienist. Once again the paintings were inseparable from their subjects and the museum visit became an extension of Sunday school. What remained was Mrs. Kingman's message that we deserved to surround ourselves with beauty, that a Reuben was always served on rye bread, and that, when viewed as a lump of paint, The Lord will set you free.

ROBERT MORGAN

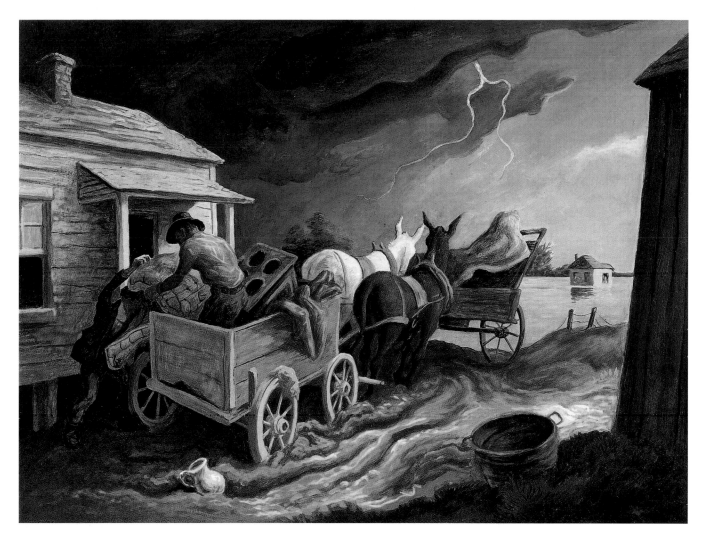

THOMAS HART BENTON

American, 1889-1975

Spring on the Missouri

1945
Oil and tempera on masonite
30¼ x 40¼ in. (76.8 x 102.2 cm)
Purchased with funds from the State of North Carolina 77.1.3

Thomas Hart Benton and the Thresholds of Expression

In 1962 I entered North Carolina State in engineering. I had attended Emory College at Oxford, Georgia, for one year, but since I did not have a high school diploma, State ranked me as a freshman. I was a farm boy from the Blue Ridge Mountains, and Raleigh was the first city I had lived in. I belonged to the generation that had been told to study engineering to "beat the Russians." In the aftermath of the first sputnik the cold war seemed far from won.

My year at N.C. State was perhaps the most intense and wrenching I have lived. It was a threshold year. After a few weeks I saw I was not cut out for engineering. But what options did that leave? I chose applied mathematics, since I had done well at Emory in calculus. I was fascinated by writing, and by film and philosophy, but those did not seem like career options for a boy from a mountain farm.

After my parents left me at N.C. State that first Sunday, I walked around the vast campus. Construction was going on in every corner, with open pits of red dirt, and cranes looming above. I explored the futuristic Harrelson Hall, built to look like a round storage tank with windows. I walked through the textile building studying exhibits of fabrics and mill machinery.

So many things happened at once at N.C. State it is hard to sort them into a sequence. In memory it feels as though I spent almost no time working at physics and math courses. I wasted hours in the bookstore on campus, and at Sembower's bookstore across Hillsborough Street.

I saw almost every movie that came to campus and to theaters nearby. Having never entered a theater until I went away to college, I tried to catch up. At a dusty theater on Glenwood Avenue, I saw *Lolita*. From the opening scene I knew this was something different. I had never heard of Nabokov or Kubrick, but I saw immediately how witty and scary their work was.

N.C. State in those boom years had more concerts and lectures than anyone could attend. There was jazz, and poetry readings. The first poet I ever heard was Howard Nemerov, and his calm, crisp delivery was a revelation. I had not realized poetry could be so natural, so contemporary.

Romulus Linney, the playwright, was artist-in-residence at the student union. He held a workshop every Monday evening, and I attended many sessions and took some of my first stories and sketches to the workshop.

But perhaps the greatest discovery for me was the city of Raleigh itself. Almost every day I walked, to a shopping center, to eat at an obscure diner, or to waste time in a bookstore. I hoofed it down Hillsborough Street to the center of the city. I walked out into the residential sections. I visited the Capitol and the Legislature building. I moseyed through the Museum of Natural History, through used car lots.

But the place I stopped most often, except for the movie theaters, was the Museum of Art, then downtown. Because it had benches to sit on, and because of the variety of exhibits, I never tired of visiting the museum. I was worried and confused about my future, and I walked to burn off the energy of anxiety. There was no better place to rest than the art museum. The dim lights and quiet of the display rooms were reassuring. And there was a sense of tradition and connection to the past. I had never been so close to a Rubens or Van Dyck. I could see the brush marks and the varnish shining over the cracked paint.

The first opening I attended at the museum was a show of the wood carvings of Riemenschneider. They were religious figures and I remember how old the polished wood looked, and how the grain contrasted with the delicate modeling of the figures.

My favorite painting in the museum was the Ruisdael,

Wooded Landscape with Waterfall. Behind the waterfall in the wilderness two figures walk in sunlight near the center of the canvas. I think it was the contrast of the wildness of the water in the foreground with the balance and peacefulness of the trees and the meadow and hills beyond that pleased me. There is such poise and repose in the painting, such authority in the details.

At times I felt an intense homesickness at State. In spite of all the new things I encountered, movies, books, concerts, paintings, the campus was a lonely place in the fall of 1962. I was so preoccupied with my own worries I was hardly aware of the Cuban missile crisis in October. I stood beside Hillsborough Street and told myself that if I turned left and followed the street west I would come to Highway 64, which ran all the way to Henderson County, to home.

But I did well in my math courses. I had a 100 average in calculus. And in the spring of 1963 I wanted to take a more advanced class in differential equations. My adviser conceded I was capable of the work. But I had been admitted to N.C. State with a deficiency in solid geometry. Because I had not made up the deficiency the adviser would not allow me to register for the advanced class.

In that same time slot I signed up for English 222, Creative Writing, with the novelist Guy Owen. I had met Professor Owen in Romulus Linney's workshop in the fall, and I had read his novel *Season of Fear*. The catalogue said students needed permission of the instructor, but I was too shy to seek out Owen and ask him. I attended the first class expecting to be refused.

There were only five other students, and they were older than I was. Professor Owen read us a story by Paul Green and talked about the use of place and local speech in fiction writing. I was pleased he let me stay though I was officially still a freshman.

Every week he sat with us in a circle and talked about writing. He said the coffeehouses and beatnik lofts from Raleigh to San Francisco were filled with talking writers who never got much down on paper. He said he wanted us to be writing writers.

Owen suggested that we keep a notebook and make lists of specific names for things. "Don't mention a tree," he said. "Mention an oak tree or poplar. Better still, mention a white oak or a tulip poplar." He said we should know the calendar of flowers so we could evoke the seasons accurately. But he stressed most that we should listen to speech. He said the sense of life in a story comes from the voices.

The more I wrote for Guy Owen's class the more I realized I could write. I wrote free-verse poems and sketches of landscapes and seasons. I wrote about places in the mountains. I wrote a story about a city kid from Asheville who visits a great-grandmother one Sunday afternoon in a cold house in a hinter cove. I knew I was doing something new and getting some things right: the smell of the boxwoods in the yard, the cats in every nook and corner, the speech of the great-aunt.

Owen brought my story to the class and announced that when he read it he had wept. And then he read it to the class. I looked at my shoes, and I looked out the window, and pretended not to care. But this was a satisfaction beyond any in calculus class.

That spring the campus at State seemed to crackle with vividness. I fell behind in math and physics, but I didn't care. I borrowed my roommate's typewriter and pecked out more sentences, more paragraphs, another story.

I wish the North Carolina Museum of Art had owned Thomas Hart Benton's *Spring on the Missouri* in 1963. In some ways Benton's painting is an equivalent to what I was trying to learn about writing, and I think I would have recognized that. Certainly the sense of place and region, and the use of a particular idiom, would have struck me. The distinctiveness of Benton's style cannot be missed.

He is one of those artists like Van Gogh who are unmistakable even to the uninitiated.

Benton is a narrative painter, and the drama of his painting would have caught my attention. One cannot be untouched by the plight of the family evacuating their home as the flood rises. Another house within sight is already floating away. The two men struggle to save a mattress along with the cookstove already in the wagon.

But the drama of the painting is also in the details, in the bold rhythms of light and shadow, in the looming black cloud and the sunlight in the foreground. Part of the force comes from the strong diagonal thrust running from the jug on the ground and the mattress, to the lightning and the sun implied behind the barn wall. The lightning cracks its whip over the mules' heads.

The tub in the right foreground sits in shadow, but the jug nearby leans away from the force of the sunlight and drama. The back of the man in the wagon is bent with the strain of pulling the mattress, and is beaten by the sunlight, threatened by the whip of the lightning.

Benton is the Sherwood Anderson of American painting, both because he portrays the grotesques of the American landscape and because he is a master of expression. As in Anderson's stories, there is nothing "realistic" about Benton's manner and method. It is all artifice, calling attention to its artifice. But the overall effect is intense. The voice in an Anderson story is urgently made-up and mannered, but it has the effect of heightened experience.

Benton wrenches and distorts almost every detail. His figures are stretched and crooked. His paintings have an urgency and insistence. The exaggerations and repetitions have the effect of semi-abstraction. A paradox of Benton's art is that while the subjects, the narratives, are almost always sad, the style is witty, sometimes even comic. Benton distorts for effect, and he does so with a light touch. It is an unsettling combination of subject and style, and I think that is a part of his appeal, and the source of controversy among critics. There is the air of a tall tale about his style, even though his subject is frustration, defeat, despair.

In my threshold year at N.C. State I learned something about the importance of the local, of the particular and specific. I am still learning how the specific, the exact, even the idiosyncratic, can be the most universal, the most accessible. The art is in the shaping, in the expressive distortion that woos attention toward a sense of intimacy.

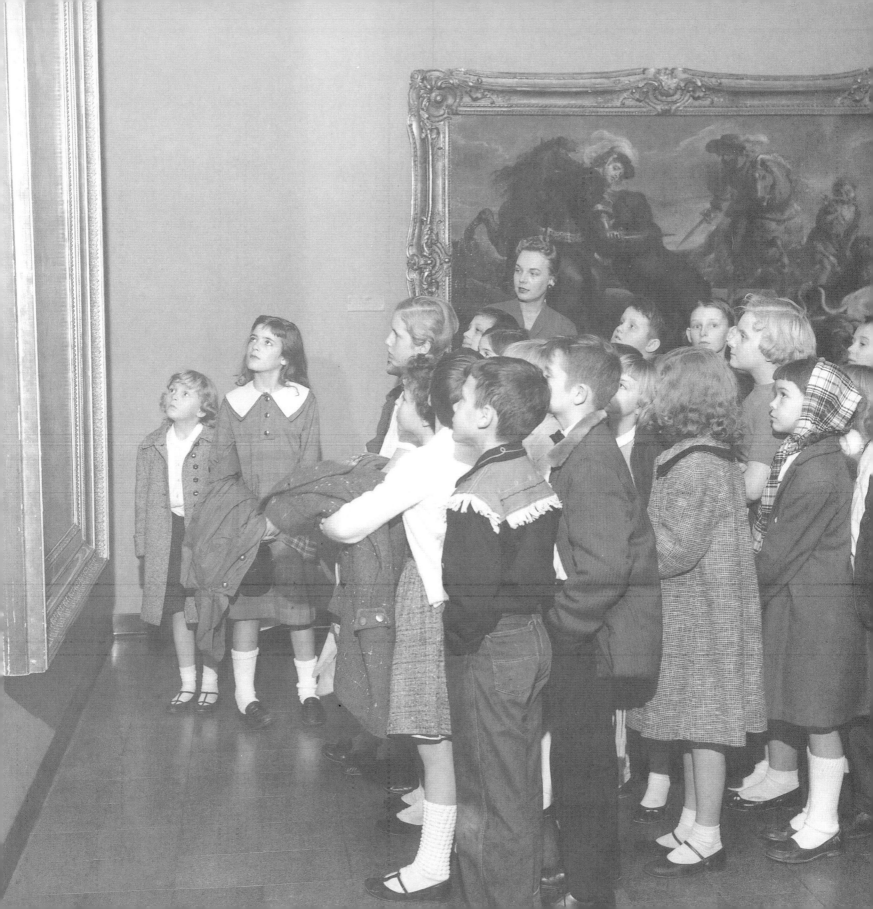

CLYDE EDGERTON

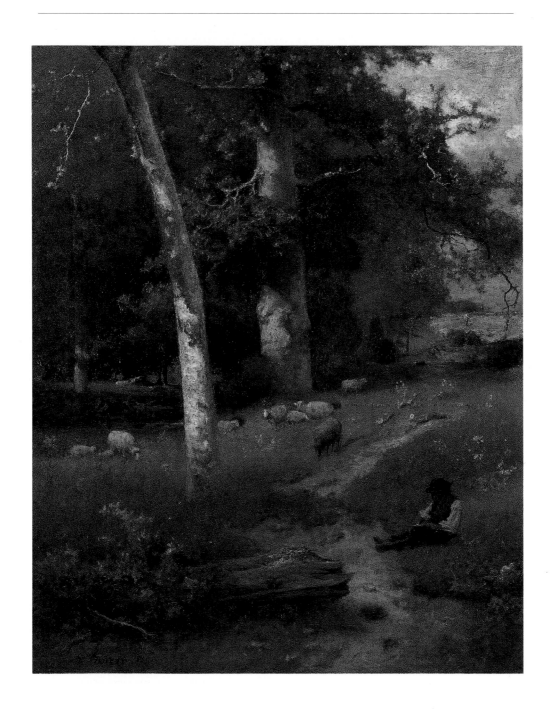

A Response

I

IN MY FIFTH NOVEL, *In Memory of Junior*, I wrote about particular aspects of sunlight:

> I looked from the homeplace front porch across the yard to the jonquils, buttercups, patches of new green grass. It was nice — had my feet propped up on the railing. The sun's rays slanted across the yard, through the trees, burning a kind of gold on the tree bark. In the edge of the woods, a dogwood tree with white petals. The air was fresh. It was all very nice.
>
> I could see that the grass was in the shade and the only sunlight was weak at the top of the trees.
>
> I wanted to ride out to the airfield to show Uncle Grove the airplane. He said he felt okay, so we went. It was cool and clear out there and the sun was in just the tops of the trees.

At the times I wrote these passages I was in command of no "artistic" reason to write about morning or afternoon sunlight on trees. My only reason, and in my view one of the most compelling, was that seeing sunlight in the top of a tree or bright on a tree's bark struck me somehow. That's all the reason I needed to unobtrusively transfer this vision, this picture, to a particular character in the story I was writing.

Time passed, I wrote a western novel — I recall no

GEORGE INNESS

American, 1825-1894

Under the Greenwood

1881

Oil on canvas

36⅛ x 29⅛ in. (91.7 x 74.0 cm)

Purchased with funds from the State of North Carolina 52.9.17

73

sunlight on trees – and have now started on a novel placed in North Carolina, and this time around I find myself writing again about low, slanting sunlight on trees – again not knowing exactly why:

The afternoon sun was lighting up tree bark like it was on fire. He liked that for some reason, made him think about the time he was on that island off the Texas coast and watched the sun go down, his shadow getting longer and longer on the sand down the beach along the surf. When the sun touched the flat horizon, he realized his shadow went down along the beach and then on out into space as far as the light of the sun would ever reach. He waved his hand and figured that the shadow with the waving hand would ride a light wave on out into space and on and on as far away as the stars and then some. All that seemed like something some kind of prehistoric tribe might have thought about. When the sun was up above, your shadow didn't go nowhere hardly.

When I saw and studied *Under the Greenwood* the mystery was partially solved, but also deepened. I now find myself even more attracted to and comforted by sunlight on the bark and in the tops of trees.

Here's what I figured out:

When the sun is above, we might say that its brilliance and power ask us to worship it, bow at its feet, for it is high and mighty and powerful, sometimes oppressive. But low in the sky the sun is much softer, less harsh. It is no longer standing mightily above us, looking down. It is no longer a harsh master; it has become, during the quietest times of the day, *beside* us, begging to be embraced, offering the soft embrace of deep golden, not bright white, sunlight.

Nothing is solved here, but through thinking about *Under the Greenwood*, I have created a metaphor telling me that besides standing above, the sun rests beside me – that the sun's brief, comfortable resting time is predictable, not haphazard.

Sometimes as often as twice a day this old universe schemes to help me feel quiet and safe.

II

We don't see, or photograph, or paint objects
– only light reflected from objects.
Outdoor light is
the sun – bright white,
off the moon – faint silver,
and indoors we are able to look
directly into earthly fire
without losing vision, uniting
comfortably with all them rusty ancestors.
And the color for home is green.

III

Standing twenty feet in front of the painting, we see that the green pulls us home, to safety. There is a depth of safety, of dark woods behind – and shade under – the two strong trees. The sun on the trees contrasts with and deepens the womb of deep green. The boy is safe and the sheep are safe. His job requires no great effort.

Then we move closer to the painting, to about five feet out, and before us is something new – another painting. The log in the foreground seems suddenly afire, a home fire not apparent from a distance. Our eyes follow the path. It leads, and pulls the eye, far beyond the boy to

an unshaded field where a man, alone, works. Beyond him – is that someone on horseback? Near smoke?

Does the future not bring safety? Framing the future – the field and the image in it – is the only dead limb in the painting, a limb that seems to reach down for the boy. If the dead limb were lightning, it would strike him.

Time, or lack of time – the boy's age – has protected him, kept him from what is to come. The safety of home and youth is green. The light in the field seems merciless, and on very close inspection we see that the smoke behind the horseman (Is it smoke? Is it a horseman?) is of a hue nowhere else present in the painting, just as there is no dead limb except above the boy and around the man.

We all play with time, with darkness, with light.

Kathryn Stripling Byer

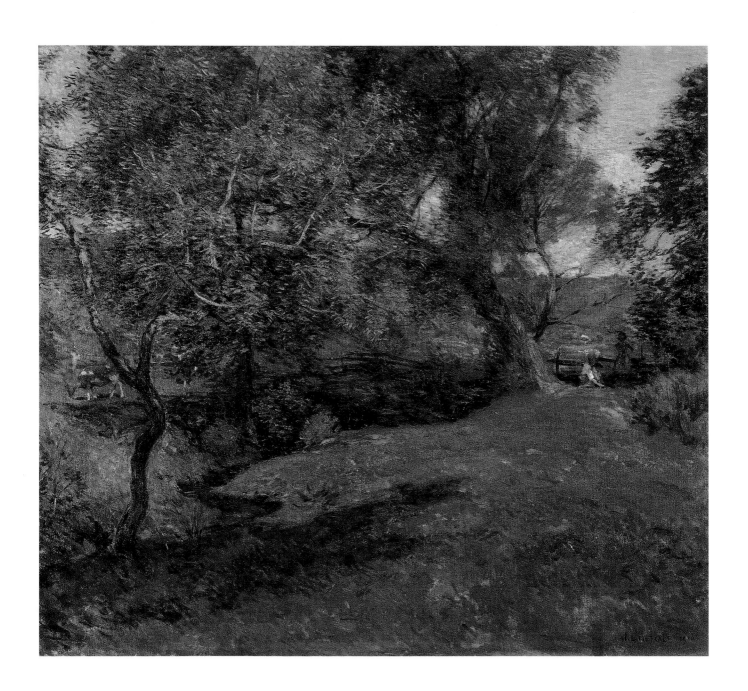

June Pastoral

Long before I could read Lorca,
I wanted to give myself over to green
as he had and be lost like a sleepwalker
in it. I wanted to hide in the honeysuckle

and never come home if it meant I must stay
by the telephone, waiting for someone
to call with the doctor's pronouncement,
my mother then turning to us to say
over and over again in my memory, *Gone*.
Such a word I would never repeat
to the oaks that held sway round my favorite pasture,
or blackberry bushes I dreamed would stay
unscythed by road crews sent forth to claim
right of way. *Verde que te quiero verde*,
I'd gladly have cried if I could,
but where are such beautiful words

when we need them? And what if that's all
this poem means now I'm middle-aged: words
as a way to want green back again
and myself in the throes of it,
even though I've learned enough about Lorca
at last to be quite sure that no *verde*
anywhere spending its June on this earth
could have out-stayed for one blessed
second what waits at the end

of the line, always
some bloodless voice
trying hard to sound human across so much
distance, its words still escaping me.

WILLARD LEROY METCALF

American, 1858-1925

June Pastoral

1910
Oil on canvas
26⅛ x 29 in. (66.4 x 73.7 cm)
Gift of Charles M. Reeves, Jr. and Family in honor of Mrs. Charles M.
Reeves, Jr. 78.23.1

TIM McLAURIN

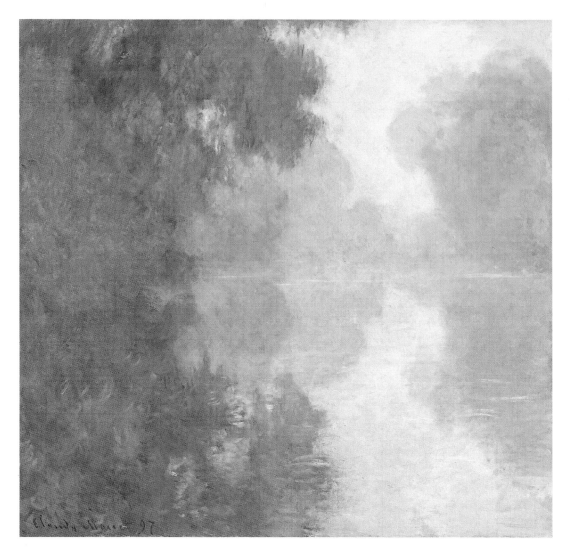

CLAUDE MONET

French, 1840-1926

The Seine at Giverny, Morning Mists

1897
Oil on canvas
35 × 36 in. (88.9 × 91.4 cm)
Purchased with funds from the Sarah Graham Kenan Foundation and the North
Carolina Art Society (Robert F. Phifer Bequest) 75.24.1

Bridges of Water

Dedicated to my children, Meghan and Christopher

LIKE THE WORLD set upside down, the moon's laughing face is upon the lake. Above, the heavens are spangled with threads of morn like a great pond rippled by the breeze. The sun is still below the tree line, and the world is cool and muted with fog like the remembrance of a good dream.

The kids are still sleeping. Nestled inside their down bags, their breath is slow. I watch them from where I stand beside the water, as I have watched them since they were infants. I recall how when they were very young and deep within silent folds of sleep, I would touch a foot or a hand, needing to see that flicker of movement that reassured me they were breathing. A father thing, but they are of my blood and bone, and will still be kids to me long after they are grown. They grew up so fast. Meghan is twelve now and Christopher nine, and these brief years seem to have flown by in a brilliant whirlwind of Christmas mornings and bouts of croup, birthdays and sick days, coloring books and good-night hugs.

This cup of instant coffee I am drinking is hot and good. In a cast-iron skillet, sausage is slowly frying. The smell is salty and fragrant and blends well with the fish odor of the water where bream are bedding in the shallows. I have a box of instant pancake mix – add a little water and, presto, hot griddle cakes that are remarkably good lathered with butter and cane syrup. Christopher has gotten to where he likes a little coffee now in the mornings, but I dilute it about half with milk.

Fish are surface feeding, a sudden little "puck" sound, then circles of water ribbons spread outward where some hungry perch or bass has sucked down a dragonfly. The gathering sun is adding texture to the sky, high cirrus clouds catching the light and mirroring the rippled lake below. The foggy morning reminds me of how when I

daydream, the surrounding world loses focus and becomes a pastel print of colors that are softened and fuzzy around the edges. But as a man of forty-two, I know well that the world is made of sharp contrasts and definitions, choices that have to be made, decisions and commitments adhered to or sometimes altered.

The sausage is browning around the edges; I've made a second cup of coffee, stirring the sugar with a twig from a willow tree. I'm reluctant to wake the children. I don't rouse them each morning now as I did most of their lives. The divorce was final a couple of months ago, another pledge once thought eternal now stored in the ashes of what has been.

Meghan's long blond hair covers half of her face. She has changed so much in the past year, the slender child I once read bedtime stories to, now possessing the body of a young woman. She attends school dances, likes boys and wears a trace of makeup. I rarely can talk her into wearing a dress. But she has not gotten so grown-up that she won't sit in my lap, or hug me and say she loves me when I am leaving. I am as quick to respond. My own father was dying from lung cancer, I a grown man, before we were able to speak those words.

Christopher is on his back, the soft wind of sleep whistling through his nose. He's tall for his age, a southpaw, slightly clumsy with a trace of baby fat. Like his sister, he has my brown eyes, his mother's nose. His birthday is a month away. He loves to fish, but is only now starting to bait his hook. He is the fire master of the camp, taking great delight in starting a blaze from scraps of paper and twigs, which by bedtime is a heap of embers. Like I did as a boy, he'll spend an hour poking the flames with a hickory stick, igniting the end and blowing it out and firing it again until all that is left is a nub. A wonderful change of focus from TV sitcoms or CD-ROM. Last night when an owl screeched near the tent, he jumped upon my lap, then a minute later was piling more wood upon the fire.

My canoe is pulled half on shore, the bow tied with a

length of rope to a sapling. This is the first year I have allowed the kids to take the canoe out by themselves. They are both good swimmers, and the rules are to wear a life vest at all times and not to paddle out of sight.

Yesterday afternoon, Meghan and I took the canoe out, following the shoreline for about a mile. An adult bald eagle swooped skyward from a treetop, a flash of black and white against the cloud-dappled sky. Meghan wears braces now. When she was younger, I used to tease her that braces attracted lightning, but I do not joke like that now. She is at that age when the flowing hormones stoke fears that are often irrational, but seem real. On nights when she is at my house, she often asks that I stay up until she is sleeping, fearful of lying awake in a silent house. I sit vigil in my reclining chair in the next room, scanning the newspaper again, although usually she is in dreamland within minutes of her head touching the pillow. At a similar age, I once feared that when I went to sleep, I ceased to exist, a beginning awareness of death. I would lie on my back, eyes wide open to the dark ceiling, until I surrendered to fatigue and opened my eyes again, reborn to the clean light of morning.

She steered the canoe sitting in back, me doing the power rowing from the front. At first we zigzagged across the water, but by the return passage she had learned to sight on a tree or point of land and keep us true to course. So strange it seemed to me, a bit frightening and wonderful at the same time, to realize that the toddler in frilly dresses was no more, grown into this lithe woman-child, our destination this moment in her hands.

The sun is like fire in the trees. The mist still hugs the lake and shoreline, but will burn away soon. The mirror will lift and the water will become slate gray beneath the overpowering flames of heaven. Across the lake where the tree line narrows to a V, I can barely see the bridge, a muted arc nearly indistinguishable from the curtain of water and shore. I hear no cars crossing because it is the Sabbath. But by midmorning, the bridge will stand out like a steel thorn in Mother Nature's palm, a crossover from the primal world of waters to where man has cut trees to build his homes.

The sausage is nearly cooked. When it's done, I'll wipe the grease from the pan with a paper towel and cut the heat down on the propane stove. I'll wake the kids before putting on the pancakes. They should be eaten hot from the griddle. I notice a bone lying in the sand at the water's edge.

Last night I cooked spareribs on a grate above a wood fire. The odor had begun to leak from the meat and fat, dusk was descending, when I noticed Christopher was still out in the canoe.

"Meghan, call your brother in," I said to her, as she sat at the picnic table reading. She walked down to the water and called his name, turning her head as she scanned the shore.

"I don't see him, Dad."

"He's right out there," I replied, leaning over the grate while flipping ribs. "Call him again."

Her call was clear upon the smooth waters, reverberating from the far shoreline. I turned from the fire and noticed that the lake was deep in twilight, darkness only minutes away. I stood beside my daughter, and lifted my voice to the sky, heard my sound return to silence. Meghan turned her face to me, her large, dark eyes wide with worry.

"Call him again, Dad."

I bellowed that time, surely a cry that could be heard a half mile away. No sight of a canoe along the exposed shoreline where he was instructed to paddle, I felt a flicker of fear in my belly. Meghan continued to stare at me, her young forehead furrowed like someone much older. She was only six when she witnessed me undergo a bone marrow transplant that cured me of cancer, but

that memory in some ways has aged her beyond her years.

"He's fine," I told her. "Probably heading in right now."

"I'm worried, Dad."

"He'll be here any second," I reassured her.

I was praying at that time. I knew my fears were mostly unfounded. A boy on a small lake wearing a life vest does not easily drown. But I lifted up my plea, as my own mother had done countless times on summer afternoons when I had wandered out of sight. I felt more in communion there by the lake since my God lives in the trees, water and wind, not the wood and brick structures I visited as a child.

A full, long minute had passed when the bow of the canoe slipped past a distant point of land where he was forbidden to go, the boy paddling with long, sure strokes. He pulled on the port side and swung the craft along the shoreline toward us.

"That's him," I said, exhaling at the same time. "He was only out of sight."

"You should fuss at him," Meghan said, leaning against me. "He knew he was not supposed to go there."

I pulled her to me and watched as Christopher came toward us, switching the paddle from side to side, then thrusting deep when he was nearly upon the shore to slide the bow several feet on the sand.

"Boy, you're a little bit late, aren't you?" I said, trying to control the anger I felt. "We were getting worried."

"I was scared, Christopher," Meghan said, her voice full of emotion. "You know you're not supposed to go out of sight."

He stood in the canoe and stepped into the shallow water. "Dad, you should have seen it. The moon is rising over the water, and it's big as a basketball."

His face reminded me of the moon, luminous and golden and smiling. He had followed his eye for the first time to a point where I could not see him, lured by the wonder of life and the draw of a vessel in his control.

"We were getting worried about you," I said softly.

"I wish you were there, Dad. I never saw the moon look like that."

He was before me then, and I clasped his shoulders and kissed his salty forehead. "Come on. Supper is about ready."

"You bubblehead," Meghan scolded. "I was worried about you."

I scoop the sausage patties onto a paper plate. I should awaken them, but still I tarry, looking once more toward the curve of the bridge. The structure is more evident now, the fog steadily lifting and forcing the earth into real time. Life passes quickly; I have made vows and broken some, and my children now hold the steering oars and seek the moon. Yet I hold faith of promise.

At the door to the tent I call their names.

ROMULUS LINNEY

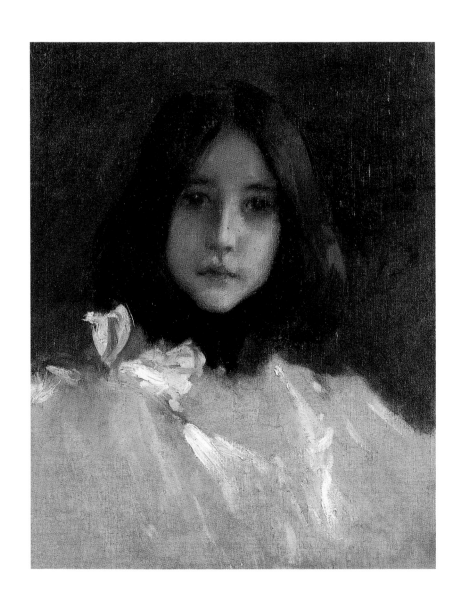

To an Artist's Daughter

Not just a model
She stares at her father
Through his fierce art
And her fierce pain.

Let me go, let me go!
While he:
This is you, as you are!
Neither is right.

He thinks he is not painting
His love for her,
But her, his seeing,
And he is wrong.
She thinks he is painting her mute,
He wants to imprison her there,
His art her cage,
And she is wrong as well.

The portrait is right.
Both must wait for it,
Honest and painful,
To be finished,
To hang on a wall,
To be recognized,
By other fathers
And other daughters,
Whose understanding
Will set them free.

WILLIAM MERRITT CHASE

American, 1849-1916

The Artist's Daughter, Alice

circa 1899
Oil on canvas
19¼ x 15⅛ in. (48.9 x 38.5 cm)
Gift of the North Carolina Art Society (Robert F. Phifer
Bequest) 28.2.7

Elizabeth Spencer

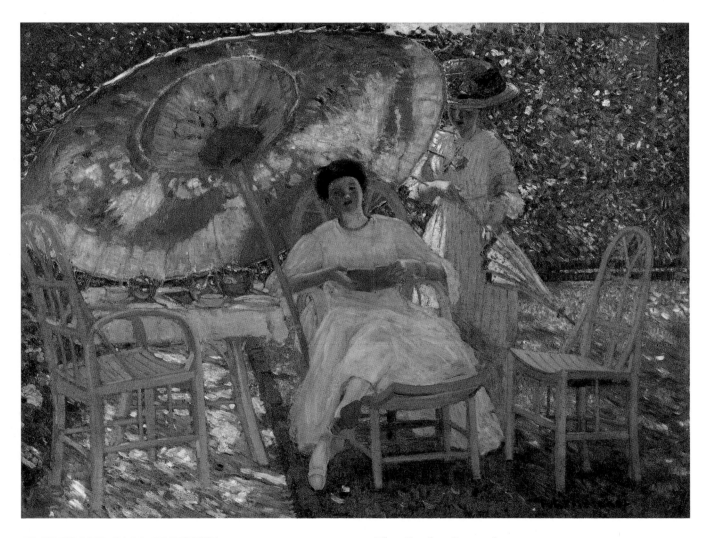

FREDERICK CARL FRIESEKE

American, 1874-1939

The Garden Parasol

1910
Oil on canvas
57 x 76 ⅝ in. (144.8 x 194.6 cm)
Purchased with funds from the State of North Carolina 73.1.4

Summer Days at Giverny

THE PAINTER of *The Garden Parasol*, a picture that blazes out at the visitor on even the most casual walk through the North Carolina Museum of Art, was Frederick Carl Frieseke.

Frieseke was born in Owosso, Michigan, in 1874, but lived most of his life in France. Looking at his face in a self-portrait, one is arrested by the fixity of the gaze. Eyes looking that steadily at anything are bound to be convinced of what they see; and so it was with this artist, whose name was unfamiliar to me, but whose painting with its flaming colors and tranquilly alluring women drew me to wonder about him.

"American Impressionist," so the record says. The Impressionist part is immediately clear, but the question of where from is at first uncertain.

Growing up in a country town in the thirties and forties, I first knew about art from reproductions of the "old masters." But when it came to "modern art," as we called it, it was the Impressionists who came to mind. They had crossed to us so easily: Monet, Manet and Renoir. Also we would have added Degas, Cézanne and Van Gogh, not knowing they were not of the strict Impressionist stamp. For all were French, or painting there, and France to us in those youthful days was the place of modern art, just as Italy and Holland meant the classical stuff.

So it is interesting that I could not tell in the Frieseke picture whether not only the painter but also the scene was American or French. It was open air, and Americans like that, a sense of freedom. It was sunlit, and we like that too. In addition, everything – from the gorgeous parasol spread wide to the open book, the relaxed posture of the seated lady who holds it, the tea set on the little garden table – speaks of generosity. "Come on out," she seems about to say. "Join us." There are two empty chairs. The flowering border behind might well be in New England, the thick foliage a shady backdrop for a delightful summer day. But let it then join the French and their kind of pleinairist painting, beckoning to us on happy afternoons: "*Bienvenue! Vous aussi pouvez venir!*"

So do they speak to us still. What could be finer than joining the Sunday crowd in a Renoir outing, strolling behind the scenes while Degas dancers are strapping on their slippers? No one would say you had to be a saint or a Greek nymph to enter these precincts. In Manet's *Le déjeuner sur l'herbe* you can come as you are, not wearing a stitch. Just being human is enough. Among the *refusés* we are happy to discover we have wound up in the right place: we are one of them, and they are one of us. It feels comfortable to be there.

The welcome that Paris extends to the stranger is a chemistry that is magical, irreplaceable, unforgettable. And so it must have seemed to the eager painters who flocked there from the States around the turn of the last century. Whistler was already very much his own master in Europe when the stocky boy from Owosso, Michigan, fresh from study in Chicago and New York, arrived in 1898. His father had financed the trip with a gift of five hundred dollars.

Frieseke studied with Whistler in Paris only about a week. But the impression Whistler's art had already made seems to have started him off on a good track. His early pictures show groupings of dark figures in interior scenes, easy but thoughtful, a meditative approach.

Beyond Parisian interiors, the French countryside lay all around, ready to model and pose. Paul Gauguin was working at Pont-Aven in Brittany and Claude Monet himself was at a little town up the Seine from Paris, easily accessible, called Giverny. Frieseke began to go there from Paris to spend his summers. So started the connection with gardens and flowers, the outdoor scene, a setting for those marvelous-looking women who were to be his main subject.

"Impressionism" means just what it says and he took it literally – to communicate in a picture the impression

made by what is seen. The process has nothing to do with intellect, Frieseke declared, but only with feeling.

In 1905 he married an art student in Paris, Miss Sarah Ann O'Bryan from Philadelphia. They then moved to a house in Giverny.

Sarah Ann seems to have been quite a find. She ran the household, kept the accounts, planned the garden, and when autos came in, she even drove the car, since Frieseke, if he saw anything attractive along the way, would leave the road and drive right toward it.

The house backed up on the River Epte, which Claude Monet, right over the fence, had diverted to flow by his garden. He was there the whole time, painting his water lilies.

Meantime, not bothering about the neighbors, Sarah Ann planted her garden, and so began the blaze of flowers and blooming trees, with the river flowing behind, ready for posing her husband's models any and everywhere, ready also at the drop of a hat to pose for him herself. He set the girls down inside or outside, anywhere he fancied. They all looked like Sarah Ann. He called her "my lady."

His work was going like crazy. One exhibition followed another, and prizes piled up by the hatful. Frieseke *was* the big American Impressionist. There were others, of course, who tripped around France, set up their easels, had memorable times easy to write up in the memoirs of later years. But the boy from Owosso seemed to be distancing everybody. St. Louis and Luxembourg, Munich and Pittsburgh, Washington, Odessa and Venice. He was the figure to watch. French, German and Italian critics discussed him with enthusiasm.

His fame went buzzing about the States. He insisted he had never entirely left home. He came back to paint hotel murals, but never returned to live. He claimed he was not an expatriate. It was only, he said, that in America he would have "to make noises like an artist." It was also, he said, that America was puritanical. Any place he moved would be shocked at his nude women.

He might get run out of town.

Even with models in flounced dresses, his awareness of the bodies beneath is all plainly evident. The lounging woman in *The Garden Parasol* wears a clinging dress and seems about to kick off her shoe. He painted his ladies in their Japanese kimonos, mending their lacy French negligées, cooing to their *perroquets*, riding in boats that float along the little River Epte, climbing up a stepladder to pick apples, putting up their hair, mending their petticoats, lying nude in sunlight, reading in windows, trying on hats.

"It is sunshine, flowers in sunshine, girls in sunshine, the nude in sunshine. . . . If I could only reproduce it exactly as I see it I would be satisfied."

He said this in 1914, at the height of his fame, in the garden at Giverny. Other American artists were there at Giverny before he came and others worked there also at the same time. But his was the reputation that climbed to the top.

As for Giverny itself, it seems that Monet had started its vogue as a mecca for painters. Who but he had begun by painting the Seine at dawn (and in every other kind of light)? Who had coaxed the tiny Epte to flow past his garden? For him light alone in those days seemed subject enough. I recall no nymphs among the water lilies.

In the early days of his residence there, Monet might be seen dining at the local hotel with Cézanne, who would have come for a visit. One might run into Renoir, Pissarro, Rodin or Sisley while strolling down the street. At first Monet was welcoming to visiting painters who arrived, but with so many Americans pouring in, he began to sulk about it, stayed away from the hotel and became almost a recluse.

But one version has it that Giverny was discovered by some American artists who didn't even know that Claude Monet lived there. They described seeing a little village of white houses and a Norman church at the foot

of a fairly high plateau, seen through the poplars bordering the Seine and across perfectly flat fields. They sped past on the train but enchantment had beckoned. Nothing could keep them from moving in. Once they settled, word got around the ateliers of Paris, only fifty miles away, and others came flocking.

By 1890 Giverny was "in." There are many names we no longer remember, but we can be sure they all had a great time. Many were women painters, "paintesses," they were called. The local hotel owner expanded, built studios, added wings. There was already the dining room (where the innkeeper's wife tried her hand at Boston baked beans), then a billiard room and finally even tennis courts. On the terraces at twilight Americans chattered in English. Artists obligingly painted murals on the hotel walls. The memoirs of those glowing years are gentlemanly to the core. Who can know what frisky adventures they kept to themselves?

One little episode is told. A Presbyterian minister from Virginia stopped by to call on one of the resident painters. He bore a proper letter of introduction from the painter's maiden aunt. When he rang the bell, a nude girl answered the door. She was just one of the many models engaged to come there from Paris. The shrieks that went up *partout* must have amazed her. Her mistress dismissed her, sent her packing. It hardly seems fair. One can imagine the girl's story when she got back to Paris. "*Quelle bêtise! C'est ridicule!*" One can also imagine what the minister told his wife, and what she said back home.

There is a singular picture of Frieseke at work. (It is now privately owned by the Frieseke family.) We see him in the garden painting a nude girl who is sitting on his right. The picture of the painter painting a picture was painted by Karl Anderson, a painter himself, and the older brother of the writer Sherwood Anderson. He must have stopped by to visit and been welcome. Those were the days.

Frieseke claimed not to have been especially interested in Monet or his art. This strikes an odd note. How could one live next door to a great name of the period and not feel the pull of his method, or experience that opposite force, rebellion against it? But each seemed to go his own way.

Another odd note: it was in his garden in 1914 that Frieseke spoke to an interviewer so feelingly of his aims, his code of painting, the beauty he strove to discover. Was he not aware of what year it was, that Europe was a tinderbox, that gardens and a small household would soon appear of little importance to the world? Amazingly, he was not. He said that he seldom read the papers and knew nothing of politics. He was not interested, he said, in what went on in the world. He stayed throughout the war in Paris.

After the war, he did not return to Giverny. He moved further into Normandy instead, and troubles waited for him. In Paris the art world was in a ferment. Post-Impressionism had already struck and already, too, Cubism was taking hold. In the restless postwar years in Paris, a dozen other movements were pushing in. In America a hard realism was breaking through in the canvases of Bellows and Hopper. Frieseke's pictures began to seem dated. He was said to dislike the new trends.

Every artist goes through a peak period, then seems either to change or decline. The point is to leave something lasting. So one has to think of the sunny days at Giverny that *The Garden Parasol* reveals. Every successful picture captures a moment and holds it still for us forever. That is just what this one does. It captures, in addition, a happy moment, a welcoming moment. "Come join us," it seems to be saying. "Pull up a chair. Have some tea. Make yourself at home."

They might have been saying that in Owosso, Michigan, too, but it wouldn't have been the same.

R. S. GWYNN

FREDERICK CARL FRIESEKE

The Garden Parasol

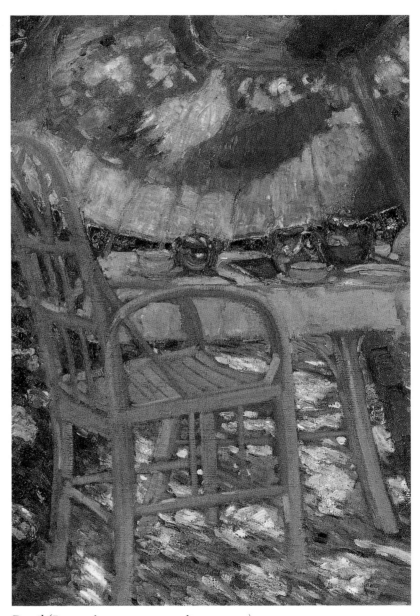

Detail *(For complete image, see preceding response.)*

The Garden Parasol

She's listening. Make her eyes stray from the book
To focus vaguely on that empty chair
Where someone sat for tea. Give her a look
Reserved for unframed distance where
His car is raising dust. Let her mind
Be elsewhere, but let it resemble ours,
Searching for mysteries we'd like to find
Where sunlight idly plays among the flowers.

And that bright parasol? A thought-balloon
Where gaudy birds of paradise parade,
Or just another airy prop for one
Who'll soon enough descend through afternoon
And afternoon to evenings where the shade
Holds nothing that can comprehend the sun.

ANGELA DAVIS-GARDNER

EUGENE BERMAN

American, born Russia, 1899–1972

Sunset (Medusa)

1945
Oil on canvas
57 ⅝ × 45 in. (146.4 × 114.3 cm)
Gift of the North Carolina Art
Society (Robert F. Phifer Bequest) in honor
of Beth Cummings Paschal 74.8.2

90

Medusa

. . . not only the dreamer but [his] own dream of the dreamer and of the dreamer's dream.

— Eugene Berman

MEDUSA'S LOST her looks, her snaky locks, her power to petrify. Oh, the men she's turned to stone. But worse, she's lost her lover, tricky Perseus, the way he slayed her over and over, fixing her reflection in his shining shield, holding her there transfixed, then slicing off her head with Ah, such *délicatesse*, such passion that from the union of her neck, his blade, sprang Pegasus, that spurt of blood, poetry, ease, and all was right with the world. She was not such a bad girl, after all.

That wig flaming in the sunset belongs to Medusa's model, the painter's wife, actress Ona Munson, who wore this same red headdress as the whore Belle Watling in *Gone With the Wind*. She's worn out with this role, nothing to do but drape her aching arms and shoulders over a stool, to be transformed, he's said – if ever he gets on with it – into a floating prie-dieu of coral. "Look tragic," he's directed her a dozen times, as if a false head of hair could have expression. She lifts her head, tilts it back, eyes closed. "How about this?" she says.

"No, no – it's the drama of the hidden face. Just five more minutes, darling, then we'll have borscht and sweetness after."

Sighing, she lowers her head. If only she could sleep. He's back to his hemming and hawing, the endless foreplay of mixing paint, the scraping of palette, the tinkle of brush stem against that glass he won't let her wash.

Finally he goes still. She can feel the stroke of his eyes upon her neck, white, virginal, compliant; no Watling she, nor Scarlett, but a martyr to art, and to love.

The wig will be challenge enough, artifice insouciantly rendered, and at the center a black jaggedness, a crevice in the skull through which erupts around her Medusa's dream. It's that dream, no dream but the world, which holds him paralyzed. How to put on canvas a world blasted all to hell, and instead of serpents curling around a Gorgon's neck, the hiss of gas through shower nozzles. Perseus had it easy. And Botticelli, nothing to paint but Madonnas and gauzy draperies, chaste wenches emerging from the sea.

This Medusa's hands will be fluid as those of any Venus, her large toe a tender morsel. In the flow of that drapery he'll trace a scallop of lines, like tide marks on a blackened beach.

Frozen in his inner eye it all comes clear: the pocked, oozing wall, the egg-shaped peephole framing a pale moon, a round tarnished shield sharp-edged as a guillotine that hangs off center, cruelly mis-poised, above the yearning neck of Hydromedusa, star of the sea, his ice maiden muse.

Behind him he can feel the light going. His figure casts an ambiguous shadow onto his grieving Medusa and the dusty floor. He shifts his eyes, stares at the blank white rectangle on the easel.

"Hurry," she murmurs, "I'm getting tired."

He hefts his palette and with one long slash of brush against canvas, begins.

DORIS BETTS

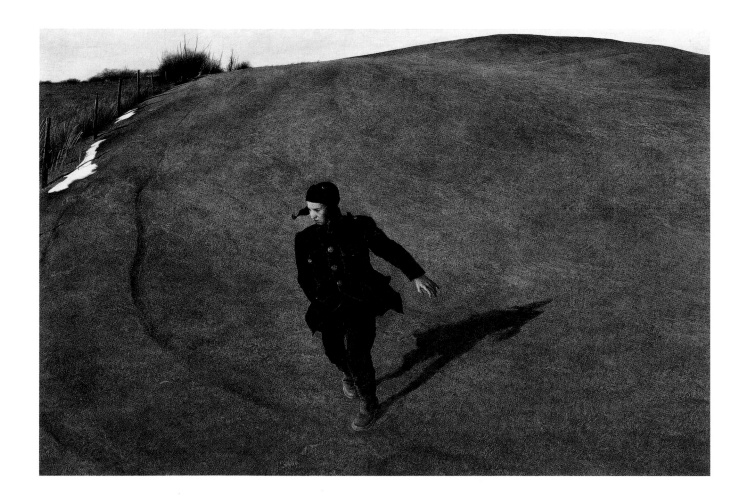

The Goal of a Realist

ALL THE TIME I was growing up in Statesville, I never went to an art museum. There was none; the weekly art teacher in public schools contented herself with the color wheel and the hope of proportionate good likenesses.

What hung in my own home were not paintings but illustrations: Columbus's three ships, that wolf howling on a snowy hill above a lamplit house, the big dog that has just pulled a drowning child ashore, a sepia Victorian lady removing love letters from a hollow tree, and a pinkish Gentile Jesus carrying the lamb ahead of His obedient flock. Even better than these, I liked the Doré Bible engravings, especially of David holding aloft the curly head of Goliath and Jehu's companions finding what little the street dogs had failed to devour of the corpse of Jezebel.

Count me in the multitude of those southern writers whose childhood spent with the King James Bible taught that ordinary concrete objects could take on timeless meanings.

Realism — in art or fiction — is not mere illustration, not just a copying of flower and barn and face. In fact, the artist's attempt to change the eccentric into the general, into how things "ought" to look or how stories "should" turn out, is the death of art, as Hallmark cards and cute garden gnomes and sentimental pastel bird/cat friends on stationery demonstrate.

Those of us who had it dinned into us at Sunday school that this everyday world was good enough for Jesus to spend thirty-three years in will probably never respond properly to Abstract Expressionism. In our storytelling as well as in the paintings we hang on our walls, we still join with Wordsworth in awe at "the very world, which is the world / Of all of us, — the place where, in the end / We find our happiness, or not at all!"

What hangs in the Betts living room now is a reproduction of Andrew Wyeth's *Evening at Kuerners* (drybrush

ANDREW WYETH

American, born 1917

Winter 1946

1946
Tempera on board
31 ⅜ x 48 in. (79.6 x 121.9 cm)
Purchased with funds from the State of North Carolina 72.1.1

93

watercolor, 1979), its loneliness relieved by the one lighted window and the muddy earliest hints of spring thaw. I know I should admire its composition, analyze the elements of light and dark, the artist's technique – and Heaven knows I'm delighted when a reader understands why a certain verb in a particular sentence is exactly the very best choice – but my readers and I are not specialists, just people moved by the wedding of eye and ear, word and image, glad to pass through the surface of a painting to the story behind it, then back again to see if art exceeds its sources. "Beauty is not so plentiful," wrote Willa Cather, "that we can afford to object to stepping back a dozen paces to catch it."

Many who are experts in the art world no longer step back to appreciate Wyeth's out-of-fashion canvases, dismissing him as an illustrator who persists in photographic realism long after the camera has made such paintings obsolete. His silent, melancholy work sometimes seems the visual counterpart of lines from Thoreau and Frost. Critics groan when barbarians pick as their favorite painting *Christina's World*, knowing these uninitiated only like "the story" it seems to tell; and I sometimes groan myself when teenagers prefer Sylvia Plath's poetry primarily because she killed herself, and thus reveal an appetite more for literary necrophilia than anything else. I want them to look at the language of many poets. There's death enough to read about. Be at the bedside of. Be on the pillow oneself.

Yet Plath's poems and the others' and Wyeth's lonesome people and places also connect with an answer Surrealists used to give in the thirties when asked, "What does that picture represent?" They would answer, "The person who did it."

This painting, *Winter 1946*, is realistic in the world it depicts but also in its representation of young Wyeth at the time.

N. C. Wyeth and his wife produced three painters, a musician, and an engineer, with Andrew the youngest.

He and his sisters and brother grew up in the Maine and Pennsylvania he was to paint. Harriette painted their famous father sometime in 1937, but Andrew never did, and he regretted that. From childhood he had developed his skills under tutelage in his father's studio, but in 1945 he called himself "just a clever watercolorist – lots of swish and swash." That year, just on the other side of the hill in this painting, N. C. Wyeth's car was struck at a railroad crossing and he was killed.

I was in eighth grade then and had barely moved up from reading Nancy Drew to rereading *Forever Amber* and was also beginning to notice that some of Doré's angels ascending and descending for Jacob had irritable faces. Andrew Wyeth was twenty-eight.

The "realistic" background is that in 1946 a Lynch family with nineteen children lived in a house on the edge of the woods, and one day Wyeth, then twenty-nine, saw Allan Lynch running down the hill toward him. In this, his first tempera (dry pigment mixed with distilled water and egg yolk) after his father's death, he wanted to prove "that what he had started in me was not in vain."

First he painted the boy at a distance, tiny, but the hill finally "became a portrait" of his father. He spent the whole winter working on this particular painting until the bulge of the hill seemed to be "breathing – rising and falling – almost as if my father was underneath." He moved the boy forward, made him darker, dressed him in an old World War II uniform (*his* father's?), made his headlong run almost a tumble downhill, out of control, gave him a pursuing shadow, pocketed one hand, flung out the other. At the time Wyeth was feeling "disconnected from everything," and the Lynch boy became "me, at a loss," on the downside of a gigantic grave.

Wyeth has quoted his friend the pianist Rudolf Serkin, who said he didn't think of "striking" the keys, but of "pulling" them with the fingers. Wyeth has said he tries to "pull" a mood from a painting rather than trying to strike or force something into it; and while some have

seen the boy's race downhill as joyful, they must not have looked at his mouth.

Wyeth has also said he wants his work not to be melancholy so much as thoughtful, that he does not wish to paint photographs but to capture the spirit of objects. In fiction writing, too, this is the goal of a realist – not to settle for being pictorial or naturalistic, but to elicit from the facts of our ordinary lives their incandescent meanings. It's not surprising that Joyce Carol Oates, another prose realist, likes Winslow Homer (one hangs in our den).

I'm told that the hill in *Winter 1946* is now covered by small houses, though just out of sight the railroad tracks remain. So the hill Wyeth saw is all memory now, and so is Valley Forge – only twenty miles away.

Sometimes this realist points out to student writers at the University of North Carolina that writing fiction is already an abstract art, the alphabet already far removed from real experience. Grief for one's father is an experience very far removed from the a-b-c marks we scratch onto paper trying to capture that experience, just as *Winter 1946* is fifty years gone, and its use of color and light now depict themselves and can never reproduce the death of N. C. Wyeth nor how that felt to his son.

But Wyeth's colors and shapes are not diminished just because the viewer shares something of what was in the mind that so arranged them. At readings, poets – too – often tell how a poem got started. I sometimes admit, with some amazement, that you can get to three hundred pages because of driving past a chicken-truck wreck in North Carolina!

Such commentary never improves nor explains away whatever is in the poem, the novel, the painting – these stand alone, succeed or fail on their own, now or never; art always exists in present tense. And what we see now is a boy, not yet full-grown, wearing somebody else's suit and careening downhill across the tracks of some unknown vehicle in a season where snow still lingers, and greenery and blooming seem a long way off.

PETER MAKUCK

ANDREW WYETH

Winter 1946

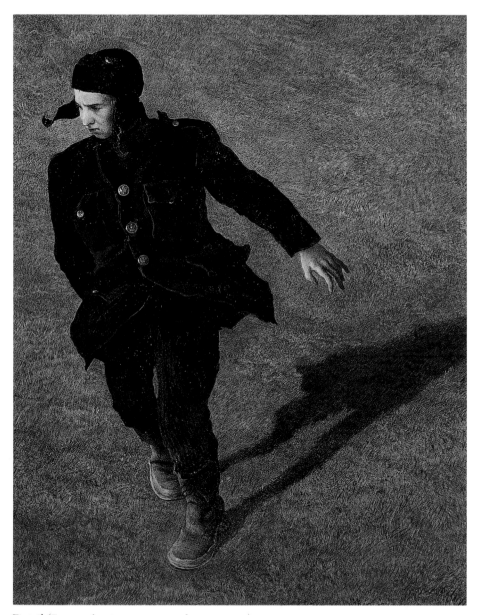

Detail *(For complete image, see preceding response.)*

Wyeth's Winter

It begins in the cold upper room
windowing the blank expanse of Kuerner's Hill,
his father not long in the ground, killed
by a train,
when this boy comes running,
a dark brown apparition, one arm drifting free,
the other frozen, an erratic figure
pitched down the steep mound of earth.
No sky or clouds, no high colors.
The blue of pie berries as forgotten as summer.
Only thin sunlight to blacken the turf
with a long shadow
stuck like flames to his fleeing heels.

It will be winter now, always
a process of separating muted color
from the earthdark his father has become –
dun and ochre, gray and black,
the whites as cold as snow.
No Frenchy greens or reds,
just murky firs, a dull brick farmhouse wall,
a blue barn door,
a geranium like an ember in the woodstove dark.
Even in the summer of *Christina's World*
it is winter, grasses of the long rise
parched and bleached, the woman sprawled
in a pink so faded it's nearly white, abandoned

like this boy – earflaps wild in the wind.
He is crossing
the ghost tracks of a farm truck
that climb the hill past patches of snow,
fence posts, bare brush fringing the top
toward that deadly crossing hidden on the other side
where trains still wail without warning.

Deborah Pope

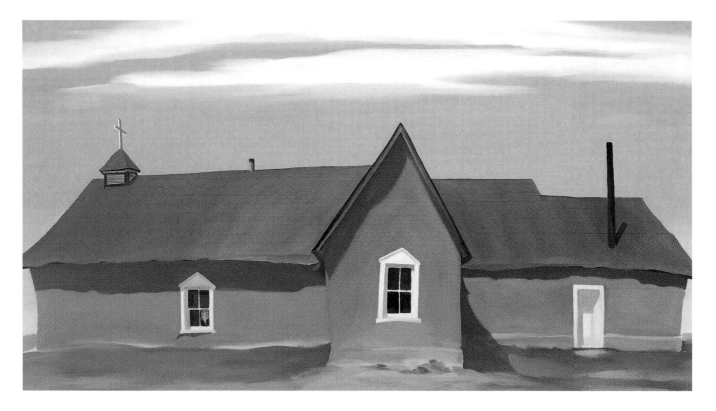

GEORGIA O'KEEFFE

American, 1887-1986

Cebolla Church

1945
Oil on canvas
20¹⁄₁₆ x 36¼ in. (51.0 x 92.0 cm)
Purchased with funds from the North Carolina Art Society (Robert F. Phifer
Bequest) in honor of Joseph C. Sloane 72.18.1

Plain Spoken

1.

Again we are struck
as always in O'Keeffe
by absence,

the absolute lack
of the need
for us.

2.

More barn than benefice,
these low walls slope
in unbroken sun,

the maize-colored stone shimmers
like a ripe crop
out of the dirt around it.

Clouds draw thin white wakes
across infinite-seeming blue.
Involuntarily

even at this remove
we squint against such light
unbidden, unrelieved.

Sealed against us,
against revealings,
a sublime sufficiency

unto itself.
It is our own need we meet.
This is the church at Cebolla.

3.

Used to invitation,
the necessary consequence
of our gaze,

we sift for easy signs,
slowly noting
the vacant air —

two sightless, blue-black windows,
a shut side door.
Portals we might have sought

are turned and imaginary.
No higher than the roof's pitch,
a wry suggestion of buttress

in the shadow,
rise perpendicular sticks
slivered almost to invisibility —

a thin limning of cross.
Cebolla, meaning bulb,
meaning onion —

enclosed, common,
of the earth.
And like an onion

there is no clear way
to enter here.
Agarrar la cebolla,

to seize power, they say
in the tongue of this place
where layers of light,

sand-wind and time
know something
of power.

Come by way
of the hard, flat field,
come to the unmarked door,

come barefoot and wait
without intentions
under the sun.

Ponder the name
of the place,
of the object

you have carried here,
plain, mysterious,
in your hand,

no beginning and no end.
Cebolla, meaning power,
meaning onion.

This is how the sacred happens.

LEE SMITH

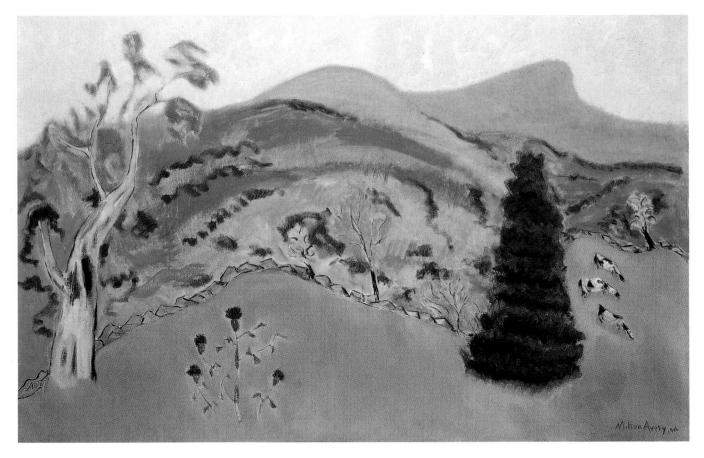

MILTON AVERY

American, 1885-1965

Blue Landscape

1946
Oil on canvas
34¼ x 53⅛ in. (87.0 x 134.9 cm)
Gift of Roy R. Neuberger 57.1.1

Daisy's Hill

THE FIRST TIME it happened Daisy was maybe eleven and she had run off from home where Mommy and Mister Oxendine and them was carrying on so and she had to stay in the little room where the bee board went up and down up and down in all those little straight rows and it was like she could not breathe. Nor could she hear something.

Leaving, she is a shadow girl, a dream girl, dodging from tree to tree. Now she can hear them calling Daisy! Daisy!

Daisy is her name.

So up the hill she goes past the silvery barn where Jeddy and Bo and Dolly played hidey-go-seek with her before they all went away, and who can blame them? Past that old stump bench where Papaw used to sit whittling, oh he could make anything. Past the orchard where he is now, and the little baby girl that never had a name. Mommy did that, and Daisy helped her. Daisy is a good girl. Then up up up past the Hat Rock and over the ridge and here she is Daisy girl of the rushing hills and the curly trees and everybody is glad glad glad to see her!

Daisy! Daisy! The very sky is shouting. And the cows stop eating long enough to say, Well Daisy honey, where the hell have you been? And how are you getting along?

The Christmas tree has a holy voice like a bell. It says You are a good girl Daisy Keen, a good girl, good girl, good girl.

Daisy twirls like a top in the wind and before long here *she* comes, that little orchard girl, and strangely enough she looks like Daisy, gold and blue, and she likes to play everything Daisy does. Such as red rover, red rover, send Daisy right over, and giant step, and pretty girl station.

And there's plenty of time up here, there is all the time in the world for giggling and telling secrets, and nothing is bad, and Daisy's a good good girl.

So she comes here as much as she can.

She comes until the state lady writes the paper and sends her away saying, Daisy, you will be better off. But she is not better off, and she is lonely, and she hates putting pencils in boxes, what kind of a job is that? and living in the little square room in the house and washing the dishes. Daisy's job is to wash the dishes, Daisy's job is to wipe the table, to cut the potatoes in little squares.

Daisy bides her time.

One of these days she will take all the money from Mrs. Patty's purse she knows just where it is and buy a ticket at the bus station she knows just where it is and come right back here and run up past the Hat Rock and over the ridge and she will be older, but the orchard girl is older too, and nothing is bad, and the hills are running too and the very sky shouts Daisy! Daisy! when they reach each other at last and hug and jump and fly up up up into all that air.

ANN DEAGON

GEORGE BIRELINE

American, born 1923

L-1962

1962
Oil on canvas
50⅛ x 69¼ in. (127.3 x 175.9 cm)
Purchased with funds from the North Carolina Art Society
(Robert F. Phifer Bequest) 63.13.1

Following pages:
Deagon has backed her poems with photographs of works by
Bireline in her collection.

GEORGE THE KNIFE DOES WINDOWS

I'm always lost in a city, or lost in a house –
lost without papers or circumstance.
You're an immigrant, somehow, in the city.
And that's how the paintings occur.

So it's a dangerous and desperate act?
You try to figure out what the marks are.
You know they're marks, no question, but what else are they?
For strangely enough, they are something else.

What is it you are trying to bring to light?
Whether there's some interior, primitive,
unconscious self . . . is there someone back there . . .
or are dreams just random firings?

As you paint, as your arm rises, George,
is there a kinetic awareness?
Yes. If you're putting it on with a knife,
the way you scrape and claw at it, or if
it's a buttering stroke, or the kind that goes off the end there . . .
you can almost sense the kind of desperation
that stroke was made with. And what the colors do –
they send me places I cannot go otherwise.

I want to know what of your life has gone into it,
but you talk only of stroke and color.
I am a head person. I don't have these passions
other people have. My ideal state
is to never get up and never get down.

Yet these are passionate paintings, George.
But they're bounded by very stable elements.
So that things can occur – outlandish things can occur –
but they are bounded, they are contained.
Everything repeats the framing edge.

A series of windows into some other world. . . .
Yes. It must be inbred, this looking out,
Standing and looking out.

Inside your head. Looking out your eyes.
These devastated landscapes . . .

IRON ANN SEES RED

I switch on. All the little icons come up:
Windows. God, how it all connects!
Sparks in the banked fire. Northern lights
in Southern parking lots. That bag of cherries
left on the bus in Naples, thirty years red,
none sweeter. Your colors hit me, George,
where I live.

Born on Red Mountain, I stoked my art
at Vulcan's rump. He stands and looks
cross town where roasting pig iron at the open
hearth made red the sky. Gone broke,
shut down, still flares behind my eyelids, still
in this your devastated city, George –
my Birmingham.

This other red's my mother's hair. She cut
her glory off when I was born. I found it
in her trunk when she was dead. It smolders
still. Her rage killed her. She told me,
Don't think I don't know why you love red:
Africans wear it. (She didn't say Africans.)
This is Africa, Lady.

Or Mesa Verde. I enter the frame.
Past the basket, the rug on its vertical loom.
My man lies asleep in the square adobe.
I begin to climb the ladder rung by rung
into the fiery sun. Your windows, George,
open into the red heart of all my living,
into the red hearts of all my dead.

LAWRENCE NAUMOFF

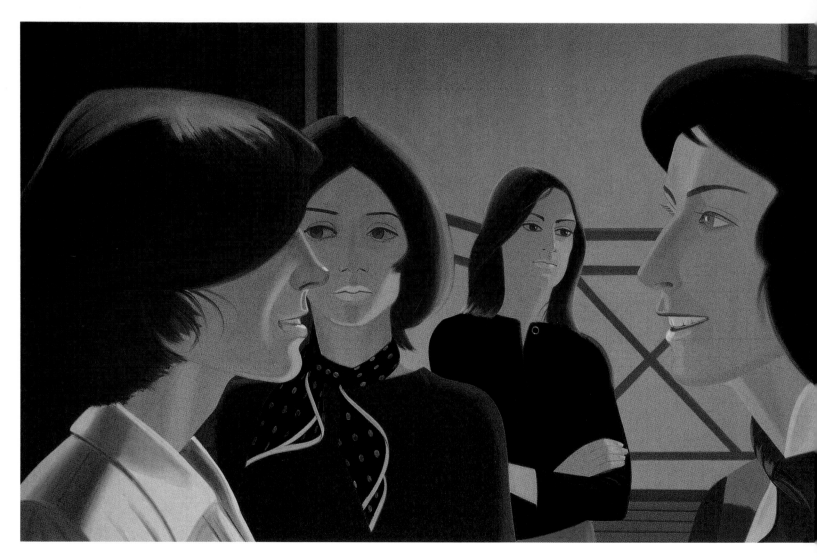

ALEX KATZ

American, born 1927

Six Women

1975
Oil on canvas
114 x 282 in. (289.6 x 716.3 cm)
Purchased with funds from various donors, by exchange 91.15

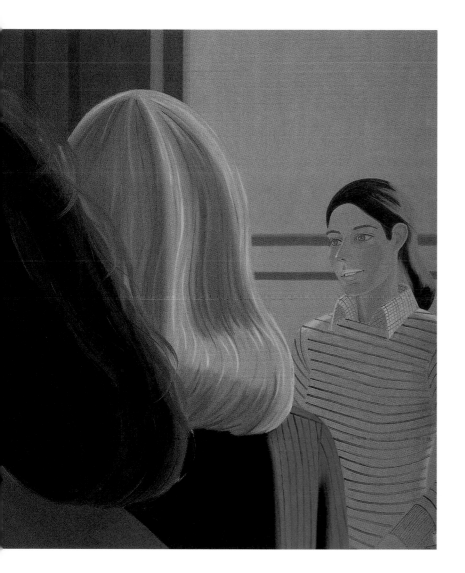

The Sixth Woman

THERE WAS AN ECCENTRIC and oddly notorious man in a rural area near Chapel Hill who was known as the father of Chatham County not for his civic deeds but for the number of children he'd fathered with his ex-wives and girlfriends.

This man arrived from the Midwest in the early 70s and brought with him a year of law school, a blond beard as long as his hair, which reached his shoulders, and a quiet, pregnant wife.

A year later the placid, dutiful wife, who'd exchanged being dominated by her father for being dominated and controlled by this wild young man, was pregnant again. This made the life the physician's daughter had chosen — no central heat, nothing to cook on except the woodstove itself, one spigot of cold water in the kitchen, a cold, miserable run to the outhouse on dreary, winter days, and a lot of vegetable matter in film canisters neatly preserved like spices — more difficult, and the father of Chatham County, that offbeat, newer side of it, anyway, was in bed with another woman who was running from something, one would expect, and soon, naturally, she was pregnant herself.

The physician's daughter returned to her hometown and raised the children alone. Though she patiently waited for either revenge or hope, she never married again, but heard about, as time passed, her ex-husband and his life.

The new woman, however, did not marry this man. It was a good thing, because she got mad about something and they split up and that baby, who she claimed was not the wild man's to begin with (when it was), went off with the mother who quickly found another man whose heart understood the primal predicament of birth and life and the vulnerability of passionate, confused women.

Then the man with one year of law school went up North and married another woman, who was a plumber, actually, because her father and brothers were plumbers and she knew the trade, and they had two children, but

there was something about the raising of children that wasn't nearly as much fun as getting the women pregnant.

The thrill of unobstructed desire, and of being desired in turn, was missing. The thrill of her believing in the absolute phenomenon of this new man was not there.

Because it wasn't going to work, and it wasn't as exciting, the father of Chatham County, who stayed up North, left this woman in a way that she was glad to see him go, never even wanting contact with him again, and he found an artist to love him.

The artist's Jewish parents had been, like, really uptight, see, and really materialistic, and this man was, like, so real and so earthy and so natural and woodsy and unfettered by convention and besides all that, her parents hated his ponytail and that woolly beard, which made her want him all the more, and she married him, and had his child.

He liked this woman and she was good to him. Her parents worried so much about their daughter, however, and suffered so her absolute loss of innocence, they sent letter after letter with checks and cash and offers in them.

A new pickup truck was arranged and this was good because cutting pulpwood for a living really got kind of old in New England in the woods in the snow even though at first it had been a challenge and seemed like a manly thing to do and the pulpwood truck, with its boom dangling and swaying, was certainly a symbol of this man's life, though he couldn't have known it, at the time, only that it fit and seemed right.

But then the man met a woman from New Zealand who'd come to the U.S. to be a nanny. He'd always wanted to go to New Zealand or Australia where the men were men and the women, he'd heard, did what they were told and were just flat out glad to have a man in bed with them at night and one to drink with.

So this woman, who was ready to return home, and the man, who was ready to move on, departed.

He left the trust funds and the new pickup because, it seemed, things simply weren't working out.

The woman then, whose Jewish parents, she decided, weren't so bad after all, was abandoned and she returned to her hometown and family, while the man who'd been so perfect and had affected her so deeply, like no one else ever had, renewed his passport and set off in an airplane to land cleanly and with a new vision, halfway around the world.

It was fun in an airplane. Legs pressed against each other. Fingers intertwined. Lips softened by the fires of fresh desire endlessly kissed.

It was exhilarating and defiant and brave to fly away with someone you loved and with whom you were starting a new life while everyone else on the plane seemed so dreary and tired and worn out from all that conventional nonsense, like raising children and all that.

It was more like life should've been to be speeding toward the morning sun while behind you dark nights and the quiet of your own thoughts and the ghosts of your conscience and heart might appear across the room like shimmering shapes of female heat rising up above you.

The clear and unobstructed dawn awaited.

Then, in the new land, in the home of this woman who was not like the other women the ex-father of many counties now had known, the woman suddenly saw this man more clearly.

He was forty-three years old and strangely going nowhere now that they were there. She asked him to leave, and he did.

He hated her for being so cold and for using him to get her home (her plane ticket had cost him eleven hundred dollars one way) and for promising to love and desire him when it hadn't been true, and this hatred he had for her was new to him because he still had good feelings for the rest of the women in his life, knowing their kind hearts like he did.

He returned to the States. He started drinking more. He discovered that the white powder that wasn't flour and was not the essence of anything herbal he'd ever known or grown before, made life more interesting.

For the first time, as well, the wild man who looked so good and so real and so very, absolutely different than the general run of boring, responsible men, was momentarily alone to consider his life.

After considering it for a few months he found a girl who was nineteen. He was lucky once again. She was young enough and full of hope enough and filled with that refreshing unbridled youthful female enthusiasm and belief in life so that she was sure she had found her calling in this man, to save him from himself, and to give of herself all that she had so much of, which would be an easy thing to do.

But then (and this is true), ex-wife number one heard about this new girl because she had known, long ago, the mother of this girl. Now it was time to do something, she thought.

Number one then called number two, who called number three and so forth, all of them knowing the next in line, and they decided it would be a good thing to talk, to get together, to very seriously meet with number six.

So they did.

On April 17, 1995, having pooled their money and flown in number five from New Zealand, they had a party.

They all looked different from the times when they'd been with the man who'd had one year of law school. They dressed in better clothes. Some of them even had scarves around their necks, not to try to stay warm in heatless houses, but for the simple pleasure of fashion and color.

For a while, number six, who was the only one with blond hair, turned her back on them, but her curiosity was stronger than she'd have guessed, and in addition, she liked these women, and would've liked them and wanted to talk with them and know them no matter where they'd met.

She liked their faces. She liked their stories, which, oddly to them all, turned out to be hilarious and goofy and sweetly sad.

The young woman was no fool, and had seen it all in the man already. It was just that she knew she could change him.

It was a wonderful day and though the girl did return to the man because she still loved him and love, itself, was a kind of truth separate from all other truths one might hear and know, she was a wiser woman now, and knew it.

"You look different," the man said. "Your face has changed."

It was true, but not just for her. It was true for all women lately. They were more glamorous than before, and yet, underneath it all, sad and degraded. The combination made for an irresistible beauty.

It was odd, since experience and contemplation should create wisdom, that women today, and not only at that party, appeared if you studied them deeply and clearly, as if they'd discovered something terrible, as if, in a faded way, they'd been refugees from a long war, as if there were black-and-white overlays that made them seem, at times, out of focus.

There, at once, if you looked closely, was the glamour of the vibrant, tawny skin, framed by the richly colored hair and yet within it, the pale specter of someone else, meager and gossamer like a hungry war-orphaned child.

"My face has changed?" she asked.

At a certain age, having lived too much and made too many poor choices, the faces of the older women showed the duplicity of their pleasures. It was contained, like a hologram, in their lips and eyes and sunken cheeks. What remained, though, was more defined than before, as if in aging, the false skin was shed.

"Yes, it has," he said.

So had his. The ponytail and the beard and the wild eyes made the man look homeless, like he'd been on the street too long, like he'd been without a home, of any kind, far too long, and the years, which had passed so quickly, had left him behind.

"And how is that?" she asked.

Passion, and the idea of it, once thought to be a liberating experience, had somehow failed. It took a long time to understand this.

WILLIAM HARMON

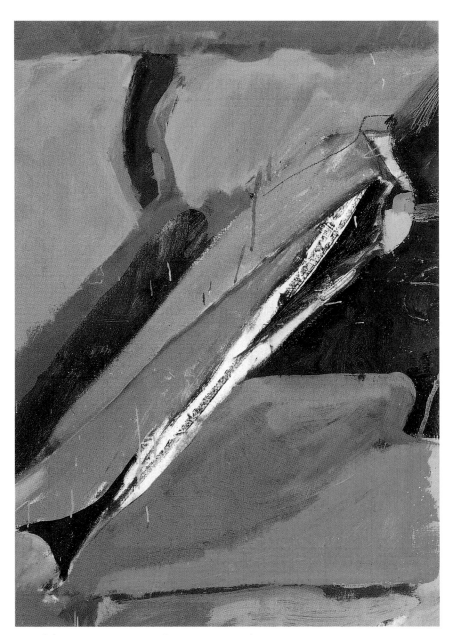

RICHARD DIEBENKORN

American, 1922-1993

Berkeley No. 8

1954
Oil on canvas
69⅛ x 59⅛ in. (175.6 x 150.2 cm)
Gift of W. R. Valentiner 57.34.3

Detail *(For complete image, see following response.)*

Riddle

Ourselves the needle
threaded with our selves

wherewith we sew
our selves together

and sow ourselves
also, well: almost so —

the quick hour and its seed
so close,

so sure the need
and sharp the shortened tether.

In memory of the artist

JONATHAN WILLIAMS

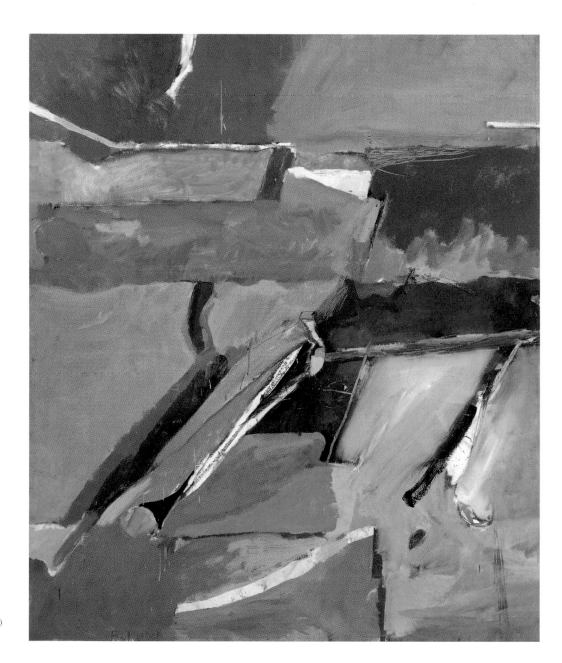

RICHARD
DIEBENKORN
American, 1922-1993

Berkeley No. 8

1954
Oil on canvas
69⅛ x 59⅛ in. (175.6 x 150.2 cm)
Gift of W. R. Valentiner 57.34.3

112

"Grain Stacked in the Shape of a House"

THE TITLE IS what the name "Diebenkorn" means, derived from an archaic Swedish word. How wonderful! Maybe he painted a picture of it? Right color; right shape.

Berkeley No. 8 is a real zinger, an Abstract Expressionist canvas by a virtuoso painter who was really cooking back in 1954. A chromatic fantasy, in musical terms, though a lot of the painters I knew in those days were more into baseball and jazz than the classic European repertoire. But, why worry if a man listened to more Mulligan and Brubeck, Bird, Monk, Mingus, Miles, Trane, and the MJQ than to the chamber music of Gabriel Fauré or the piano music of Maurice Ravel?

Matisse spoke of art as being more than pictures of the visible world. It was a "condensation of sensations." Baseball and music foster concentration as well as condensation. Tocqueville worried long ago that Americans would have a hard time concentrating on this big, empty continent. People who dig baseball (real fans), and people who are "all ears" usually have the eyes to go with it. Who was it who said of Monet that he was "just an eye — but what an eye!" John Russell likes the "eye-music" that Diebenkorn makes on a canvas.

Diebenkorn seems to me to be a formidable assimilator. His painting might be said to be one sumptuous performance after another. He has spoken of the physical aspect of painting, and the intellectual aspect, and the intuitive aspect – how they need to balance. They usually do in his canvases and that is a great source of their pleasure. Just as, if you combine a piece of Roquefort, a ripe pear, and a glass of Château d'Yquem, you are not going to be disappointed by this mouthwatering taste. It took generations to figure out that palate.

If you try to enumerate his sources and influences, you come up with a considerable list: Cézanne, Matisse, Bonnard, Monet, Edward Hopper, Charles Sheeler, Mondrian, William Baziotes, Mark Rothko, Miró, Clyfford Still, David Park, Hassel Smith, Elmer Bischoff, Edward Corbett, de Kooning, Kline, Motherwell, Gorky, Hofmann. Obviously, I am missing some. (I am guessing it would be safe to exclude Picasso, Grant Wood, Ivan Albright, Pavel Tchelitchew, Soutine, Guston, Dubuffet, Rouault, but, suddenly, I wonder about several of them.) In Gerald Nordland's excellent monograph on Richard Diebenkorn (Rizzoli, 1987), he quotes a lucid comment by Robert Motherwell: "Every intelligent painter carries the whole culture of modern painting in his head. It is his real subject, of which anything he paints is both an homage and a critique." Diebenkorn said: "Art, for me, was always something I did privately."

Charles Olson, in *The Maximus Poems*, says: "one loves only form, / and form only comes / into existence when / the thing is born . . ." It is a truism whose veracity is endless. Through formal power art engages the marvelous: standing in front of a Diebenkorn, listening to Thelonious Monk play "'Round Midnight," watching Greg Maddux throw those pitches that carve up the strike zone like we've never seen before.

So, get *Berkeley No. 8* inside you. It's an eye-opener. Somebody says, "Nobody sees the same movie." Nobody sees the same painting either, which is often why I prefer to talk "around" a picture and concentrate on the world of the artist or on the atmosphere of the time he painted it. If I had Diebenkorn in my library this evening, we'd have a few drams of Bushmill's Black Bush with a little branch water. We'd check out the week's accomplishments of the Atlanta Braves pitching staff, and I'd probably ask him a riddle – a riddle with some rich Diebenkorn color in it:

> what's your favorite irish
> joke my favorite irish
> joke is what's green
> and stays out at
> night give up the
> answer is patio furniture

HEATHER ROSS MILLER

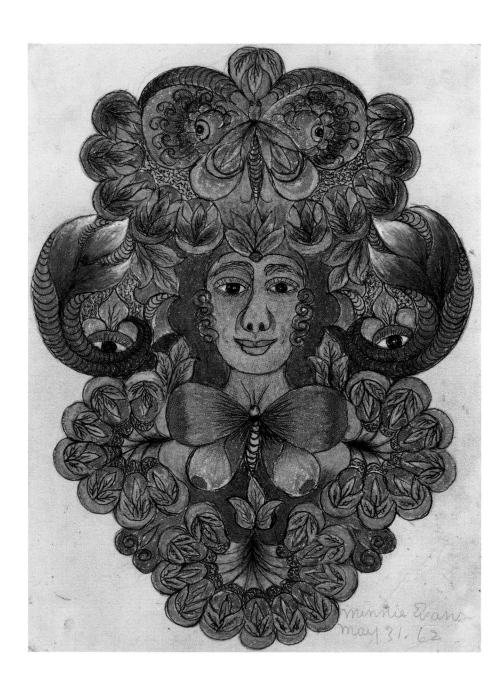

MINNIE EVANS
American, 1892-1987

The Eye of God

1962
Colored pencil on paper
11⅞ x 8⅞ in. (30.2 x 22.5 cm)
Gift of Mr. and Mrs. D. H. McCollough
and the North Carolina Art Society
(Robert F. Phifer Bequest) 87.4

Carmen Miranda in the Twinkling of an Eye

THIS is a children's story.

When I go back to a little girl, Carmen Miranda is what comes out. I see her looking at me through the azaleas by the corner, Carmen Miranda flashy like butterflies, looking a little like titty-nipples, like black deer eyes in the hot leaves. And if you think I have gone crazy, you listen to this.

I was going to the picture show with my mama in World War II in the summer. We always sat down at the front, smelling the salty tough popcorn in our bags and the suntan oil all over her and the white Griffin shoe polish on my sandals. She loved to put those sandals on me, white T-straps with a jingle tap in the heels. I loved it, too. But my daddy, who got irritated at nothing, hated the racket of me dancing along and jingling taps. He yelled out, "Goddamn it! Get them things off her! I can't stand it!"

He was irritated because he had to go to work and make money for us to spend at the picture show. He kept spilling coffee over the tall gray thermos, stuffing sandwiches in waxed paper. "Why don't you make me something decent," he yelled, "something I can eat!"

My mama barely said pshaw and went on smoothing deep rosy-red lipstick across her mouth. The smell of that lipstick, like a live animal, brought a real color to her, a hot presence. She looked at him in the mirror and he looked back at her and I looked at them both. It was a dizzy thing.

Then we went to the picture show together, me and my mama, while he was supposed to be working a three-to-eleven shift at the smelter, punching aluminum, pouring out hot bright pigs in the ingot yard. We went to look at Carmen Miranda, the lady in the tutti-frutti hat.

I want to tell you how that was: us down in the swarming dark, her up on the screen that went from side to side to top to bottom, a whole big fantastic wall of nothing but Carmen Miranda. Carmen Miranda up there like bananas and fancy elephants and flowers and flying angels, *wait!*, like yellow butterflies with wide-opened black eyes on all four wings, deer eyes, Carmen Miranda eyes, *cha cha cha! chee chee chee!*

Nothing else mattered in the picture show but looking up at Carmen Miranda, counting all the eyes on the screen, hers and the butterflies', peeping out from behind azaleas and leaves, bananas and pineapples. She had little bunches of cherries dangling at both ears, green vines curling down her shoulders, and in the places where her titties shook, right on the titty-nipples, she had two great big spotted butterflies.

And she wore on her feet, *hallelujah!*, platform sandals with heels stacked in rainbows and buckled around each ankle. Those sandals beat out a terrific rhythm from one side of the screen to the other, those platforms built up like towers to transport Carmen Miranda, her ankle straps, her colors shading from coral pink to orange to rosy red.

I jingled my taps in applause, *Oh, Carmen Miranda!*

My mama kept looking around over the people, their faces rippling in Technicolor light and shadow. Their green-splattered fists went to their mouths, stuffed in blossoms of popcorn red as blood, *cha cha cha! chee chee chee!*

My mama kept getting up to go to the bathroom. "Stay here," she hissed, "don't get up." But I had no thoughts of getting up. I was stuck like glue, jingling my taps, and staring.

Nothing else mattered. I believed in the picture show. In Carmen Miranda, transported to a brand-new spirited dimension, speaking in tongues, *cha cha cha! chee chee chee!*, and I traveled along on her marvelous platform sandals, learning the steps, the turns and dips of the dance.

And when we got home from the picture show, when

my daddy didn't come home that night and my mama called up her sisters on the phone and they said, "Throw his stuff out in the yard," I believed in Carmen Miranda even more. She was a good thing. A real thing.

I cut apart brown paper bags from the grocery store and spread them across the kitchen table and started to draw. I put in bananas and fancy elephants following each other in a circle, I put in pineapples and green vines and flying angels looking down on the top of Carmen Miranda's tutti-frutti hat.

I drew the whole time my mama was talking on the phone to her sisters. The whole time she was throwing my daddy's stuff out in the yard. I kept on drawing and coloring even after she sat down at the table and let out a big dramatic exhausted sigh. "What're you doing?"

"Drawing Carmen Miranda." I started bearing down hard on the yellow crayon until it broke and stubbed up under my fingernail.

"That's what happens when you bear down," my mama said.

I peeled the paper off the yellow crayon, brushed the waxy crumbs off my fingernail. "I don't care," I said. "I had to do it."

"Well, we got to go to bed, so quit coloring and come upstairs."

I left my stuff all over the kitchen table, but the next morning, my mama had moved it, stacked it in the pantry with the Sears catalogs and old newspapers. "You put my Carmen Miranda in the pantry!"

"I thought you got done with it," she said.

"I ain't never done!" I grabbed the brown paper up and flourished it like a flag. "I ain't never done!"

"Pshaw," she went on stirring the oatmeal into my bowl. "Eat your breakfast."

"I don't want no oatmeal! This is the hot summertime! I want some cornflakes!"

"Cornflakes're for trashy people," she said. "You eat this oatmeal. It builds strong bones and teeth, it makes rich red blood." She smacked the bowl on the table, added raisins. "It makes you pretty, too."

I couldn't fight that, strong bones and teeth, rich red blood, and something to make me pretty, too. I ate the oatmeal. I ate with Carmen Miranda spread beside my bowl and I ran my fingers over the waxy colors I'd laid on thick enough to be Braille for the blind. Carmen Miranda's big eyes glittered, her lashes curled, and her lips puckered deep rosy red, like my mama's lipstick, a strong and wild color, a healthy fragrance.

I drew and colored all over the apartment, on the linoleum, on the front steps, in my bed, and out on the roof where my mama never knew I climbed. My daddy stayed gone. My mama's sisters came over, sat around smoking cigarettes and sipping Coca-Colas out of frosty bottles. They sipped through long straws. I don't know where my mama got straws. It seemed fancy to have straws in Coca-Cola bottles back in World War II right there in our kitchen. My mama got stuff. I don't know how, to this day, but she did.

"Can't you draw nothing but Carmen Miranda?" the sisters asked.

"No," I said. "I can't draw nothing but Carmen Miranda."

"She's cut up all the paper bags I got," said my mama. "Drawing nothing but Carmen Miranda."

"Well," they said, "take her to see something else. Take her to see *Bambi* or *Snow White*. Take her to see *Gone With the Wind*."

My mama didn't want to see anything but my daddy. I knew that.

Not the picture show, not my T-strap sandals with the jingle taps in the heels, not Carmen Miranda, not nothing. Just him to come back, walking the way he did, sort of half-slouchy and half-important, right around the corner and say, *Hey!*

"Well, look," they got back to my daddy, "look, you oughta known when you got married, he was gonna run

around on you."

"Well, I didn't," she said.

"Well, you oughta."

And when the sisters left, I sat looking at my newest Carmen Miranda spread on the back porch. I colored right over the porch decking underneath the paper, so the colors had a slanted texture, first going to the left, then to the right as I had shifted my position, crouching over them. One of Carmen Miranda's black eyes looked bigger than the other. This time I put a big plain moth instead of a butterfly on her titty-nipples. I didn't color the moth much. Kept it pale green and yellowy, put two big eyes on the lower wings, and colored them pale brown, the color of my mama's titty-nipples when they got shriveled up in the shower. She would hate me knowing that. Hate me drawing this moth to match her titty-nipples. But I did it. I didn't care.

And the pale spots were eyes without being eyes, didn't have any centers to them, no lashes, no reflections to shine things back at me. And that made me sad to look. But I still kept looking at Carmen Miranda and the big moth and the pale brown spots until I noticed some crazy things were going on: I was looking at Carmen Miranda and she was looking at me and she was also looking past me at something I didn't know.

It was three crazy things going on. Three presences. I didn't understand things like presences back then, but I knew something was going on, and it was all in our eyes, mine and Carmen Miranda's and somebody else's eyes outside of my picture on the porch.

I looked and looked a long time and then I sort of guessed what it was Carmen Miranda was looking at, and I knew I couldn't turn around to make sure. I had to just take it on faith, like they said all the time, take it on faith.

I felt both scared and happy and started coloring the wings on the moth darker and darker green, like jewels and silks I heard about at either the picture show or in the Bible. I made them green as pastures, as still waters, rich

and brilliant, smoothing away the slants from the porch decking underneath. I made them change in the twinkling of an eye. *Twinkling!* I exaggerated my lips working the sounds of that, *the twinkling of an eye!* Made my lips the strong sucking parts of an insect or a little baby.

I colored fast to keep those three presences right in front of me, bearing down hard on the crayon: me and Carmen Miranda and the something else she saw outside somewhere, a good thing, a healthy thing, a man and a woman and their little girl, *hallelujah!*

And it wasn't long after this, my mama cooked some wonderful stuff, like a great big coconut cake. I don't know where she got coconuts in the hot summer in the middle of the war, but she did. And made a pan full of pineapple-upside-down cake, too. And a bowl of banana pudding with meringue three inches thick. She spread it on the kitchen table, the snowy delicate coconut, the pineapple glassy brown under melted sugar, and the banana pudding studded with vanilla wafers.

I couldn't stand it. I wanted to eat everything. She said, "No, it's not for you yet." And she leaned in the open door, wearing a print skirt and a white off-the-shoulder blouse with a long lacy ruffle. Her shoulders were tanned, soft and fragrant as new bread. She was looking for something way off past us. Just like Carmen Miranda looked.

Then I saw him the same time she did, saw him come around the corner beside the hollyhocks, the morning glories, brushing through the heavy azaleas, and I burst out ahead of her to meet him, my taps jingling on the sidewalk, *Hey!*, and it was like God said, *Amen! little girl, you might live to be ninety, little girl, you might live to be a hundred!*

MICHAEL MCFEE

MINNIE EVANS

The Eye of God

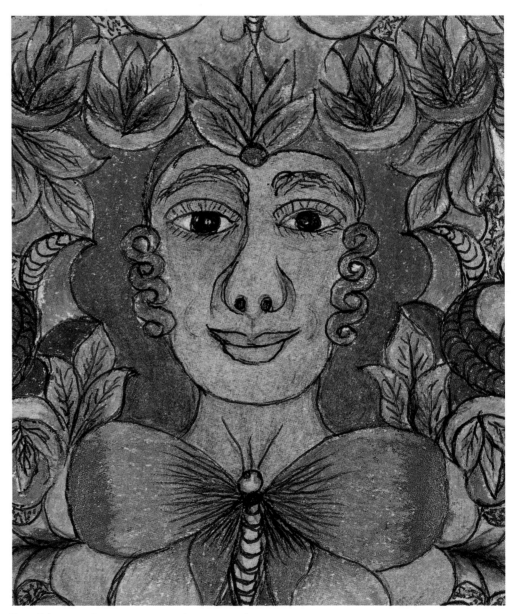

Detail *(For complete image, see preceding response.)*

The Gospel According to Minnie Evans

The Eye of God,
her drawings testify,

is plural and symmetrical
and everywhere visible,

it watches our world
from breasts, yes,

and butterflies' hindwings
and visionary plants

unfolding and infolding
their ecstatic colors,

it is not judgmental
but perpetually curious,

a version of Minnie's own
eye and I and aye

centering the blossoming
of her mind and hand

into tendrils and petals
and delicate antennae

in kaleidoscopic patterns
of 3s and 5s and 7s:

this is the good news
of her gardens and dreams,

the gospel her colored pencils
and crayons and oils and ink

kept singing until she fiinally
ran out of paper and time:

God can only see God
through Creation.

FRED CHAPPELL

The Phantom Pattern: A Pantoum

Abel engraved the wavy tables
Of all the tidal slides and idlings;
Upon the seizures of his measures
Rolled the ocean's soulful onus.

To all these tidal slides and idlings
Belonged a song of strangest longing.
The ocean tolled its noble opus;
Within its booming fugal music

There rang a song of strongest longing.
Thunderous among these numbers
Boomed a fugal swooning music,
Elemental contrapuntal.

From the thunder of his numbers
A glorious solemn ghostly cosmos
(Contrapuntal, elemental)
Abel made to shape his fable.

And from the ghostly solemn cosmos
Reared a rich and wistful bridge
That Abel shaped to make his fable,
Vaulting starward from dark waters:

A rich and rare far-stretching bridge,
Composed of naught but thoughts and aughts,
Vaulting starward from dark waters,
Poised upon a transparent pattern.

Composed of naught but awesome thought,
This actual and fantastic structure
With practical transparent pattern
Joined the material and immaterial.

This practical fantastic structure
Merged Material and Immaterial
In a fugal human music
Umbrally slumbrous among the numbers
Composed of naught but awesome thought –
Elemental, contrapuntal –
That treasure of the azure measures
Of capable Abel's wavy tables.

*For purposes of metaphor, the mathematician Niels
Henrik Abel appears in this poem as an oceanologist.*

FRANK STELLA
American, born 1936

Raqqa II

1970
Synthetic polymer and graphite on canvas
120 x 300 in. (304.8 x 762.0 cm)
Gift of Mr. and Mrs. Gordon Hanes 82.16

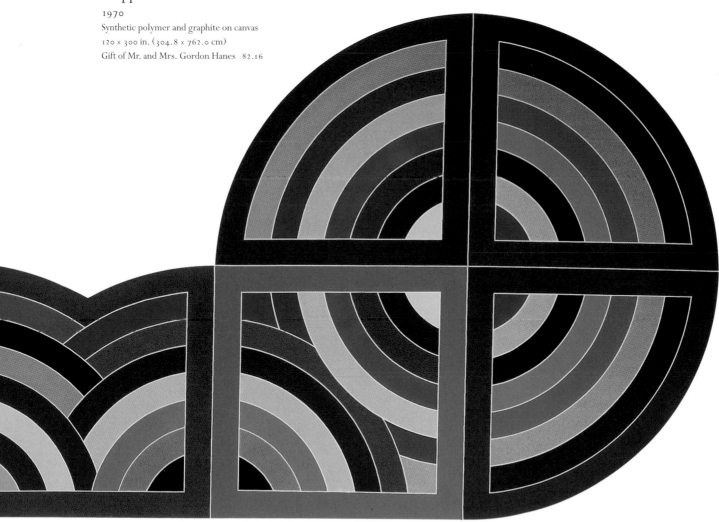

LINDA BEATRICE BROWN

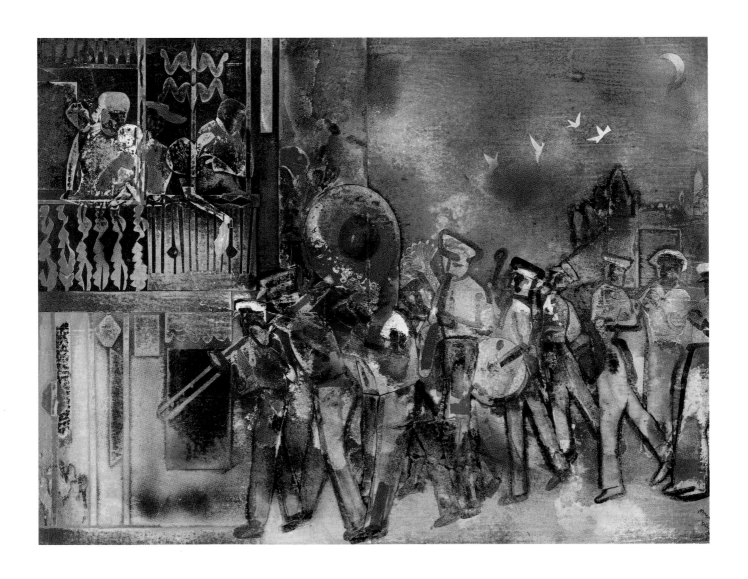

ROMARE BEARDEN
American, 1912-1988

New Orleans: Ragging Home,
from the *Of the Blues* series

1974
Collage of plain, printed, and painted papers, with acrylic, lacquer, graphite,
and marker, mounted on masonite
36⅛ x 48 in. (91.7 x 122 cm)
Purchased with funds from the State of North Carolina and various donors,
by exchange 95.3

An excerpt from Dangerous Pretty

SHE PAINTED THEM very carefully, each beautifully
shaped nail on each long brown finger. And after each nail
she'd sit and let it dry all the way through while the music
filtered through her closed shutters like bits of sunlight.
They were a ways away, but not too far to be there with
her. That wonderful sound like dancing liquid running up
and down her spine. She tapped her red nails one by one
and hummed as they dried. She listened for her life in the
music, her beginning and her end, her love and her death.
It was all there and she knew it, even before she knew
Coats.

Coats was the one. Selected out of time. Made for
her hands, his horn like Judgment Day. He was gold, he
was Heaven. He was her last dream. And she knew it even
before she washed her wild mane of hair in the washtub
and dried it on Nana's good white towels. She hung her
head out of the upstairs window to let it finish drying in
the early morning light. There was just a line of pink light
where the sun would be in another hour. The breeze was
lifting her heavy hair and she knew it would happen. She
could hear them goin home from the night before. It was
five o'clock and a lonely melancholy light was sliding
under her shutters.

So by the time she had washed her body in water she
hauled from the sink pump and warmed on Nana's big
woodstove, and then washed her hair and painted her
nails, she knew the sun would be strong that day, and
something would happen like nothing before.

Coats was his name. From up North. Must be his
papa and mama was from down here. Must be he had
angel wings they couldn't see. Must be.

And she slipped on her white dress Nana's fine stitch-
ing had made. Slipped it on over a black body she knew
most women could only dream of having. Slipped it on
only because there was no reason to tempt the devil by
walkin naked, except everybody knew she really was,

walkin naked, under that simple shift, because everybody could see in their minds' eyes every single move she made, and she walkin only for Coats and they all knew that too.

They all knew that Coats had been sent just for her. There was no mistake. Manni Ruth Vermillion was not theirs. Not ever meant to be theirs. They knew she belonged to her music, because she touched the piano keys like she was makin love to a man, and no man inside her heart, and she in her late twenties already. No man able to say she was his except Little Daniel, who didn't have a claim on her except he thought he did, because he wanted to. Because he wanted her. She knew that, but she pretended not to. He wanted her fingers; she thought that was it. He wanted her to touch him the way she touched those black and white keys.

But afterwards, she belonged to her music *and* her man. After she had only seen Coats once. Steppin out in the funeral parade. Steppin out fine and fair. Sounds like honey comin out of his horn. His horn that made the death of that child seem like a gift from the angel of death come down to save it from the hardness of the world. His horn that spoke to the mama about her hurt, spoke to them all about how it was a better place the child was goin to, and so let the pain be, the horn said, let it be. He played the dead boy right on up to Jesus. She was standin on the corner, thinkin about that dead boy and then she saw Coats playin him through, walkin and dancin him through, and she knew Coats was the one. Didn't even know his name. Heard somebody say softly, "He called Coats," and knew they couldn't be talking about anybody else.

Little Daniel saw her out of the corner of his eye, blowing his tuba, but she knew he was looking all the same. The funeral parade went on by and before that sun was all the way down, she had made up her mind.

That night, the band played at Sweet Joe's. Big Mason asked her to fill in for the regular piano man. She played it loud and she played it good. Manni Ruth Vermillion shook her head, and flung her hair with the rhythm. She made love to the box. But it wasn't the keys, and it wasn't the music she was longing for, it was Coats from up North, Coats in the beautiful black suit and the red tie, Coats who could play people into heaven. It was her time, her music; she was with it and in it. Her dream time had come. Her dream to be more than just a once-in-a-while piano player when the boys felt like letting her; but to be doing it for her life, for herself. She made the band sound better than they ever had. Everybody hit the floor, everybody danced. Folks who'd never been there before, never thought of coming into Sweet Joe's before that night came into the place off the street. Folks stomped their feet and hollered for more music. They spent money on drinks and hollered for more music.

And in between the sets, Big Mason said, "Baby, how'd you like to play with the Batiste Royales, to be a part of our band regular like?" A woman with all the guys. Not just any woman, but Manni Ruth herself. She looked up at Coats and grinned her wide grin. She looked up at Coats, not Big Mason, and not Little Daniel, who had loved her all her life it seemed like, but at Coats, the horn man from up North. And she didn't have to say a word. It was her dream. And wasn't she gonna have her man too? Didn't the man who played the best horn on this side of the Jordan River give her his lips right there on the bandstand? Put his hands around her waist that was wrapped up in her best red silk sash and kiss her full on the lips in front of everybody? Everybody loved it. Everybody said, "Yeah Man!" And Little Daniel put down his horn and went home. Just put it down right there in front of the piano where everybody could see and went home in the middle of the gig.

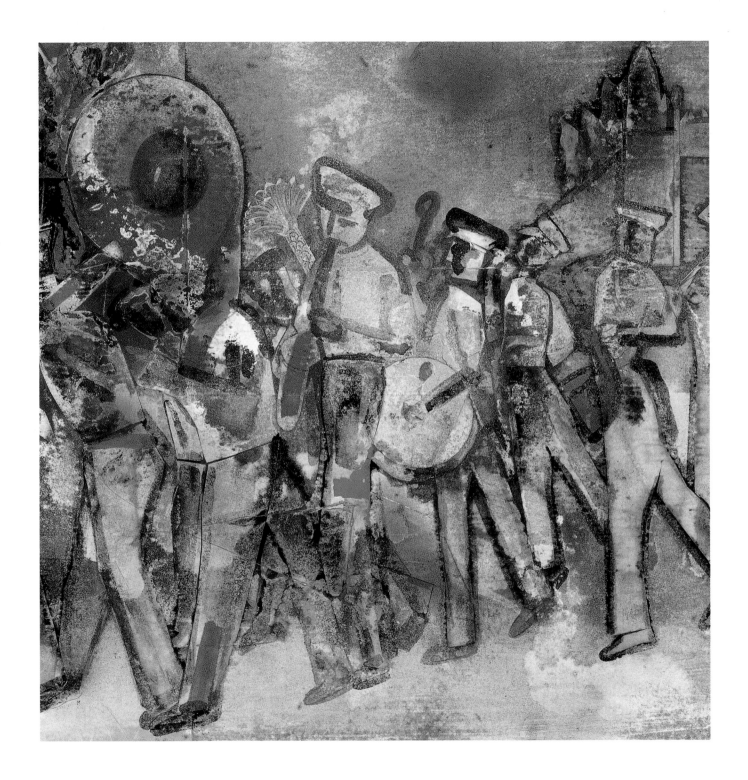

Marianne Gingher

My First Marriage

By late October, the balmy stupor of Indian summer had finally lifted. Nights chattered with the spiky roll of leaves and blown twigs and the scoot and puffery of wind torn loose from the North Star. Flies disappeared. The last of the cicadas clinked miserly like tiny china teacups dropping somewhere in the woods. Pasture grass was not so high that you might stumble down a hole walking out to catch a horse. Persimmons had fallen off the persimmon trees and the horses made clown faces, eating them, curling their lips, nickering to one another as if to laugh off the filmy, puckering taste. At dusk, the sky dropped over the land like chilly blue silk, and the horses, snorting air that had turned into frosty tonic, frisked around the paddock, impatient to be fed.

The horses acted drunk with life, and why not? They were sated with good fortune: brisk weather, warm barn, pastureland and woods to roam, the velvetizing closeness of each other. We doted on them. We pretended that they loved us back, that in their suede-soft eyes we glimpsed tenderness and gratitude, but we knew otherwise. We forgave them their bad tempers, their indifference, because we were young girls, learning to please, and would someday want to love men and accommodate children, and the horses were teaching us how. We fed them orchard grass, clover, lespedeza hay, palmfuls of sweet feed, timothy and alfalfa. We cracked the skim of ice off their water buckets with our bare hands and rode them without saddles or halters, holding onto their manes in a swoon of trust. We brushed them and sang to them and hung rapturously on their necks. We counted on their magic to lift us past ourselves.

◆ ◆ ◆

I had sold my pleasure horse and bought Goldy, a thoroughbred and jumper, so that I could fox hunt and go

to horse shows and win ribbons. I suppose I had sold the pleasure horse because I'd grown bored with gentleness and wanted to be fancy. I was nearly fifteen. I was not as interested in pleasure anymore as I was boys, but I still went up to Mr. Lambeth's barn every day after school to ride.

I'd taught myself how to ride when I was younger, mostly willing the knowledge out of desire and tenacity. I had a certain prescience about horses; I thought I understood their hearts. We all felt that way. We would have *been* horses if given the choice. It was an enthrallment, less like seduction than onslaught. We smelled like them, ran like them, bluffed like them, looked like them in our ponytails. We dipped handfuls of sweet feed out of the bins and chewed it because it was theirs.

I remained shy around Goldy, daunted by her grandeur, her habits unpredictable and strange. I could not always control her, a truth that thrilled me in some lovesick way. Her willfulness suggested part of my own evolution towards a spiritedness that might wreck us.

Since the weather had cooled, she'd turned all the more glamorous, tossing her chestnut mane, snapping her tail to and fro. I knew better than to gallop a spitfire in the direction of home at feeding time. You galloped on your way out, but not on your way in, not on a horse that had been bred for racing.

We were jogging home that October afternoon, up Jefferson Road, when she spooked at something fluttering in the ditch, perhaps a Dixie cup. Pam was riding Gay Girl, such a lady of a horse that she seemed to carry her saddle as primly as a pocketbook. Pam danced her politely out of our way while Becky struggled to restrain Let's Go. Let's Go was all nerves, walleyed and huffy, and her neck, checked by a martingale, arched like a carousel pony's. Her turbulence was contagious, a signal to Goldy who, like all beasts of burden, was essentially an opportunist.

The fluttering Dixie cup may have started the stampede, or Let's Go's influential derangement on the sort of brisk afternoon when the weather might have been blamed as well, cold air whipping horses' sassy flanks, dropping down their backs like tricks of ice. Whatever the cause of the runaway, it began. I was powerless to stop it, although I yanked and pleaded. When a horse goes haywire — and this happens suddenly, at any given moment, even to a horse you think you understand — you are too intent about hanging on to jump off. The more powerful reflex is to cling and subdue.

Although she strained to follow, we passed Let's Go in a streak. She was too cantankerous and unfocused to compete. Scattering her energy in ornery skittishness, she preferred dervish to stride. Goldy was a strider, elongating as she ran. Her roiling speed, as oddly lilting as it was thunderous, felt sturdy and purposeful, not chancy. Once I gave into her, it was as if I rode in the eye of her storm. I lay as flat against her neck as her own two ears and accepted my diminishment, felt the streamlining effect of the wind purling by.

Up ahead I saw the split-rail fence that bordered posted land, and I knew that she would take it, that I couldn't stop her, that she bore me away like a magician performing a vanishing act. Indeed, she leapt the fence as if it were no taller than a weed, then headed into an opulence of unfamiliar grass and sky, advancing across a tilt of golden fields towards a distant row of dark trees shaped like flames.

In hues of blush and radiance, the whole sky rushed my face, or perhaps it was the tender color of my eyelids closed against a late-flung sun that throbbed against the vibrancy of my tears, loosened by wind and fear and exultation. For we had both survived Goldy's leap, had we not?

Ahead unfolded a terrain that seemed to bloom away from itself, urgent to consume us. And if there were spaces between the cedar trees, I never saw them. I only saw the princely trees, tall and severe, a march of

husbandry around this place, a landscape that addressed us like a formal suitor. The trees loomed almost watchfully, balancing silver epaulets of clouds on their fine shoulders. But the earth pitched towards us, not we to it. If I had been able to halt Goldy, I'm certain that the earth would have continued to unfurl beneath us, would have insisted on our trespass. Whip-like grasses drummed us along, and we raced full speed ahead. There were no more fences, but we prepared ourselves for ascent.

Up over the vertical cedar we soared, or possibly it bent and scooped us up in its giant spade. I swear that's how it happened. We arrived, for an instant, at the zenith of my girlhood, transcendent, like true unfreighted love, wildly certain art, a two-star constellation, the ornaments atop a wedding cake.

GIBBONS RUARK

BEN BERNS
Dutch, born 1936, active in the U.S. since 1963

Swamp Mallows

1995
Oil on canvas
51 ¹⁄₁₆ x 90 ¹⁄₁₆ in. (129.7 x 228.8 cm)
Purchased in memory of William Luther Staton (1871-1944) and Mattie Worsley
Staton (1882-1963) with funds from their daughter Mary Lois Staton 95.8
© Ben Berns

Swamp Mallows

Nearly still water winding among the grasses.
Low white clouds of blossoms, "useless for picking
Since they wilt within an hour." A cumulous sky.
This looks so much like a version of the calm
We might slip into out of troubled waters,

You will forgive me if I sense my father
Just out of sight around some mallowy bend.
At the painting's edges time unravels anyway,
So we might as well let it be summer,
Eastern Carolina, 1949,

The moment he leans down to steady the johnboat
Beside the dock for me to clamber into.
Then, when he has me balanced in the bow,
He reaches me the rods and tackle box
And steps down gingerly into the business end.

This time he has only a single paddle.
We won't be going far, and he loves the quiet
As the boat ripples into a channel
So narrow we can touch the brush on either side.
Then it is all drift and fish — the sun lowering,

The "weedless" hooked lines skimming the bottom for bream —
Casting and reeling till down the long perspective
Of the evening we grow weary of fishing
And catching nothing, lay the gear down carefully
In the slick boat-bottom and give in to drift.

My father's hat is tilted over his eyes
As we float in the freedom of saying nothing
Till warmth and water ferry us into a drowse.
Anybody watching from the bank would see us
Slide unknowingly under a little footbridge

Where a few old ones with kerchiefs on their heads
Are lifting their crab lines with the patience of heaven,
And then we scrape a tree stump and wake up to this:
Nearly still water winding among the grasses.
Low white clouds of blossoms. A cumulous sky.

We have come around in a backwater silence
Still white with mallows. In the face of all this air
And water and slow-to-perish brightness,
We might for once imagine death has been neglectful
And surrendered our passage to be banked with bloom.

Night Wing

FROM THE WINDOW of the plane we look out at the city. At first it's a carnival of colors and light. Then we recognize a field of oil storage tanks, like frogs' eggs clinging to a leaf. Highways like gold ribbons. Dark water. A necklace of bridge. Geometries of white, green, blue.

We can't see these patterns from the ground. We did not even know we were making them. We thought we were building a road, marking a channel for barges, lighting a suburb, erecting a refinery. Playing night baseball. Driving to the supermarket. Yet, like bees creating a hive, like petals organizing themselves into a blossom, without thought we turned the night landscape into an expressionist quilt. Life rearranges matter into patterns. The organic shapes the inorganic.

Thousands of invisible people live down there. They are too small to see. They think they know what they're doing, where they're going. Each has his own motives, purpose, history, goals. Their multitude of individual wills, at odds, in unity, at random, create this hieroglyph, waiting to be read by someone flying above. Like the mysterious images of spiders, llamas, and monkeys on the Nazca plains of South America. Whom are we signaling? What message are we sending?

Across the folds of light – the lines, this code – stretches the dark wing. Cold, silent. The wing is shockingly close, where the landscape is far. Dark, where that is bright. Stationary, while that moves. Yet we know it is the wing that moves, not the landscape. The earth isn't tiny: We are. In its mute solidity the wing gives no hint that we depend on it to keep us up here, separate, in an illusion of mastery. But we are also animals, like those bees in their cells. If we're lucky, we'll descend again. We'll meet our wife and child, forget what we saw. Become one of those lights, part of that darkness.

He wakes in the night to the sound of a jet passing high over his house. Thinks: High. Dark. Dependent. Fragile. In transit.

JOE ASHBY PORTER

ANSELM KIEFER

German, born 1945

Untitled

1980-86

Oil, acrylic, emulsion, shellac, lead, charcoal, and straw mounted on photograph, mounted on canvas; with stones and lead and steel additions

Left panel: 130¼ x 73 in. (330.8 x 185.4 cm)

Center panel: 130⅝ x 72⅝ in. (331.8 x 184.5 cm)

Right panel: 130¼ x 72⅞ in. (330.8 x 185.1 cm)

Overall: 130⅝ x 222¼ in. (331.8 x 564.5 cm)

Purchased with funds from the State of North Carolina, W. R. Valentiner, and various donors, by exchange 94.3

© Anselm Kiefer

In the Mind

YEARS AGO, when I was a young man, it was my duty to inspect a mind, my charge simply to make a brief tour and then present observations. I suspected that my learning might hinder me in the company of other men but, thinking it pointless to pretend to be of their sort, I dressed in a conservative suit and proceeded to the entrance, ready to meet reserve or hostility with courtesy. My guide, some forty years old, had spent his adult life in the mind. While he seemed amused by the whole business, he put me at ease with a respectful friendliness.

We rode a noisy cage elevator down a shaft cut in living stone. Odors of the man's sweat and of graphite lubrication for the winches made me lonely, for I was leaving behind the world as I knew it.

We alighted in semidarkness on a platform at the intersection of several tunnels. It seemed quiet after the elevator ride, though I heard distant machinery. The guide lighted a torch from a pot of fire, and we advanced through the largest tunnel, its walls wet and alert as a dog's nose. I watched in vain for signs of ore, and in fact saw none during my tour, for it lay deeper than the level I explored. Beyond a depot where stood a line of dusty cast-iron trolleys, we emerged into a spacious chamber where a dozen men sat cooking at a campfire. I heard a tin can drop and roll on stone. As we drew nearer I saw past the fire a circle of spectators standing about a performer.

The men at the fire, ten and more years my senior, wearing faded denim and hobnailed boots, stood as we approached. The guide presented me and explained my mission — unnecessarily, for they expected me. These men's deference and even affection cost me the most difficult moment of the tour. As one extended his hand, I saw with some consternation that he had recently lost his fingers, so that sticky orange disks edged his palm, itself blistered and scored. I must have hesitated but I took his hand, and several others variously maimed and none healed.

I left the guide eating beans at the fire, and moved to the group of middle-aged spectators, who ringed a dancer not much younger than I. He alone wore no shirt beneath his overalls. As he entered the final stage of his stiff-legged dance, I felt a pang of sympathy for him, his fine thin body and whole hands, and his face yet free of his seniors' expressions and mannerisms; and the accident of our respective positions gave me some pause. He embraced me and led me down a tunnel where the firelight gave way to a suffused gray, like dawn.

We passed alcoves and galleries dug into the walls of the corridor. In one, three men in respite from their work knelt around a game board opened on the stone. I watched one of the players manage, despite injured hands, to roll a die and nudge forward his counter with a portion of a finger. Stepping closer, I identified their diversion as the humble aleatory game of snakes and ladders. Other of the niches I peered into stood empty. A petroglyph on the rear wall of "His Master's Voice" represented a gramophone, and gazing at it I seemed to hear a distant tinny rant, with faint applause — echoes from greater depths of detonations and rock slide, perhaps. In the recess called "Stone Tears," boulders hung suspended against the crag face, as if the men had so chosen to commemorate the melancholy of their lot, or even of the mind itself. I found myself recalling Virgil's *lachrymae rerum*, the tears of things.

To my surprise, at length the corridor opened onto a kind of underground universe. We looked down on a railroad track where a flatcar bearing a coffin of dull black wood strewn with dusty pink roses, perhaps because it contained a woman, began to roll away, and in time disappeared in the distance. I waited until a proper train arrived, and boarded it.

I detrained in a Mexican village where lived a famous recluse, a collector and singer of folk music, whose work

I had long admired. Presumptuous though it seemed to consider visiting his hacienda above the village, I had no alternative, for no life stirred below. I hoisted my luggage and toiled up the narrow winding streets.

A wall surrounded the buildings. I pulled a bell-rope, and soon the carved gates opened onto a courtyard, across which I saw the proprietor on a balcony. He smiled and beckoned me forward. Thickset men with machine guns flanked me, one took my luggage, and the other escorted me into the house. The musician greeted me and led me up a wide stair to a salon where tea was served. I did not question him about the armed men, nor did he mention them at once. For my part, I supposed them a simple necessity in what was then a backward and dangerous territory.

The musician had been born and educated in Madrid, had traveled widely, spoke excellent English, and seemed wise beyond his thirty-five years. I told him of my long-standing admiration for his work, and we conversed in some detail about a particular song. He was quiet, deliberate, and unassertive. Presently, without changing his manner, he told me that he intended to subject me to an experiment of his devising, and that until I complied I should not be permitted to leave the villa. Naturally I was anxious. That the experiment would be of a radical sort was suggested not only by the armed guards but also by my impression of the man's gravity. Still, resistance appeared futile and, since he seemed trustworthy, I signified my willingness to commence forthwith.

We entered an adjoining library where I sat in an apparatus like a dentist's chair with a cushioned headrest. Meanwhile, the musician explained the experiment. He had discovered that he himself was able to look directly at a source of pure white light of great intensity. The same light had promptly and painfully blinded all animals to which he had subjected it. He believed that the effect on animals resulted from their inability to maintain a steady gaze. He intended to shine this light into my eyes. I

would, he said, feel no pain nor lose my sight so long as I made no attempt to look away.

When I pressed my head against the support, the light source moved into my field of vision and brightened. For some thirty seconds I looked into the light, conscious of little else but the need to hold quite still. All was as the man had predicted. Soon afterwards I returned from the town as I had arrived, to where I had first boarded the train. There the mind now stood deserted. I retraced my steps to the elevator, which I contrived to operate, and so returned to the surface.

BETTY ADCOCK

ANSELM KIEFER

Untitled

Left panel *(For complete triptych, see preceding response.)*

© Anselm Kiefer

Untitled Triptych

Anselm Kiefer, German
Born 1945

LEFT PANEL

The leaden landscape is itself a twilight
shadowing these massive rocks, severed
puppet-strings of heaven dangling
like electric wires. The great stones drop
out of no sky.

 Or these lines are the broken
cables of gravity that braided
granite to earth, iron to earth,
cut now like balloon-strings.
Distracted boulders rise
in graceless desire without
any color on them of light,
adamantine in the pure
negatives of fire: slag, ashes —
the smelter's children
rising as the first mountains
rose on pinions of stone.

There can be no horizon.

RIGHT PANEL

Here is landscape in which a fire has eaten,
in which the storm opens its mouth.
Flecks of lead flare half-hidden,
engine-glints among great patches of lichen
or rot, as if ruins long asleep
had stirred.

 Or these are patches of bombsmoke
pocking huge distance, pieces of metal
descending like miniature shrapnel,
like starshine – a mockery of rain
toward a mockery of bloom: one
tumorous blossom reaching out
from its corkscrewing stem:
the root upgrown,
the tornado touching down.

 And this is the mangled
loudspeaker, sorcerer's vortex
into which the detritus of war has drained:
teeth, shoes, the light-bitten bone.
Out of such darkest cornucopias,
voices marched in trick fire,
a language of ashes taking the names.

If this be as well
the alchemist's funnel, breakable
vessel encoded as spirit,

what is transformed?

CENTER PANEL

Light would break around it but cannot,
is reined into the thing itself:
helix made of intermittent
lumps of light and coal-chunks of shadow –
a boiling certainty in its cauldron of elements.
*It is possible not to see
the serpent*. It is possible not to know it is made
at all, of light or of darkness.

Overhead the damaged ladder launches
twelve steps toward heaven, twelve
toward the ground.
 Or perhaps reflected light
scales only a piece of scalded railroad track
uplifted, no longer directed toward what was
never the alchemist's furnace but a new
kind of burning.
 Rung by rung this wounded
Jacob's ladder recites a desperate alphabet,
that text depending from what may be
the flowering and serpent-making rod of Aaron –
or may be only our blunt
iron inheritance,
the extruded industrial mind.

What reaches toward this narrowed, high
horizon? What climbs earthward
toward that cold fire?
Something is on its way to the sun.
Something is on its way out of the lightened sky.
A brightening almost golden
swirls in the thickening river,
eddies around the ladder.

Everything is awake here:
the promise of knowledge, which was death;
the promise of war, which is kept;
the promise of change, which keeps us.

This serpent is not trodden upon,
this thing only beginning
again as it has always begun,
though the bombs fell and the children
fell, and the gods fell in the fields,
as the world fell and keeps falling
out of the blank sky to become itself —
a mutable beauty, and terrible,
climbing like hope

out of the one coiled heart.

Center panel *(For complete triptych, see preceding response.)*

© Anselm Kiefer

CONTRIBUTORS AND
THEIR CHOICES

arranged alphabetically by choice

WILLIAM MERRITT CHASE
The Artist's Daughter, Alice
ROMULUS LINNEY

GIUSEPPE MARIA CRESPI
The Resurrection of Christ
DAVID SEDARIS

RICHARD DIEBENKORN
Berkeley No. 8
WILLIAM HARMON
JONATHAN WILLIAMS

WILLEM DROST (attributed to)
St. Matthew and the Angel
JULIE SUK

MINNIE EVANS
The Eye of God
MICHAEL MCFEE
HEATHER ROSS MILLER

FREDERICK CARL FRIESEKE
The Garden Parasol
R. S. GWYNN
ELIZABETH SPENCER

THOMAS HICKS
The Musicale, Barber Shop, Trenton Falls, New York
MAX STEELE

WINSLOW HOMER
Weaning the Calf
JAMES APPLEWHITE

GEORGE INNESS
Under the Greenwood
CLYDE EDGERTON

YVONNE JACQUETTE
Night Wing: Metropolitan Area Composite II
JOHN KESSEL

ALEX KATZ
Six Women
LAWRENCE NAUMOFF

ANSELM KIEFER
Untitled
BETTY ADCOCK
JOE ASHBY PORTER

GEORGE COCHRAN LAMBDIN
The Last Sleep
JILL MCCORKLE

LUIS EGIDIO MELÉNDEZ
Still Life with Game
JIM GRIMSLEY

WILLARD LEROY METCALF
June Pastoral
KATHRYN STRIPLING BYER

CLAUDE MONET
The Seine at Giverny, Morning Mists
TIM MCLAURIN

GEORGIA O'KEEFFE
Cebolla Church
DEBORAH POPE

JEAN-BAPTISTE OUDRY
Swan Attacked by a Dog
CHARLES EDWARD EATON

JACOB VAN RUISDAEL
Wooded Landscape with Waterfall
WILMA DYKEMAN

AUGUSTUS SAINT-GAUDENS
The Puritan
JAMES SEAY

GERARD SEGHERS
The Denial of St. Peter
DAVID BRENDAN HOPES

SEGNA DI BONAVENTURA
Madonna and Child
MARGARET MARON

FRANK STELLA
Raqqa II
FRED CHAPPELL

PIERRE-JACQUES VOLAIRE
The Eruption of Mt. Vesuvius
MICHAEL PARKER
ROBERT WATSON

DAVID WILKIE
Christopher Columbus in the Convent of La Rábida Explaining His Intended Voyage
ELEANOR ROSS TAYLOR

ANDREW WYETH
Winter 1946
DORIS BETTS
PETER MAKUCK

A native of San Augustine, Texas, **BETTY ADCOCK** has lived in North Carolina for more than thirty years. She is the author of four books of poems. Her most recent volume, *The Difficult Wheel*, won the Texas Institute of Letters Award for poetry. Previous collections – *Walking Out*, *Nettles*, and *Beholdings* – received, respectively, the Great Lakes Colleges Award, the Roanoke-Chowan Award, and the Zoe Kincaid Brockman Award. In 1994 Adcock won *Shenandoah* magazine's James Boatwright Prize. She has held fellowships in poetry from the National Endowment for the Arts and the state of North Carolina and in 1996 was presented with the North Carolina Award in Literature. Since 1983 the poet has been Kenan Writer-in-Residence at Meredith College in Raleigh.

JAMES APPLEWHITE was born and raised in Stantonsburg, a small tobacco-farming town in eastern North Carolina. He attended Duke University, where he received his B.A., M.A., and Ph.D. He first taught at the University of North Carolina at Greensboro in the early 1960s, where he worked informally with poet Randall Jarrell; in 1972 he returned to Duke to teach. Applewhite has published eight books of poetry, including *A History of the River* and *Daytime and Starlight*. In addition to a Guggenheim Fellowship in 1976, his awards in poetry include a National Endowment for the Arts Fellowship, the American Academy of Arts and Letters Jean Stein Award for 1992, and the 1995 North Carolina Award in Literature. He is a professor of English at Duke University.

Born in Cambridge, Massachusetts, **DAPHNE ATHAS** moved to Chapel Hill, North Carolina, at age fifteen. She received her B.A. from the University of North Carolina at Chapel Hill and did graduate work at the Harvard University School of Education. Her novels include *The Weather of the Heart*, *The Fourth World*, *Entering Ephesus*, and *Cora*. Athas is the author of a nonfiction memoir, *Greece by Prejudice*, and coauthor of the play *Sit on the Earth*. Her latest book is a collection of poems, *Crumbs for the Bogeyman*. She has received the Sir Walter Raleigh Award, a National Endowment for the Arts Fellowship, and a MacDowell Fellowship. Athas teaches writing at the University of North Carolina at Chapel Hill.

Books of poems by **GERALD BARRAX** include *Another Kind of Rain*, *An Audience of One*, *The Deaths of Animals and Lesser Gods*, and *Leaning Against the Sun*. The last was nominated for both a Pulitzer Prize and a National Book Award. Barrax is a professor of English and poet-in-residence at North Carolina State University in Raleigh, where he teaches creative writing and American literature and is editor of *OBSIDIAN II: Black Literature in Review*. His poems have appeared in *Poetry*, *Poetry Northwest*, *The Georgia Review*, *Black American Literature Forum*, *New Virginia Review*, *Callaloo*, *Shenandoah*, *The American Poetry Review*, and *The Gettysburg Review*. The poet was born in Attalla, Alabama, in 1933.

DORIS BETTS was born in Statesville, North Carolina, in 1932, and studied at the University of North Carolina at Greensboro and at Chapel Hill. In 1966 she began teaching at Chapel Hill, where she is now Alumni Distinguished Professor of English. She has published several novels and short story collections, including *The River to Pickle Beach*, *Heading West*, *Souls Raised from the Dead*, and *Beasts of the Southern Wild*. Among the honors she has received are the G. P. Putnam-University of North Carolina Fiction Award, the Sir Walter Raleigh Award, the North Carolina Award in Literature, and the Medal of Merit in the Short Story from the American Academy of Arts and Letters. Betts lives with her husband in Pittsboro, North Carolina.

LINDA BEATRICE BROWN is the author of the 1995 novel *Crossing Over Jordan*. Her other publications include "Treasure," a short story in *O. Henry Festival Stories*; poetry in *Edge of Our World*; and the novel *Rainbow 'Roun Mah Shoulder*, for which she received a first-prize award from the North Carolina Coalition of the Arts. Born in Akron, Ohio, Brown received her undergraduate degree from Bennett College, her M.A. from Case Western Reserve University, and her Ph.D. from the Union Institute. A Distinguished Professor of Humanities at Bennett College since 1992, she previously taught at Guilford College and the University of North Carolina at Greensboro. Brown is married to visual artist Vandorn Hinnant and resides in Greensboro.

KATHRYN STRIPLING BYER received her M.F.A. from the University of North Carolina at Greensboro, where she studied with Fred Chappell, James Applewhite, and Robert Watson. Her first book, *The Girl in the Midst of the Harvest*, was published in 1986 in the Associated Writing Programs Award Series, and her second, *Wildwood Flower*, was the 1992 Lamont Poetry Selection for the Academy of American Poets. Her third book, *Black Shawl*, will be published in 1998. A native of Camilla, Georgia, Byer has lived in the mountains of western North Carolina since her graduation from the University of North Carolina at Greensboro and is poet-in-residence at Western Carolina University in Cullowhee.

FRED CHAPPELL was born in 1936 in Canton, in the western mountains of North Carolina. He received his undergraduate and graduate degrees from Duke University and for many years has taught English at the University of North Carolina at Greensboro. Author of a dozen books of verse (including *Spring Garden*, *C*, *Midquest*, and *First and Last Words*), two volumes of short fiction, and seven novels, Chappell has been awarded the Best Foreign Book Prize from the Académie Française, the Sir Walter Raleigh Award, the North Carolina Award in Literature, and the Bollingen and Aiken Taylor Prizes for his poetry. He and his wife, Susan, live in Greensboro and are devotees of the North Carolina Museum of Art.

ANGELA DAVIS-GARDNER has written two novels, *Forms of Shelter*, published in 1991, and *Felice*, published in 1982. Born in Charlotte, North Carolina, she attended Duke University and the University of North Carolina at Greensboro. Davis-Gardner, who teaches creative writing at North Carolina State University in Raleigh, was awarded an Artist's Fellowship from the Japan Foundation in 1996, enabling her to live in Japan for an extended period.

A Birmingham, Alabama, native, **ANN DEAGON** came to North Carolina to study classics at the University of North Carolina at Chapel Hill. Recently retired from Guilford College, where she was a professor of humanities and writer-in-residence, Deagon continues to work in theater and film and to present readings and workshops in writing and mythology. Her publications in poetry include *Carbon 14*, *Poetics South*, *Indian Summer*, *Women and Children First*, *There Is No Balm in Birmingham*, and *The Polo Poems*. Her fiction includes *Habitats*, *The Pentekontaetia*, and *The Diver's Tomb*. In 1981 she received a National Endowment for the Arts Fellowship. Deagon, the widow of actor Donald Deagon, former director of the drama program at Guilford College, lives in Greensboro, North Carolina.

WILMA DYKEMAN, born in Asheville, North Carolina, keeps homes on the North Carolina and Tennessee sides of the Great Smoky Mountains. Travel on five continents has strengthened Dykeman's awareness of the uniqueness and universality coexisting in people's lives, and she has made this theme central to her seventeen books of fiction, history, biography, and social commentary. Among these works are *The French Broad*, *The Tall Woman*, and *Return the Innocent Earth*. A graduate of Northwestern University and nationally known lecturer, Dykeman has received a Guggenheim Fellowship, a Senior National Endowment for the Humanities Fellowship, the North Carolina Award in Literature, the Thomas Wolfe Trophy, and the Hillman Award for the best book published in the United States on world peace or race relations.

CHARLES EDWARD EATON was born in 1916 in Winston-Salem, North Carolina, and educated at the University of North Carolina at Chapel Hill, Princeton University, and Harvard University, where he studied with Robert Frost. After serving as vice-consul in Rio de Janeiro for five years, he taught creative writing at the University of Missouri and the University of North Carolina at Chapel Hill. He is the author of thirteen collections of poetry, four volumes of short stories, a novel, and a book of art criticism. These works include *The Country of the Blue*, *A Guest on Mild Evenings*, and *The Shadow of the Swimmer*. Among the numerous honors he has received are the Roanoke-Chowan Award for poetry and the North Carolina Award in Literature. Eaton resides in Chapel Hill.

CLYDE EDGERTON is the author of several novels, including *Redeye*, *In Memory of Junior*, and *Killer Diller*. He has recently collaborated with photographer Jean-Christian Rostagni on a book about the Durham Bulls baseball team. Born in 1944 in Bethesda, North Carolina, Edgerton attended Durham County public schools and received his undergraduate degree from the University of North Carolina at Chapel Hill, where he also earned his Ph.D. in English education. He has taught creative writing at St. Andrews College, Agnes Scott College, Duke University, and Millsaps College. Among the many awards he has won are Guggenheim and Lyndhurst Fellowships. The novelist lives in Orange County, North Carolina, with his wife, Susan, and their daughter, Catherine.

Born and raised in Black Creek, North Carolina, **ANDERSON FERRELL** is the author of two novels, *Where She Was*, published in 1985, and *Home for the Day*, published in 1994. His short fiction has appeared in *Mississippi Review*, *Men on Men*, and *The Quarterly*. Winner of a 1996 Whiting Writer's Award, Ferrell lives in New York City.

MARIANNE GINGHER was born on Guam in the Mariana Islands and grew up in Greensboro, North Carolina. She received her undergraduate degree at Salem College and her M.F.A. at the University of North Carolina at Greensboro. Gingher is the author of the 1986 novel *Bobby Rex's Greatest Hit* and the story collection *Teen Angel and Other Stories of Young Love*, published in 1988. Her short fiction and criticism have appeared in several periodicals, including *Redbook*, *The Southern Review*, and *The New York Times*. Director of creative writing at the University of North Carolina at Chapel Hill, Gingher lives in Greensboro with her two sons, Rod and Sam.

JIM GRIMSLEY was born in Rocky Mount, North Carolina. He attended the University of North Carolina at Chapel Hill and lives in Atlanta, Georgia, where he has been playwright-in-residence at 7Stages Theatre since 1986. Grimsley's first novel, *Winter Birds*, won the 1995 Sue Kaufman Prize for First Fiction from the American Academy of Arts and Letters and the Prix Charles Brisset, given by the French Academy of Physicians. His second novel, *Dream Boy*, won the 1996 Award for Gay, Lesbian and Bisexual Literature from the American Library Association; the book was also one of five finalists for the Lambda Literary Award. Grimsley's plays include *Mr. Universe*, *The Lizard of Tarsus*, *White People*, and *The Existentialists*. His third novel, *My Drowning*, appeared in 1997.

ALLAN GURGANUS is the author of the 1989 novel *Oldest Living Confederate Widow Tells All*, for which he won the Sue Kaufman Prize for First Fiction from the American Academy of Arts and Letters. He has also written *Plays Well With Others*, a forthcoming group of four novellas, and *White People*, a collection of stories. For *White People* he received *The Los Angeles Times* Book Prize for best work of American fiction, and he was awarded the National Magazine Prize for his 1993 work, *The Practical Heart*. Gurganus, born in 1947 in Rocky Mount, North Carolina, has recently returned from fifteen years in Manhattan to live in his native state.

R. S. GWYNN was born in Eden, North Carolina, in 1948, and educated at Davidson College and the University of Arkansas. The author of six collections of poetry, including *The Drive-In*, published in 1986, he has also edited reference books, anthologies, and textbooks. Gwynn is a professor of English at Lamar University in Beaumont, Texas.

Born in 1938 in Concord, North Carolina, **WILLIAM HARMON** is the James Gordon Hanes Professor of English at the University of North Carolina at Chapel Hill, where he has taught for more than twenty-five years. His five volumes of poetry include a Lamont Poetry Selection and a William Carlos Williams Award-winner. Harmon has edited three anthologies (*The Oxford Book of American Light Verse*, *The Classic Hundred: All-Time Favorite Poems*, and *The Top 500 Poems*) and the three most recent editions of Prentice Hall's *A Handbook to Literature*. He also serves as the barbecue editor of the *North Carolina Literary Review*.

DAVID BRENDAN HOPES was born in Akron, Ohio. He is a professor of literature and humanities at the University of North Carolina at Asheville. He is also director of the Pisgah Players Theater Company, the Urthona Press, and the Urthona Art Gallery in downtown Asheville. Hopes's latest book, *Blood Rose*, was published in 1996; other works include *The Glacier's Daughter* and *A Sense of the Morning*.

JOHN KESSEL is a professor of American literature and fiction writing at North Carolina State University in Raleigh. Born in Buffalo, New York, and educated at the University of Rochester and the University of Kansas, he has lived in North Carolina since 1982. His stories have appeared in *Fantasy and Science Fiction*, *Omni*, *Asimov's*, *New Dimensions*, and *The Berkley Showcase*. In 1982 his novella *Another Orphan* received the Nebula Award, and his short story "Buffalo" won the 1991 Theodore Sturgeon Award and the Locus Poll. His novels include *Freedom Beach*, written in collaboration with James Patrick Kelly, and *Good News from Outer Space*. His 1992 story collection, *Meeting in Infinity*, was nominated for the World Fantasy Award and named a Notable Book of the Year by *The New York Times*.

ROMULUS LINNEY is the author of three novels and many plays, which have been staged throughout the United States and abroad. They include *"2"*, *The Sorrows of Frederick*, *Holy Ghosts*, *Childe Byron*, and *Heathen Valley*. Linney has received two Obie Awards; two National Theater Critics Awards; three Dramalogue Awards; fellowships from the National Endowment for the Arts and the Rockefeller and Guggenheim Foundations; and the Award in Literature from the American Academy of Arts and Letters. Born in Philadelphia in 1930, Linney lived in Boone, North Carolina, early in his life. He is a professor of the arts at Columbia University and teaches in the Actors Studio M.F.A. program at the New School in New York City.

A teacher at East Carolina University, **PETER MAKUCK** also serves as editor of *Tar River Poetry*. He has published five volumes of poems, including *Pilgrims*, which

won the Zoe Kincaid Brockman Award in 1989, and most recently, *Against Distance*. He is the author of a collection of stories, *Breaking and Entering*, and the co-editor of *An Open World*, a collection of essays on the Welsh poet and short story writer Leslie Norris. Makuck's essays, stories, and poems have appeared in *Poetry*, *The Yale Review*, *The Southern Review*, *The Sewanee Review*, and *The Virginia Quarterly Review*. In 1993 he received the Charity Randall Citation from the International Poetry Forum. Makuck was born in New London, Connecticut, in 1940.

MARGARET MARON is the author of thirteen mystery novels and numerous short stories. In 1993 her North Carolina-based *Bootlegger's Daughter* won the Edgar Allan Poe Award and the Anthony Award for best mystery novel of the year, the Agatha Award for best traditional novel, and the Macavity for best novel – an unprecedented sweep for a single novel. She is a past president of Sisters in Crime and actively participates in the Mystery Writers of America, the American Crime Writers League, and the Carolina Crime Writers Association. Her latest novels are *Fugitive Colors* and *Up Jumps the Devil*. Maron was born in Greensboro and reared in rural Johnston County, North Carolina. She lives with her husband near Raleigh.

JILL McCORKLE, a native of Lumberton, North Carolina, graduated from the University of North Carolina at Chapel Hill and received her M.A. from Hollins College. She is the author of the short story collection *Crash Diet* and five novels – *The Cheer Leader*, *July 7th*, *Tending to Virginia*, *Ferris Beach*, and *Carolina Moon*. McCorkle has taught creative writing at the University of North Carolina at Chapel Hill and Tufts University and currently teaches at Harvard University and in the Bennington College M.F.A. program. She lives near Boston with her husband and two children.

MICHAEL McFEE has published five collections of poetry – *Colander*, *To See* (in collaboration with photographer Elizabeth Matheson), *Sad Girl Sitting on a Running Board*, *Vanishing Acts,* and *Plain Air*. He also edited the 1994 poetry anthology *The Language They Speak Is Things to Eat: Poems by Fifteen Contemporary North Carolina Poets*. His poems and essays have appeared in many publications, including *Poetry*, *The Virginia Quarterly Review*, *The Hudson Review*, *Parnassus: Poetry in Review*, and *Bulls Illustrated: The Official Magazine of the Durham Bulls*. McFee, who was born in Asheville, North Carolina, teaches poetry writing and contemporary North Carolina literature at the University of North Carolina at Chapel Hill. He lives with his wife and son in Durham, where he is an assistant editor for *DoubleTake* magazine.

TIM McLAURIN was born in Fayetteville, North Carolina, in 1953. He attended public schools and graduated from Cape Fear High School in 1972. Then he joined the United States Marine Corps and served in Panama, Puerto Rico, and the Caribbean. He received an honorable discharge as a lance corporal in 1974. After a two-year stint in the Peace Corps in Tunisia, McLaurin earned a B.A. in journalism from the University of North Carolina at Chapel Hill. He briefly worked for a newspaper; he has also worked as a soft-drink salesman and as a carpenter, in a factory and in a traveling reptile show. The author of *Woodrow's Trumpet* and three other novels as well as a memoir, *Keeper of the Moon*, McLaurin teaches fiction writing and literature at North Carolina State University in Raleigh.

Born in 1939 in Albemarle, North Carolina, **HEATHER ROSS MILLER** is a member of the North Carolina writing family that also includes Eleanor Ross Taylor. Miller is the author of fourteen books of poetry and fiction, including the recent collection of

stories, *In the Funny Papers*, and two collections of poems, *Hard Evidence* and *Friends and Assassins*. The holder of three creative writing fellowships from the National Endowment for the Arts, she has also received the North Carolina Award in Literature. Miller teaches at Washington and Lee University in Lexington, Virginia, and maintains a home in the North Carolina Piedmont where she was raised.

ROBERT MORGAN was born in Hendersonville, North Carolina, and grew up on the family farm in nearby Green River. After attending Emory College and North Carolina State University, he graduated from the University of North Carolina at Chapel Hill in 1965 and earned his M.F.A. from the University of North Carolina at Greensboro in 1968. The author of nine books of poetry, including *Sigodlin* and *Green River: New and Selected Poems*, he has also published four books of fiction, most recently *The Hinterlands* and *The Truest Pleasure*. The latter was cited by *Publisher's Weekly* as one of the best novels of 1995. Winner of the James G. Hanes Poetry Prize and the North Carolina Award in Literature, Morgan has taught at Cornell University since 1971.

LAWRENCE NAUMOFF was born and raised in Charlotte, North Carolina, and graduated from Myers Park High School and the University of North Carolina at Chapel Hill. In the late 1960s he published short stories and novel excerpts under the pseudonym of Peter Nesovich. After winning prizes and honors for his fiction, he stopped writing entirely for almost fifteen years. When he began to write again, he published two critically acclaimed novels, *The Night of the Weeping Women* and *Rootie Kazootie*. His 1992 novel, *Taller Women: A Cautionary Tale*, was a *New York Times* Notable Book of the Year. Author of the two recent books *Silk Hope, N.C.* and *A Plan for Women*, Naumoff lives in Carrboro, North Carolina.

Fiction and nonfiction by **MICHAEL PARKER** have been published in *The Georgia Review*, *Carolina Quarterly*, *The Greensboro Review*, and *The Washington Post*, among other periodicals. Parker's novel, *Hello Down There*, was named a 1993 Notable Book of the Year by *The New York Times*, and his collection of six short fictions, *The Geographical Cure*, received the 1994 Sir Walter Raleigh Award. Additional recognition has come his way, including his recently being named a regional finalist in *Granta*'s Most Promising Young Novelists in America competition. Parker was born in 1959 in Siler City, North Carolina, and grew up in Clinton. A graduate of the University of North Carolina at Chapel Hill and the graduate writing program of the University of Virginia, he is an assistant professor in the English department at the University of North Carolina at Greensboro.

DEBORAH POPE's poems have been published in *Poetry*, *The Southern Review*, *The Georgia Review*, *Poetry Northwest*, *Prairie Schooner*, *Shenandoah*, and other magazines. In addition to the recently published *Mortal World: Poems by Deborah Pope*, she is the author of *Fanatic Heart* and *A Separate Vision: Isolation in Contemporary Women's Poetry*. Pope also co-edited *Ties That Bind: Essays on Mothering and Patriarchy*. A native of Cincinnati, Ohio, she teaches at Duke University.

JOE ASHBY PORTER is the author of the novel *Eelgrass* and of the collections, *Lithuania: Short Stories* and *The Kentucky Stories*, the latter a Pulitzer Prize nominee. His short stories have appeared in many periodicals and in anthologies, including *The Best American Short Stories*, *New Directions in Prose and Poetry*, *Contemporary American Fiction*, and *The Pushcart Prize: Best of the Small Presses*. His awards include two fellowships from the National Endowment for the Arts. Porter, a professor of English at Duke University, teaches fiction writing and has directed the Duke Writers' Conference. He has also served

as a writer-in-residence at Brown University and on the faculty of the Sewanee Writers' Conference. Porter was born in Madisonville, Kentucky, in 1942.

REYNOLDS PRICE was born in Macon, North Carolina, in 1933. Educated in the public schools of his native state, he earned an A.B. summa cum laude from Duke University. In 1955 he traveled as a Rhodes Scholar to Merton College, Oxford University. Upon earning a B.Litt. degree (with a thesis on John Milton), he returned to Duke where he continues teaching as James B. Duke Professor of English. With his 1962 novel *A Long and Happy Life*, he began a career that has produced numerous volumes of fiction, poetry, plays, essays, translations, and memoir. He has received the North Carolina Award in Literature; the William Faulkner Award for *A Long and Happy Life*; the National Book Critics Circle Award for fiction for *Kate Vaiden*; and the Levinson, Blumenthal, and Tietjens awards for his poems. Price is a member of the American Academy of Arts and Letters, and his books have appeared in sixteen languages.

Born in Raleigh, North Carolina, in 1941, **GIBBONS RUARK** grew up as the son of a Methodist minister in various eastern North Carolina towns. A graduate of Laurinburg High School, he holds degrees from the University of North Carolina at Chapel Hill and the University of Massachusetts. His poems have appeared in such magazines as *Poetry*, *The New Yorker*, and *The New Republic*, and have won him many awards, including three fellowships from the National Endowment for the Arts. Among his books are *A Program for Survival*, *Reeds*, *Keeping Company*, and *Rescue the Perishing*. A member of the English faculty at the University of Delaware since 1968, Ruark lives with his wife in Landenberg, Pennsylvania.

JAMES SEAY, born in 1939 in Panola County, Mississippi, was educated at the University of Mississippi and the University of Virginia. Since 1974 he has been teaching at the University of North Carolina at Chapel Hill, where he was named a Bowman and Gordon Gray Professor for excellence in undergraduate teaching. Seay has published four books of poetry – *Let Not Your Hart*, *Water Tables*, *The Light as They Found It*, and *Open Field, Understory: New and Selected Poems*. His work has also appeared in *Antæus*, *Esquire*, *The Nation*, *The Southern Review*, and elsewhere. In addition, he co-wrote (with George Butler) the film *In the Blood*. Among Seay's honors are an Emily Clark Balch Prize and an Award in Literature from the American Academy of Arts and Letters.

DAVID SEDARIS is a commentator for National Public Radio's "Morning Edition" and the author of the books *Barrel Fever* and *Naked*. His stories and essays have appeared in *Harper's*, *The New Yorker*, and *New York Magazine*. A founding member of The Talent Family, he is the coauthor (with his sister, Amy) of the 1995 Obie Award-winning play *One Woman Shoe*. Sedaris was born in Johnson City, New York, and grew up in Raleigh, North Carolina. He lives in New York City.

ALAN SHAPIRO is the author of five books of poetry – including *Happy Hour*, which received the William Carlos Williams Award from the Poetry Society of America, *Covenant*, and most recently, *Mixed Company* – and a volume of autobiographical essays, *The Last Happy Occasion*. Among Shapiro's many honors are a Guggenheim Fellowship, two National Endowment for the Arts Fellowships, and an individual Writer's Award from the Lila Wallace-Reader's Digest Fund. Born in Boston, Massachusetts, in 1952, Shapiro is a professor of English and creative writing at the University of North Carolina at Chapel Hill.

LEE SMITH has published nine novels and two collections of short stories, including *Saving Grace*, *The Devil's Dream*, *Fair and Tender Ladies*, and *Family Linen*. She has received the North Carolina Award in Literature; the Sir Walter Raleigh Award; and other national prizes. Born in Grundy, Virginia, in 1944, she often writes about the Appalachian mountain region of her childhood. Smith teaches writing at North Carolina State University in Raleigh and lives in Hillsborough.

ELIZABETH SPENCER was born in Carrollton, Mississippi, a small town in the north central hill country. She has taught literature and creative writing at various universities and lived in Italy for five years and in Montreal for many years as well. In 1986 she and her husband moved to Chapel Hill, North Carolina. Spencer has written nine novels and three volumes of stories, including *The Voice at the Back Door*, *The Light in the Piazza*, *Jack of Diamonds*, *The Salt Line*, and *The Snare*. Her latest book is *The Night Travellers*, published in 1991. She is currently at work on a memoir. Spencer has received many awards, including the 1994 North Carolina Award in Literature.

MAX STEELE, born in 1922 in Greenville, South Carolina, headed the creative writing program at the University of North Carolina at Chapel Hill from 1966 to 1987. He is the author of two books of short stories, *Where She Brushed Her Hair* and *The Hat of My Mother*. These stories, now published in many textbooks and anthologies, first appeared in such national magazines as *The New Yorker*, *The Atlantic Monthly*, *Harper's*, *Esquire*, *Mademoiselle*, *Cosmopolitan*, *Story*, *The Paris Review*, and *Carolina Quarterly*. His children's book, *The Cat and the Coffee Drinkers*, is often heard on public broadcasting stations.

JULIE SUK's most recent collection of poems, *The Angel of Obsession*, won both the 1991 University of Arkansas national poetry competition and the Roanoke-Chowan Award for best book of poetry by a North Carolina writer. Her other books include *The Medicine Woman*, *Heartwood*, and *Bear Crossings: An Anthology of North American Poets* (co-edited with Anne Newman). A 1993 recipient of the Bess Hokin Prize given by *Poetry*, Suk lives in Charlotte, North Carolina, where she is an associate editor of *Southern Poetry Review*. The poet was born in Mobile, Alabama.

ELEANOR ROSS TAYLOR was born in Norwood, North Carolina, and received her undergraduate education at the University of North Carolina at Greensboro, where she studied with Caroline Gordon and Allen Tate. Her collections of poetry are *Wilderness of Ladies*, *Welcome Eumenides*, *New and Selected Poems*, and most recently, *Days Going / Days Coming Back*. She has received awards from the American Academy of Arts and Letters and *The Kenyon Review*. She is a member of a family of writers. The sister of novelists James Ross and Fred Ross and short story writer Jean Justice, Taylor is the aunt of Heather Ross Miller. She was married to the late Peter Taylor, and their children, Katherine Taylor and Ross Taylor, have also written poems and stories. Eleanor Ross Taylor lives in Charlottesville, Virginia.

ROBERT WATSON has published six collections of poetry, most recently *The Pendulum: New and Selected Poems* and *Night Blooming Cactus*. He is also the author of two novels, *Three Sides of the Mirror* and *Lily Lang*, and has won many honors, among them awards from the National Endowment for the Arts and the American Academy of Arts and Letters. He has taught at Williams College, The Johns Hopkins University, and, for many years, at the University of North Carolina at Greensboro. Watson, born in 1925 in Passaic, New Jersey, lives in Greensboro.

Poet and photographer **JONATHAN WILLIAMS** was born in Asheville, North Carolina, in 1929. In the early 1950s he studied with Charles Olson at Black Mountain College and founded The Jargon Society, a poet's press now in operation nearly fifty years. Williams is a much-in-demand essayist; his work has appeared in international journals and innumerable exhibition catalogues. His books include *An Ear in Bartram's Tree*, *Lines About Hills Above Lakes*, *Portrait Photographs*, and most recently, *Horny & Ornery* and *Kinnikinnick Brand Kickapoo Joy-Juice*. Among his many honors are a Guggenheim Fellowship, grants from the National Endowment for the Arts, and the North Carolina Award in the Fine Arts. Williams and his poet/astrologer companion, Thomas Meyer, divide their year between Highlands, North Carolina, and Dentdale, Cumbria, England.

INDEX

of contributors (in bold), artists, and
works of art

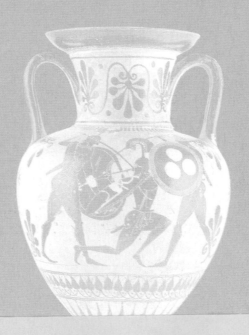